THE COLD WAR

First published in 2010. A catalogue record for this book is available from the British Library

ISBN: 978-1-844259-49-6

Published by Haynes Publishing, Sparkford, Yeovil, Somerset BA22 7JJ, UK
Tel: 01963 442030 Fax: 01963 440001 Int. tel: +44 1963 442030 Int. fax: +44 1963 440001
E-mail: sales@haynes.co.uk Website: www.haynes.co.uk

Haynes North America Inc., 861 Lawrence Drive, Newbury Park, California 91320, USA

Images © Mirrorpix

Creative Director: Kevin Gardner
Designed for Haynes by BrainWave

Printed and bound in the US

THE COLD WAR

An Illustrated History

Andrew Heritage

LEFT: *The image of tanks on the streets while civilians attempt to lead their day-to-day lives is one of the enduring icons of the 20th century, from Budapest to Beijing and beyond. This is Prague in 1968.*

INTRODUCTION

According to US President George Bush Sr, the Cold War officially ended in 1991, with the dissolution of the Union of Soviet Socialist Republics (USSR).

Quite when the Cold War began is a different matter, but the general consensus is that it started with the rapid cooling of relations between the Western Allies and the Soviet Union at the end of the Second World War. It may be that the detonation of atomic bombs over the Japanese cities of Hiroshima and

and East that reached new heights by the late 1940s had been a process spread over several decades, one which was only held in suspension, as if frozen, during the struggle against Hitler's Germany and Japan.

This cursory definition raises a number of questions. How and why did this cooling effect occur so rapidly? This can only be answered by looking back deep into the early years of the 20th century, or possibly earlier, where an inherent clash of ideologies – democratic free market economies versus ideologically controlled centralized economies – formed the root of a clash of cultures. Industrialization and the creation of a burgeoning urban proletariat

Nagasaki in August 1945 provides the sort of neat starting point that teachers of history like. But, despite the intentions behind US President Harry S. Truman's decision to deploy the only two nuclear weapons to date used in active warfare, the ideological differences between the two superpowers that emerged from the ashes of the Second World War dated back much earlier, to the first decades of the 20th century. The deteriorating relations between West

had provoked Karl Marx and Friedrich Engels to formulate their socialist theories concerning the redistribution of wealth, which led to the Bolshevik revolution in Russia. But, in a country such as China, communism was a means to an end – quite simply how do you feed so many people? And the implementation of such ideologies could be achieved only by the imposition of the will of a few upon mass populations, often at an enormous cost and

with great brutality. Inevitably, as the socialist sceptic George Orwell pointed out in his 1945 satirical novel *Animal Farm* (published 11 days after the Hiroshima atomic bomb attack), "All animals are equal, but some animals are more equal than others." In the same book he anticipated one of the more chilling dictums that would come to characterize many aspects of the Cold War: "War is war. The only good human being is a dead one."

As wars go, even the neatly defined Cold War had a long lifespan, but its peaks and troughs cannot really be defined in conventional military terms, that is to say it cannot be characterized as a clear succession of campaigns or battles, decisive or otherwise. It was, rather, a long slow-burning fuse with many intermittent sparks of "Hot War" activity around its edges. As has often been observed, it might be seen as a "Hot War" in slow motion. The embers are, unfortunately, still glowing, as many of the core components of the Cold War still flare up in the world of today, albeit hidden by a different array of masks: inequality, particularly between the developed and the developing world, remains a seemingly unsolvable issue, as does the struggle for control of resources. The threat of nuclear war has not diminished, but has indeed grown as "rogue" states such as Iran and North Korea, among others, develop atomic technology, while the black market trade in fissionable material presents the threat of terrorists being able to construct "dirty bombs".

What remains interesting is the way in which the Cold War tapped into the persistent human need for conflict and confrontation. And that it provided on an abundant scale, from almost intimate atrocities, the My Lai massacre during the Vietnam War for example, to the industrial – and quite literal – decimation of a country's population in Cambodia under the Khmer Rouge.

Why is this? For the student of the period, it is instructive to consider a number of broad subject headings which military historians

BELOW: *Berlin: divided city, 1961.*

frequently bring to bear when analyzing warfare, whether ancient or modern.

The first problem is one of political ideology. Most wars before the 20th century were about territorial gain and control of resources. The ancient Greek historians Herodotus and Thucydides might argue for exceptions, in the case of Greece versus Persia, and Athens versus Sparta respectively, where democracy was portrayed as battling against insuperable imperial odds – but what emerged was an Athenian city state that by force of arms dominated the Hellenic world until it was absorbed by Rome. Were the Crusades that dominated the medieval Mediterranean world truly launched in the name of Christianity rather than a desire for territorial or political

control, spiced with a taste for revenge? And while it might be argued that the appalling atrocities of the Thirty Years' War were the product of bitter religious differences, were they just as much the product of a power struggle between the old, established Catholic states of the Mediterranean and the emerging states of northern Europe? Was embracing Protestantism just as much a means of struggling free from Roman domination, the new states of northern Europe having set their sights set on colonial spoils far beyond the borders of traditional Christendom? Few sustained wars have occurred purely as a result of fundamental ideological differences. In the case of the Cold War there were two immediate precedents: the Spanish Civil War and the Second World War,

US ARMY CHECKPOINT

both of which can be seen as part of its story.

The second is one of technology. The First World War, with its reliance on transport, new technologies such as telegraphy and aeroplanes, and the sheer industrial capacity the participants could bring to bear down on human flesh – producing enough ships, guns, aircraft and explosives to turn the battlefield into a charnel house – had already rewritten the rulebook. Only a generation later, in the war against Hitler and the Greater German Reich, there were two new dynamics: racism and political ideology, but in the background lay the capacity to interdict intelligence and the ability to bring the punishment of warfare to the civilian population on an unprecedented scale. The flattening of German cities under the Allied Combined Bombing Offensive remains controversial, as does the use of nuclear weapons against Japan. However, as W G Sebald pointed out, in 1942 Nazi Germany was quite capable of wiping out 40,000 souls in Stalingrad by bombing – a battle for a city that it eventually lost.

The third concerns global geography. For centuries, indeed millennia, the battlefield was like a table-top. Most military confrontations took place within a closely defined geographical area, and aging generals could describe their campaigns over port and cigars by simply moving salt cellars and pepper pots around over the tablecloth. This began to change with the growth of power projection – specifically, the extension by navies of sea power and mobility in the 18th century; indeed, the Seven Years' War (1756–63) has sometimes been characterized as the first 'world war', wherein British and French navies conducted a war by proxy way beyond the core battlegrounds of

central Europe. A generation later, Napoleon and his enemies would add flesh to the conceit by extending a war of European domination to Scandinavia, Egypt, Russia, the West Indies and the Indian Ocean. By the time of the First World War it was clear that the battlefield ranged far beyond the killing grounds of the Western Front.

The fourth involves levels of subterfuge. The Cold War was a period of suspicion, paranoia and uncertainty, dominated by a singular, almost inescapable truth, that, by the time of the Cuban missile crisis in 1962, annihilation by nuclear warheads was only a breath away. The psychology of Mutually Assured Destruction (with the apt acronym MAD) produced a sort of monolithic stalemate in the shadows of which a devilish new catalogue of strategies was added to the conventional war-book programmes of flesh versus steel.

The Cold War emerged as a new kind of conflict, one that successive generations in the West often talked about in hushed voices: it was the elephant in the corner of the room, a constant uncomfortable presence, but one which few could really do much about. It was a "war" that was experienced by five generations, at least. For those who had been actively involved in (and survived) the Second World War, returning home, confronted by rationing and in some cases total national reconstruction, it must have felt like a disappointing outcome after years of struggle. For the generation born during and immediately after the Second World War, the "baby boomers", the Cold War was seen as an unwelcome legacy of the old order. For those born during the last quarter of the 20th century, it already feels like archaeology. How can these differing perceptions be reconciled?

This is what this book seeks to address.

Prelude to
the Cold War
1900-1940

The first four decades of the 20th century witnessed dramatic political, social and technological transformations that changed the world beyond recognition.

For almost anyone born in the last two decades of the 19th century, the world of 1940 was a strange and very different place. They had witnessed the coming of the automobile, the aeroplane and the tank, of radio communications and the cinema. Mass production had been developed to feed a new consumer economy.

Democracy had expanded considerably, especially with votes for women, although by 1940 fewer than 15 countries actually enjoyed democratic elections – many more were still under the sway of colonial rule. But two great doomed experiments in political ideology were also under way: communism in Russia and elsewhere, and fascism, most specifically in Europe.

The imperial certainties that had prevailed for the previous three centuries were now under pressure from indignant nationalists.

The pivotal event of the period was the so-called "Great War", World War I. It was a cataclysm which spawned revolutions in science, technology and politics, and the art of mass slaughter.

LEFT: *Troops advancing across "No-man's land" at La Boiselle on the first day of the Allied Somme offensive, on the Western Front. Some 56,000 casualties occurred on the first day of the battle, which dragged on for a further four months.*

1900-1918

1900 Boxer Rebellion in China: populist uprising targets both ruling Qing dynasty and Western imperialist interests in China.

1900 Max Planck develops quantum theory (Germany).

1901 First radio messages sent in Morse code across Atlantic.

1903 Panama Canal Zone ceded to the United States.

1904-05 Russo-Japanese War; provokes anti-imperial nationalism in Asia.

1905 First Russian Revolution.

1905 Einstein's Theory of Relativity (Germany).

1910 Mexican Revolution begins. First radical socialist government in Americas established by 1920.

1910 Portuguese royal family overthrown, republic proclaimed.

1911 Chinese Revolution; Sun Yat-sen becomes president of first Chinese republic, ending 4,000 years of imperial rule.

1912 First use of aircraft for bombing.

1912 "First" Russian Revolution. Left-wing rebellions suppressed.

1913 Henry Ford introduces production line manufacturing techniques (USA).

1914 Panama Canal opens, providing the USA with a new gateway to the Pacific.

1914 Outbreak of World War I in Europe.

1916 Battle of the Somme; mass slaughter of troops.

1917 USA declares war on Central Powers; beginning of USA/UK "special relationship".

1917 First use of massed tanks, on Western Front.

1917 Bolshevik Revolution in Russia, creation of first modern socialist state.

1917 Balfour Declaration promises a Jewish homeland.

1918 Collapse of Ottoman empire. Middle East to be divided into jigsaw of "mandated" territories, largely under European control.

1918 Central Powers (Germany and Austria-Hungary) sue for armistice. End of World War I.

1918-21 Civil war and foreign intervention in Russia; Bolsheviks emerge victorious.

THE FIRST COMMUNIST REVOLUTIONS

At the beginning of the 20th century a rash of radical, anarchist or republican movements spread across the established face of the globe, which threatened on various levels the comfortable status quo of the handful of European nations/empires that coloured and controlled much of the map of the world in 1900. Popular dissent against the imperial ruling dynasties in both China and Russia had been rumbling through the last decades of the 19th century, but broke into bloody conflict in China in 1900 with the Boxer Rebellion. In Russia, a populist uprising in 1905 by both civilians and the military squeezed concessions from the ruling royal family. In 1910, a revolution broke out in Mexico, one that would last for almost a decade but that would eventually see a radical socialist government established on America's southern border.

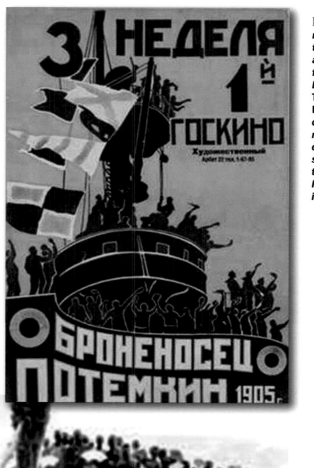

LEFT: *Often regarded as the finest of all propaganda films, Eisenstein's The Battleship Potemkin (1925) celebrated a naval mutiny during the first stirrings of the Russian Revolution, in 1905.*

LEFT: *The punishments meted out to revolutionaries could be harsh. Thousands of Chinese Boxer rebels were summarily beheaded. For survivors, this only hardened their resolve.*

BELOW: *The
first tanks were
deployed on the
Western Front
in September
1916.*

THE FIRST WORLD WAR

The clash between the Central Powers (Germany, Austria-Hungary and the Ottoman Empire) and an alliance of Great Britain, France, Italy and imperial Russia, joined only in 1917 by the USA, proved to be a watershed between the old world values of the 19th century and a new, idealistic and industrialized 20th century.

The main focus of the war was in Europe where, on the Western Front, with millions of troops confronting each other in lines of largely static trenches, a brutal war of attrition developed. On the Eastern Front there was more movement, but inadequate supplies and weak command saw the Russian imperial army effectively collapse – many of the war weary ready to embrace a socialist cause which would eventually produce the Bolshevik Revolution.

The use of gas, heavy artillery, trench mortars, mines, machine guns, tanks and aerial bombing brought technology and slaughter on an industrial scale onto the battlefield.

65 million troops were mobilized; over 9 million men were killed and a further 23 million left irreparably damaged by the war. Among them were many civilian deaths resulting from bombing, starvation or disease.

"The War to End All Wars", as US President Woodrow Wilson called it, did not live up to his expectations.

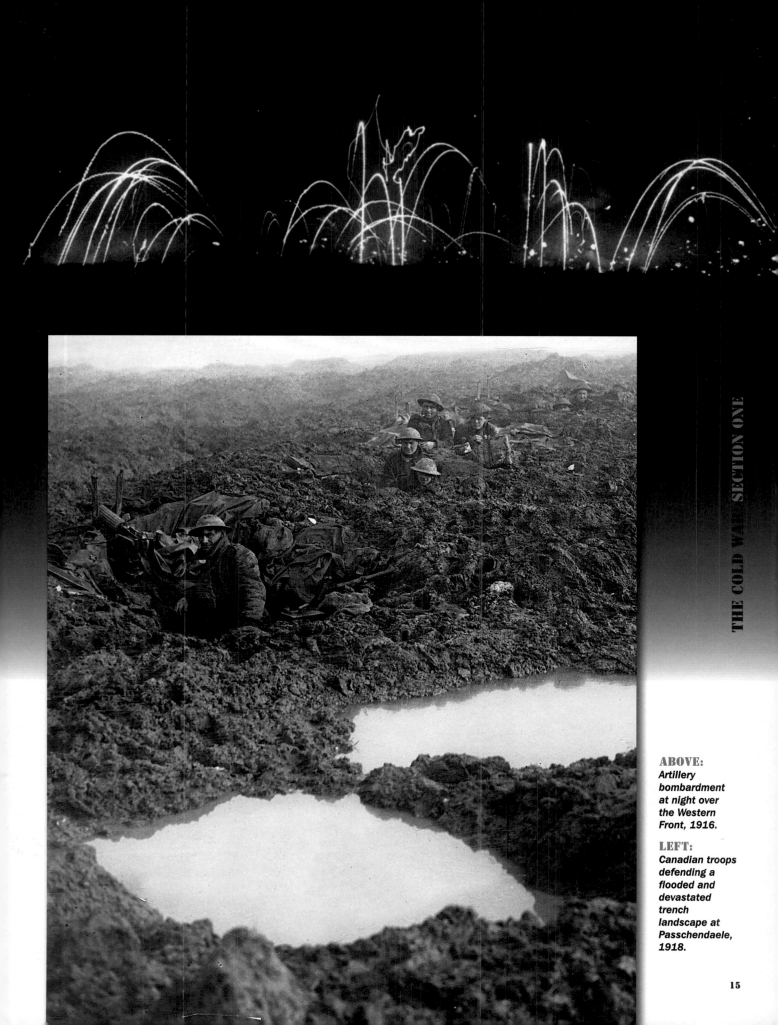

ABOVE:
Artillery bombardment at night over the Western Front, 1916.

LEFT:
Canadian troops defending a flooded and devastated trench landscape at Passchendaele, 1918.

15

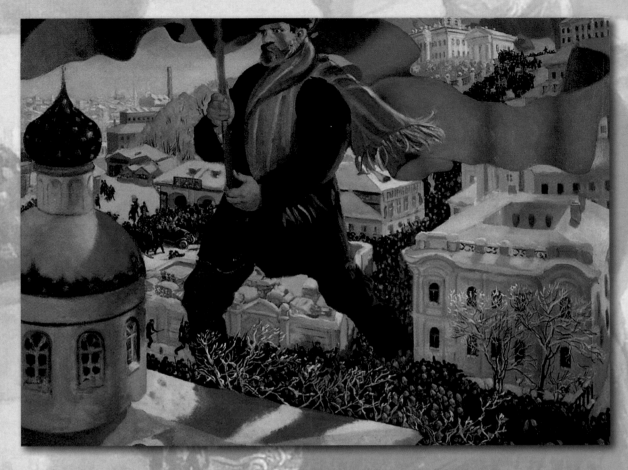

RIGHT: *The first crisis of the Bolshevik Revolution began in St Petersburg when crowds surrounded and then stormed the imperial Winter Palace.*

BELOW: *Rioting and demonstrations spread rapidly to other Russian cities.*

THE BOLSHEVIK REVOLUTION AND CIVIL WAR

The unsustainable pressure of World War I led in March 1917, to the collapse of the Tsarist imperial regime, and then that of the Socialist Provisional Government set up to run the country under Alexander Kerensky. The Germans released and repatriated the

communist revolutionary Vladimir Ilyich Lenin in an attempt to cause further disruption. By October 1917, Lenin's Bosheviks had seized power; in November they declared a new government; and in December sued for a peace settlement with the Central Powers. Poland, the Baltic states and Georgia were ceded to Germany when an agreement was signed at Brest-Litovsk in March 1918. Within months the Bolsheviks were consolidating their creed across Russia, and had exterminated the royal family. The disenfranchised, largely aristocratic "White Russians", launched an attempt to dislodge the Bolsheviks, leading to a three-year civil war in which they were backed by forces including British, German, American and Czech troops. That the Bolshevik "Red Army" emerged victorious from this messy affair only underlined the Soviet determination to spread the socialist "revolution" around the world under the Communist International (Comintern) banner.

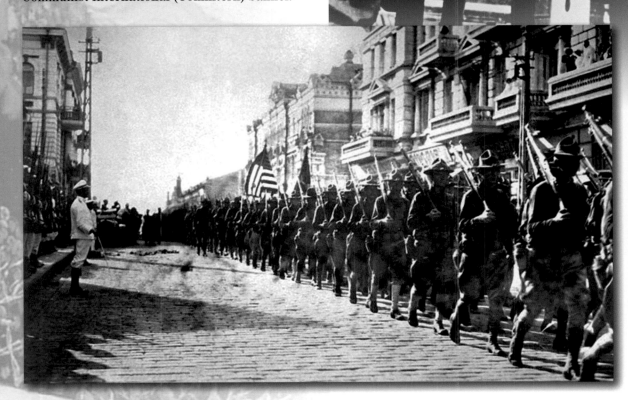

ABOVE: *After the murder by the Bolsheviks of the Russian royal family in July 1918, symbols of their rule, such as this statue of Tsar Nicholas II, were rapidly destroyed – only to be replaced by even more grandiose monuments to Lenin and his successors.*

LEFT: *American troops entering Vladivostok to support the multinational struggle against the new Bolshevik state.*

1919-1929

1919	Paris peace treaties begin redrafting of map of Europe and Middle East. The USA refuses to ratify the agreements (1920).
1919	US Senate opts out of plans for a "League of Nations".
1919	First crossing of Atlantic by aircraft (USA).
1919	US Federal Bureau of Investigation (FBI) established.
1919	Rutherford splits the atom (UK).
1920	First regular public radio broadcasts (USA/UK).
1920	League of Nations established in Geneva. USA opts out.
1920	USA refuses to ratify European peace settlements, and withdraws to political isolation.
1921	Consolidation of Bolshevik power in Russia following victory in civil war; New Economic Policy includes limited capitalist concessions to kick-start economy. Famine for next two years kills an estimated 6 million.
1921	Chinese Communist Party founded.
1921	Mongolia declared independent of China.
1922	Egypt granted conditional independence by Britain.
1922	Union of Soviet Socialist Republics (USSR) created.
1922	Benito Mussolini becomes leader of fascist state in Italy.
1922	Washington Conference recognizes territorial independence of China and sets limits on naval strengths of USA, Britain and Japan.
1922	First purpose-built aircraft carrier (USA).
1923	Treaty of Lausanne confirms new Turkish republican state under Kemal Atatürk.
1923	Germany enters hyperinflation as costs of war reparations demanded by Allies begin to bite.
1924	Death of Lenin. Stalin becomes de facto leader of USSR.
1925	Treaty of Locarno stabilizes European borders; creation of new central European states of Finland, Czechoslovakia and Yugoslavia.
1925	Civil war breaks out in China between Nationalists and Communists.
1925	Chinese–Soviet border agreed.
1925	First television transmission (UK).
1925	Hubble discovers principle of expanding universe (USA).
1926	Communist insurgency against Dutch rule in Indonesia.
1927	Kellogg-Briand Pact between the USA and France, designed to forestall international crises. Ineffective.
1928	Stalin launches first Five-Year Plan to reform the Soviet economy. His main rival, Trotsky, exiled.
1928	Penicillin discovered by Alexander Fleming (UK).
1929	Wall Street Crash (29th Oct.) sparks world-wide recession.

VERSAILLES AND THE PEACE AGREEMENTS

The Paris peace talks at the end of World War I focused on how to contain the threat of a similar war ever occurring, and how to exact punitive reparations from the losers.

One major measure was the creation of a series of states in Central Europe stretching from the Arctic Ocean to the Mediterranean: Finland, Estonia, Latvia, Lithuania and a reshaped Poland were constituted in the north. Austria–Hungary was dismembered to form Czechoslovakia and the much reduced separate nations of Austria and Hungary, while an artificial union of the Balkan states created Yugoslavia.

The Paris talks also made provision for later conferences to agree the reconstruction of Europe and the formerly Ottoman Middle East. In the meantime, White Russia (Belorussia, modern Belarus), Ukraine, Georgia, Azerbaijan and Armenia all gained brief years of independence before being swallowed up, in the main by the USSR.

AMERICAN ISOLATIONISM

In the wake of its reluctant commitment to the Allied cause in World War I, the USA under President Woodrow Wilson withdrew to its isolationist stance soon after the conclusion of the war. It refused to ratify any of the initial European peace agreements, and declined to support the League of Nations, a body conceived as an international group to control world security. America felt that its own destiny had to be fulfilled before entering the world stage, a destiny that lay in its dominance of industry, finance, its "back yard" – Latin America and the Pacific – and in the promotion of the democratic experiment on its own terms.

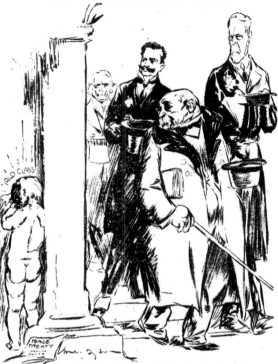

PEACE AND FUTURE CANNON FODDER

The Tiger: " Curious! I seem to hear a child weeping ! "

THE FIRST RED SCARE

Dread of communism, especially in the USA, was sparked off by a series of anarchist attacks known as the Galleanist bombings in 1919, which targeted government buildings and personnel. There was outrage. Attorney General Mitchell Palmer, himself a target, authorized police raids; well over 3,000 suspected radicals and anarchists were rounded up, and some 300 eventually deported. Mass migration to the USA since 1870 had seen the population swell enormously, and among the millions pouring through immigrant centres like Ellis Island many believed there were troublemakers. They were probably correct, but suddenly the potential "enemy within" became an obsession, and the observation and infiltration of organizations such as the Industrial Workers of

"COME UNTO ME, YE OPPREST!"

the World (the "Wobblies") became a top priority. As if to confirm American suspicions, in 1923 the reality of the Communist International threat saw Leftist uprisings in Germany and Bulgaria being ruthlessly crushed.

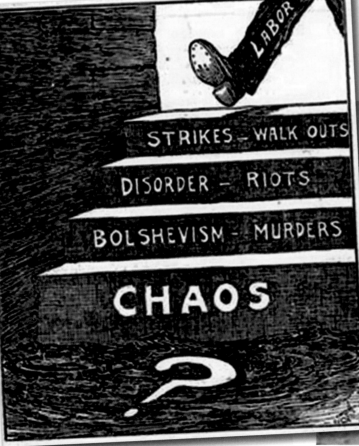

LABOR

STRIKES – WALK OUTS

DISORDER – RIOTS

BOLSHEVISM – MURDERS

CHAOS

?

What the prevailing atmosphere did produce was a rise in formal secret intelligence and security agencies, bodies which would come to dominate the Cold War. In Russia, the Bolshevik Cheka took over the role of the former Tsarist security police, but with almost unlimited authority. In Britain, MI5 (in the pre-war years a tiny Whitehall office) became expert at signals interception and intelligence gathering. In the USA, the Bureau of Investigation (BOI, formed in 1908 with a mere 12 "Special Agents", whose initial remit was monitoring vice) emerged in 1932 as the Federal Bureau of Investigation (FBI), with a young, rabid anti-communist, J. Edgar Hoover, at the helm.

LEFT: *The FBI proved to be a formidable (though often autonomous) force during the Cold War.*

MIDDLE LEFT: *Formed in 1905, the Industrial Workers of the World organization proved a particular thorn in America's side during the 1920s.*

LEFT: *The US Army Transport ship* Buford, *nicknamed the "Soviet Ark", departing from New York in December 1919 with 249 "Reds" on board, as the caption subtly put it: "America's Christmas present to Lenin and Trotsky".*

THE GREAT DEPRESSION

The Wall Street Crash in October 1929 precipitated a world-wide economic depression. By 1932, the US economy had shrunk by one-third and a quarter of the labour force were unemployed. Such economic conditions nurtured political extremism on both Left and Right. In Britain, the situation was highlighted by such polarized events as the Jarrow March (1936) and the rise of the British Fascist Party under Oswald Mosley in the 1930s.

RIGHT: *With unemployment at over 70% in the shipbuilding yards of the English north, a demonstrative march was undertaken by unemployed workers from Jarrow to the Palace of Westminster in London.*

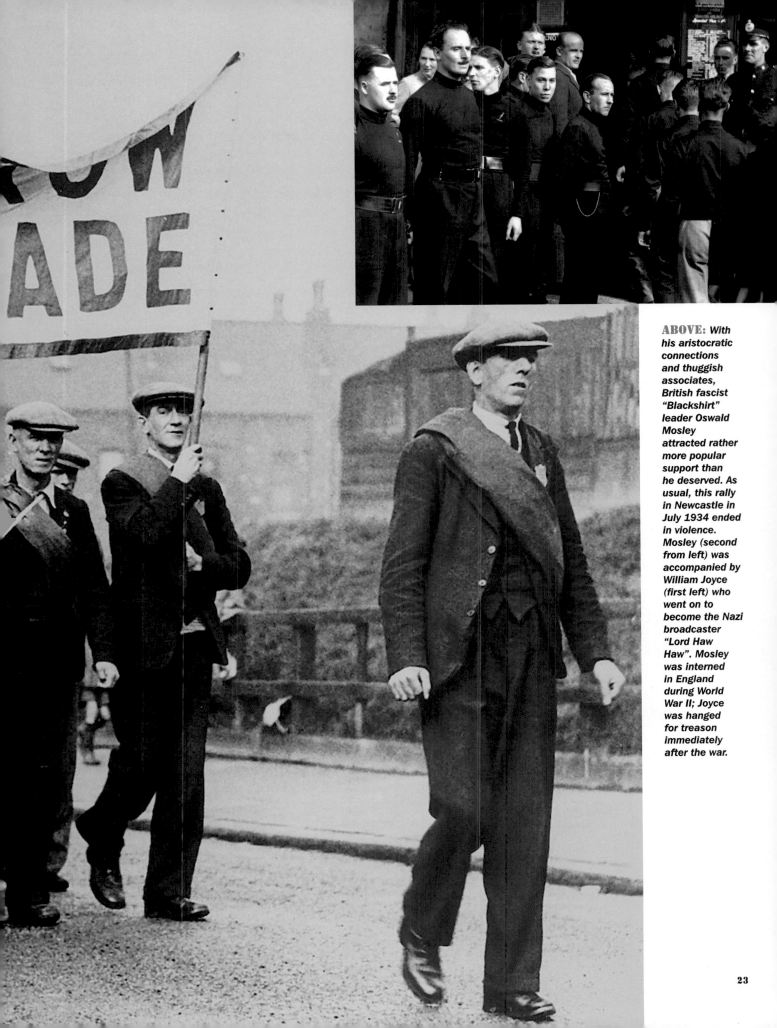

ABOVE: *With his aristocratic connections and thuggish associates, British fascist "Blackshirt" leader Oswald Mosley attracted rather more popular support than he deserved. As usual, this rally in Newcastle in July 1934 ended in violence. Mosley (second from left) was accompanied by William Joyce (first left) who went on to become the Nazi broadcaster "Lord Haw Haw". Mosley was interned in England during World War II; Joyce was hanged for treason immediately after the war.*

23

1930-1940

1930 Soviets launch rearmament programme. Pu'an Soviet in central China created by Chinese Communist Party (to 1935). Right-wing military state established in Brazil under Getúlio Vargas. Whittle develops first jet engine (UK).

1931 Collapse of a Central European bank provokes continent-wide recession. Japan invades Manchuria; beginning of Japanese campaign to control East Asia. Republican government elected in Spain.

1932 Stalin's collectivization programme in the USSR leads to famine and an estimated 5 million deaths.

1933 Franklin D. Roosevelt (1882–1945) becomes Democratic president of the USA (to 1945). National Socialist (Nazi) leader Adolf Hitler elected German Chancellor. Stalin launches first purges of Communist Party in USSR. Launch of Roosevelt's "New Deal" begins US economic recovery.

1934 USSR joins League of Nations (to 1939). Beginning of Great Terror in Soviet Union.

1934-35 "Long March" of Chinese Communists.

1935 Italy secures control of Libya and conquers Abyssinia. Radar developed (UK).

1936 Great Terror in Soviet Union: Stalin purges government and military; show trials condemn many to death. First public television transmissions (UK). Outbreak of Spanish Civil War; right-wing Nationalists launch military campaign to oust Republican government. Military dictatorship takes power in Bulgaria. Japan agrees to Anti-Comintern Pact with Germany.

1937 Italy withdraws from League of Nations and joins Anti-Comintern Pact with Germany. First jet engine tested (UK).

1938 Anschluss: Germany annexes Austria. Germany annexes German speaking areas of Czechoslovakia.

1939 Nazi–Soviet Non-aggression Pact secretly agreed to divide Poland. Germany invades Poland; Britain and France declare war on Germany (Sept.). USA declares neutrality in war in Europe. Japan withdraws from Anti-Comintern Pact. Nuclear scientists Einstein and Szilard deliver letter to US President Roosevelt indicating potential for developing nuclear bomb. Single-rotor helicopter invented by Sikorsky (USA). Roosevelt begins US nuclear research initiative that will become the Manhattan Project.

1940 Germany invades Denmark and Norway. Germany invades France and the Low Countries. Battle of Britain for control of air space over the English Channel. Assassination of Trotsky in Mexico by Soviet agent. Italy invades British Somaliland. Japan signs Tripartite Pact with Germany and Italy. Italy invades Albania and Greece. Italians attack Egypt, driven back by British by end of year. Roosevelt elected US President for unprecedented third term.

STALIN'S RUSSIA

In 1927, Stalin assumed power in the Soviet Union. In 1929, he launched the first Five-Year Plan to collectivize agriculture, stimulate industry – especially rearmament – and establish one-party rule in all areas of Soviet life. Economically these policies took the USSR forward, but at an enormous cost in human life. Food shortages that were largely engineered brought peasant kulaks (farmers) to their knees, often only to receive a bullet in the neck. In 1933, Stalin then moved against his associates by beginning to purge the Communist Party of any dissent. Show trials in 1936 condemned many in the military, political and scientific communities to death or hard labour in the Gulag prison system. Terror became the method of government, backed by the feared Cheka secret police.

HITLER'S GERMANY

Adolf Hitler's vision of a racially-cleansed Greater German Reich gained Nazi votes on the back of extreme economic decline (in Germany largely created by the crippling reparations demanded by the Allies after World War I) and a strong anti-communist stance. It soon became clear that Hitler intended to rebuild Germany into the dominant state in Europe. Industry was modernized and galvanized, rearmament undertaken on a massive scale, and "undesirables" – especially Jews and communists – removed from office. His opening move was the re-occupation of the Rhineland

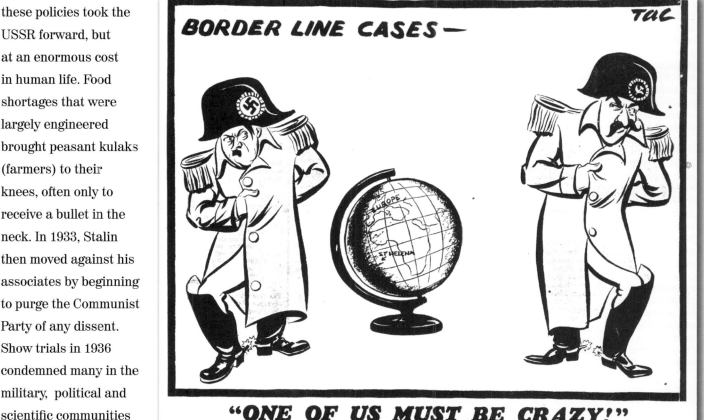

(1936), occupied by France in World War I, then a forced union of Germany with Austria (the "Anschluss", 1938) and the occupation of the Czech German-speaking region of Sudetenland. Seemingly unopposed, Germany invaded the rest of Czechoslovakia in March 1939. Despite his anti-communist stance, in August 1939 Hitler signed a Non-aggression Pact with the Soviet Union allowing both states to carve up Poland in September that year, an act which finally provoked a declaration of war on Germany by Britain and France.

ABOVE: *Hitler's Non-aggression Pact with Russia fooled few. Sceptics were proved right in 1941, when the Nazis launched Operation Barbarossa.*

25

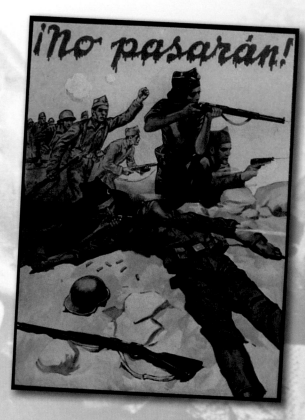

THE SPANISH CIVIL WAR

In many ways the Spanish Civil War was the first "hot" war in the style of the Cold War period, in that it was the result of a bitter confrontation of ideologies, and in part fought by proxy. In July 1936, a democratically elected Republican Popular Front government, violently anti-clerical and archly reformist, provoked a rebellion led by a dissident army leader General Franco. With the Spanish military supporting Franco, along with the political Right and the Catholic Church, his Nationalist army rapidly gained the upper hand over the Popular Front. Britain and France decided not to intervene (France even sending refugees back across the border). Franco was soon backed by Italian and German "volunteers", covertly supplied by their respective fascist governments. Ranged against him was a badly organized Popular Front, backed by anarchists, socialists, communists, Basque and Catalonian autonomists, and limited Soviet expertise, funds and armament. In addition, there were the International Brigades, volunteers from Europe and America sympathetic to the Popular Front cause.

The supply to Franco of German military personnel and planes, and further *materiel* and men from Mussolini's Italy meant that, by 1938, the war was a foregone conclusion. The bombing of Madrid, then Guernica, by the Luftwaffe Condor squadron were only the first of a number of punitive outrages imposed on the Popular Front by the Nationalists. By the time of the armistice in 1939, 600,000 lay dead, and Franco went

on to eliminate a further 200,000 Republicans. Spain remained a repressive fascist state (and neutral throughout World War II) until Franco's death in 1975. The legacy of the ideological confrontation still divides many Spanish families today.

RIGHT: *They Shall Not Pass! The Popular Front attracted passionate supporters from all areas of society and all corners of the world.*

BELOW: *The use of bombing by both sides against civilians became a powerful propaganda tool. It presaged the war-winning bombing campaigns of World War II.*

BELOW RIGHT: *Writers such as Ernest Hemingway (in* The Fifth Column, *1938 and* For Whom the Bell Tolls, *1940), and the British radicals George Orwell (*Homage to Catalonia, *1938) and Laurie Lee (*A Moment of War, *1991) rallied to the Popular Front cause.*

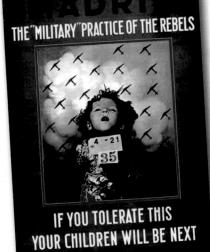

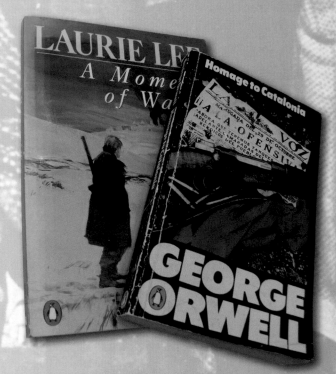

THE FAUSTIAN PACT: EAST OR WEST?

As the dust settled on the turmoil of the 1920s, Soviet Russia was as keen as Nazi Germany to promote its progressive new vision of how a "fair" socialist society might provide a political blueprint for the future. The inherent racism of the Nazis, however, led to a massive migration of intellectuals (not exclusively Jewish) from the "fatherland" seeking refuge in the East or West. It proved something of a lottery but, as Nazi intentions became increasingly clear by the mid-1930s, and while the appeasement of Hitler by Western European governments appeared to be the preferable option to a return to war, the Soviet stance against the rising tide of fascism attracted many in the West to their cause. Many of the "spies" unmasked in the post-war years, including the "Cambridge Five", had looked to the Soviet Union when the British and Americans had appeared to be doing nothing to counter the threat of fascism in Europe. By 1942, with the USSR now part of the Allied cause, their continuing allegiance to the East seemed entirely justifiable, sowing the seeds of Cold War espionage rings in all quarters.

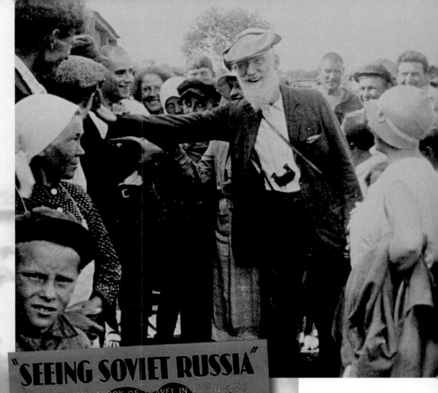

ABOVE: *Among the celebrities invited to Soviet Russia was the Irish left-leaning playwright, Fabian Society member and polemicist George Bernard Shaw, shown here in a valuable photo-opportunity visiting a peasant collective farm in the Ukraine.*

LEFT INSET: *The Soviet travel agency Intourist promoted visits to the Soviet homeland, despite Stalin's increasingly totalitarian oppression.*

LEFT: *Nuclear physicist Albert Einstein fled Germany in 1933, one of many to escape, with a Nazi price of $5,000 on his head. He was domiciled in the USA by the mid-1930s. Here he addresses a Jewish refugee gathering in London in 1939.*

The Impact of the Global War
1941-1950

The birth of the Cold War lies in the critical years of World War II when first the Soviet Union and then the USA were drawn into a global conflict as allies of an isolated Britain and various governments-in-exile from mainland Europe. This unlikely and uneasy relationship was forged in order to destroy the Nazi behemoth and its collaborators on the other side of the world, Japan.

World War II was irrevocably to transform the traditional balance of global power.

For the USA, the war provided the industrial stimulus it needed to escape the Depression years, and transformed it into the world's leading economic power. There were no direct attacks on the American homeland.

For the USSR the war very nearly proved disastrous, and it was only steely determination – despite appalling depredations, and unprecedented losses of armed forces, civilian lives and industrial plant – that saw it through to victory. There is little doubt that the Soviet Union bore the brunt of the fight against Nazi Germany, and the nation emerged with an understandable feeling of deep resentment towards its former allies.

While the war saw the eradication of the Nazi's Greater German Reich and Japan's imperial ambitions in East Asia, it also left Europe shattered, with the major colonial powers of Great Britain and France exhausted and weakened. In its wake, the USA and the USSR emerged as two "superpowers".

The Cold War formed the battleground of their ideological and political confrontation, a battleground that soon spread around the world, dominated by a new sort of power projection, one that depended increasingly both on the conquest of hearts and minds and on the ownership of new technologies and weaponry. The most significant of these were nuclear devices.

LEFT: Jubilation in London at the defeat of Hitler's Germany was soon to be dampened by the realization that Europe was in ruins and a new threat was developing: the possibility of the Soviet domination of the continent.

1941-1942

1941	British and Commonwealth troops halt Italian advances in North Africa. German forces committed to North Africa.
1941	Russo-Japanese neutrality pact.
1941	German invasion of Greece.
1941	Operation Barbarossa: Germany invades the Soviet Union.
1941	Japanese forces overrun most of Southeast Asia and attack US base at Pearl Harbor (Dec.). US declares war on Japan and Germany, entering World War II.
1942	Hitler inaugurates the "Final Solution", the mass extermination of Jews, communists, gypsies and other "undesirables".
1942	Manhattan Project set up.
1942	Fermi builds first nuclear reactor.
1942	First mass exterminations at Auschwitz death camp.
1942	Battle of Midway; first major US naval success against Japan. US Army halts Japanese advance at Guadalcanal.
1942	German troops in Russia grind to a halt: siege of Stalingrad begins.
1942	British defeat German forces at El Alamein; US troops land in northwest Africa.
1942	Turning point of Battle of the Atlantic; British decryption of German Enigma codes allows targeted reduction of U-Boat "Wolfpack" campaign against Allied shipping.
1942	US begin amphibious landings in southwest Pacific.

JAPAN DECLARES WAR ON BRITAIN AND U.S: 3 FLEETS IN BATTLE

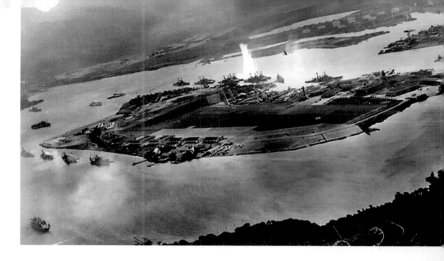

AMERICA ENTERS THE SECOND WORLD WAR

Although the United States had followed its isolationist path after war broke out in Europe, lending material support through a "lend-lease" scheme to beleaguered Britain but refusing to become engaged, this all changed after Japan's lightning attack on the US Fleet's Pacific base at Pearl Harbor on 6th December 1941. The nation declared war on Japan and almost simultaneously Germany declared war on the USA. Its first priority was to halt the rising Japanese tide in the Pacific, which involved a new style of warfare heavily dependent on air and naval power, especially aircraft carriers and submarines, and combined operations such as amphibious landings.

For Britain and the governments-in-exile of many other European countries, the entry of both the USA and the Soviet Union on the Allied side by the end of 1941 of what was until now a European war was seen as a godsend. It would, however, be another four years of long struggle before the war was over. For the moment Soviet numbers and American industrial prowess would contain the threat. By the end of 1942 the tide was beginning to turn in the Allies' favour.

NUCLEAR COLLABORATION

In the 1920s and early 1930s there had been a considerable amount of collaboration between scientists of many nationalities in the exciting new field of nuclear research. It seemed to be the pathway to a future world – a seemingly inexhaustible energy source and one that might open new horizons, not least space travel.

Warning bells about the technology had begun to ring by the mid-1930s. The novelist Eric Ambler had already written a prescient thriller, *The Dark Frontier* (1936), in which an Eastern European state develops an atomic weapon.

In 1939, US President Roosevelt received a letter from Albert Einstein and a Hungarian physicist Leó Szilárd warning that Germany was experimenting with nuclear fission, and there were indications that such research could produce a devastating weapon. He ordered the creation of the Uranium Committee to pool the research already under way in various centres around America; the committee also took advantage of the many European scientists who were among the refugees from Nazi Europe. Further, there was collaboration with Britain's MAUD Committee. It was the latter who were aware of a breakthrough by Otto Frisch and Rudolf Peierls researching the fissile properties of uranium. They informed the Uranium Committee.

Nevertheless progress was slow until 1941. With America's entry to the war, however, a greater urgency was felt, and the Manhattan Project was set up specifically to develop a nuclear weapon. By that time the decision had been made to only share limited amounts of information with one ally – Britain. Russia would be kept in the dark.

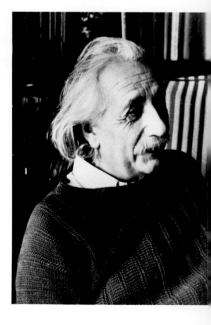

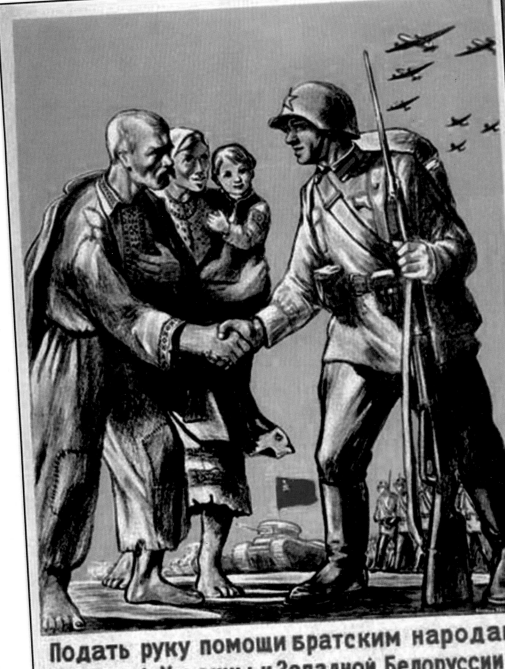

Подать руку помощи братским народам Западной Украины и Западной Белоруссии—наша священная обязанность!

RUSSIA'S WAR

In June 1941, Hitler tore up his non-aggression pact with Stalin and launched Operation Barbarossa, a full-scale invasion of the Soviet Union. However foolhardy an undertaking,

it was nevertheless Hitler's ultimate aim to destroy his communist neighbour and harvest the benefits of an ethnically cleansed empire that would stretch to the Ural Mountains, if not ultimately to the shores of the Pacific. After dramatic initial success, especially in the Ukraine, the Nazi juggernaut ground to a halt as Russia gathered its strength to fight back. The turning point was the siege of Stalingrad, where the Germans were forced to surrender in spring 1943.

It would be a long hard road for the Red Army to the gates of Berlin. Stalin's resourcefulness and determination did not waver: much of Russia's industrial plant had been moved east to Siberia in the late 1930s in anticipation of a war with Germany; tractor factories were adapted to produce tanks; mass conscription provided an insuperable weight of numbers; and a massive supply of US aid, machinery and weapons were

Invincible Nazi Spread-Eagle!

the critical factors in the eventual Soviet victory.

Stalin's continual pleading with his Western allies to open a "Second Front" in Europe in order to relieve the pressure on his nation would not be met until late 1943, by which point the Red Army was approaching the borders of Poland. Stalin never forgave Britain or America for what he perceived as their lack of support.

RIGHT:
Soviet military production during the war reached a peak in 1943, with over 122,000 artillery pieces being produced, 29,000 tanks and 33,000 aircraft that year alone. This early wartime poster, "Long Live the Mighty Aviation of the Socialist Country", proved no hollow boast.

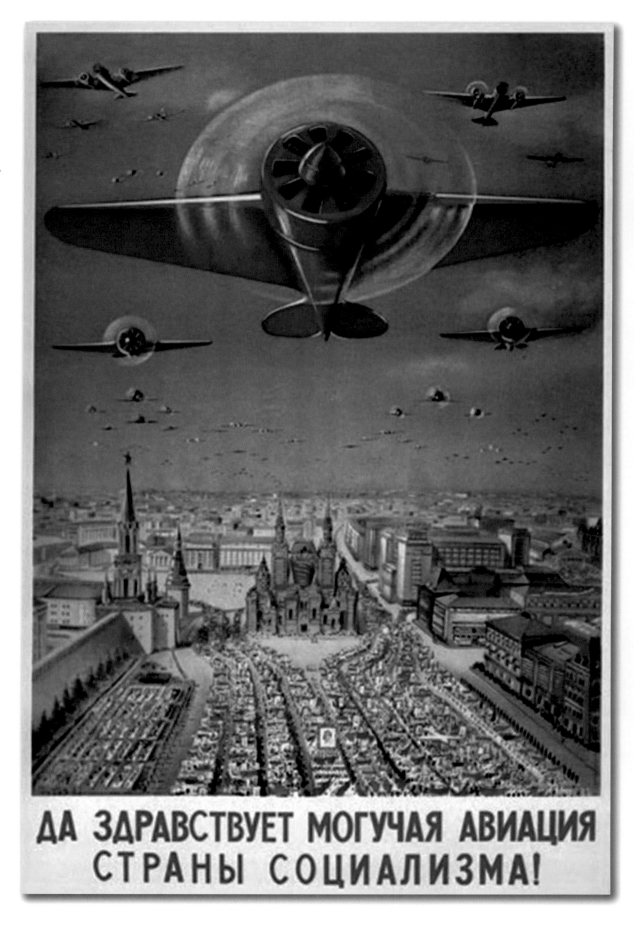

ДА ЗДРАВСТВУЕТ МОГУЧАЯ АВИАЦИЯ СТРАНЫ СОЦИАЛИЗМА!

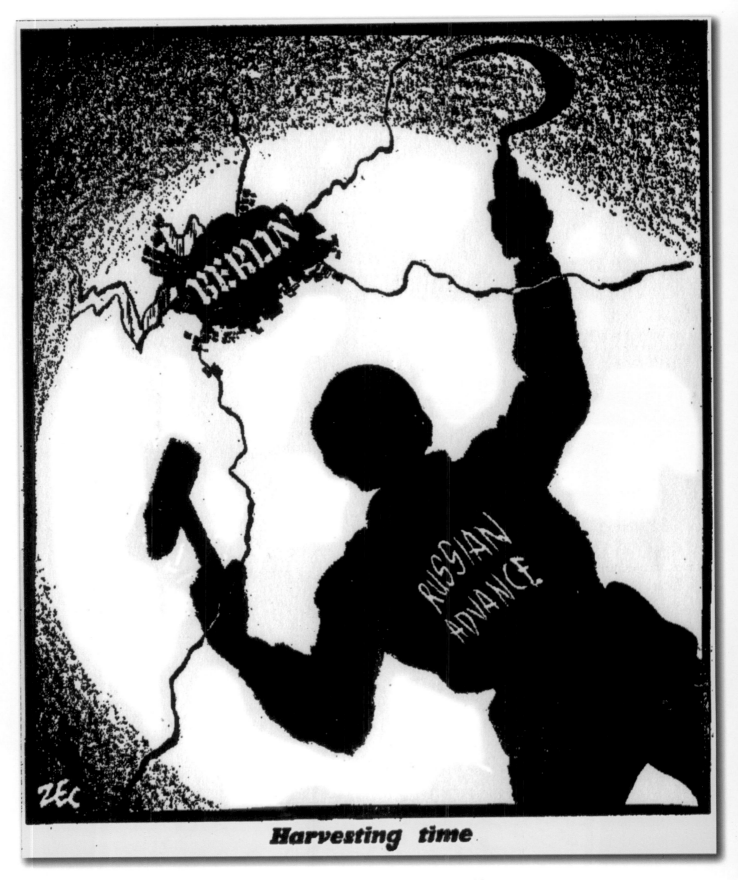

Harvesting time

ABOVE: *By 1944 the cartoonist Zec could celebrate the Soviet Union's imminent invasion of Germany.*

1943-1944

1943	US President Roosevelt and UK Prime Minister Churchill in conference at Casablanca to plan the invasion of Europe by the Western Allies (Jan.)
1943	Axis surrender in North Africa.
1943	Russians defeat Germans in tank battle at Kursk.
1943	Allied landings in Sicily.
1943	Italy surrenders to Allies; declares war on Germany.
1943	Roosevelt, Churchill and Stalin meet at Tehran. Stalin presses for opening of a "Second Front" in Europe to relieve pressure on USSR.
1944	End of German 900-day siege of Leningrad.
1944	V-weapons used by Germans to bomb London, which becomes first city to be attacked using ballistic missiles with use of the V-2.
1944	D-Day: Allied landings in Normandy.
1944	Battle of Leyte Gulf: turning point in US victories in southeast Pacific. US troops begin liberation of Philippines.
1944	Battle of the Bulge: Allied troops defeat German counter-offensive in the Ardennes.

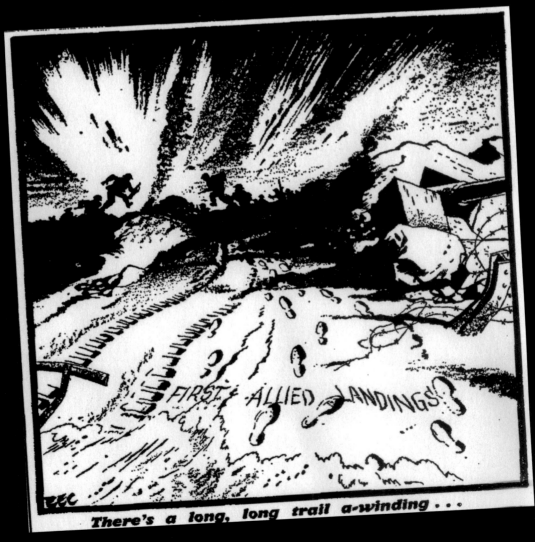

There's a long, long trail a-winding . . .

THE SECOND FRONT

The opening of the so-called "Second Front" in Western Europe, was finally achieved after the Allied conquest of North Africa in 1943. Despite continual Allied bombing of the Greater German Reich since early 1943, the landings on Sicily did not occur until July of that year, and it would be a further 11 months before the Normandy landings on D-Day in June 1944. It was clear from the success of the Soviet counter-offensives that the race was on to reach Berlin.

THE VENONA DECRYPTS

Very soon after the USA joined World War II, the Western Allies began to monitor Soviet radio traffic. They soon discovered top-level signals transmitted in an apparently impregnable code. The signals were monitored and recorded, and it would not be until 1946 that any were decrypted. This became known as the Venona project. The reason for the impregnability of the signals was the use of "one-time" pads for encryption (a code that is unique to each message, making it all but impossible to decrypt). The reason that some were cracked was often laziness on the part of the Russians: occasionally the same one-time pads had been used repeatedly, at least until 1945. The pieces of information that were decrypted provided valuable insights into the workings of Soviet military and intelligence operations, most prominently information concerning Soviet collaborators in the West. The information was so sensitive that the FBI fed only partial briefs to the White House and the CIA. The attempts to decrypt the Venona transcripts continued until 1980. Among the shreds of information that were decrypted, however, were details of several Soviet spies and spy rings operating in the West, although much of this intelligence merely filled in the gaps long after the event.

AMERICAN INDUSTRIALIZATION

Roosevelt's "New Deal" in the 1930s was designed to stimulate the US economy and motivate industry. America's entry to the war gave the economy the boost it needed. Between 1941 and 1945 the production of aircraft rose from fewer than 10,000 to 90,000, and the tonnage of shipping launched increased fivefold. Thirty thousand tanks were built between 1940 and 1943: peak production, US factories were producing one aircraft every five minutes, and one "Liberty" ship (a convoy freighter) every day.

By 1944 America's exports were three times greater than in 1940. A stream of supplies and armaments crossed the Atlantic, two-thirds to the British empire, and some 22% to the Soviet Union, including over 14,000 aircraft.

At the end of the war, with thousands of demobilized men now available to work in manufacturing, and with new markets in Europe and Japan, the boom continued.

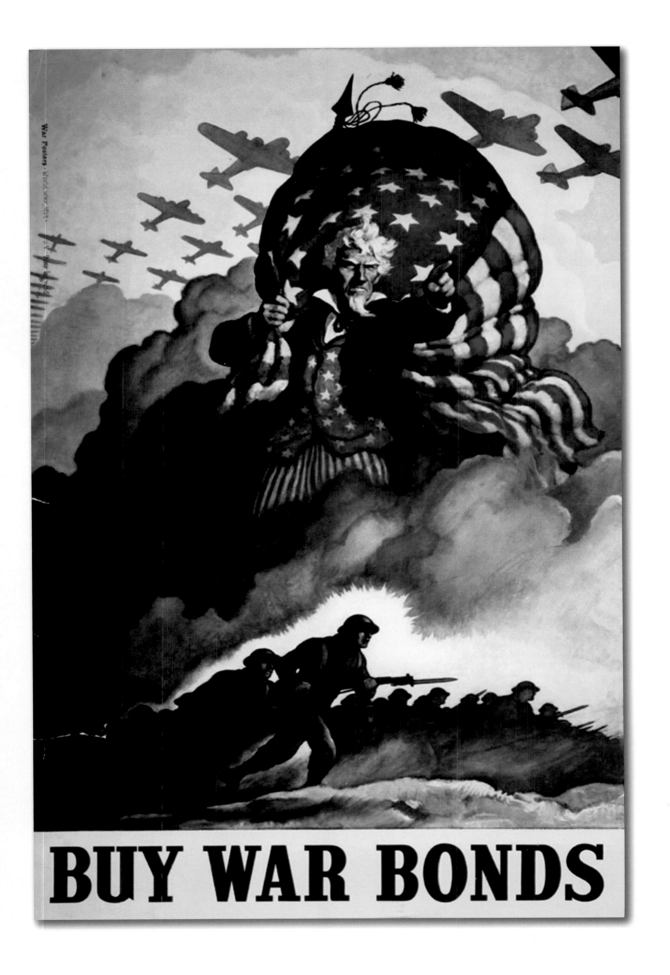

BUY WAR BONDS

THE MANHATTAN PROJECT

RIGHT: *The first stage of the first nuclear test explosion, code named Trinity, near Alamogordo, New Mexico.*

BELOW: *The prototype of the first plutonium fission bomb, code named Fat Man, which was detonated over Nagasaki on 9th August 1945.*

The code name for the rapid development of a nuclear weapon derived from the fact that it originated in research centres in New York, including Columbia University. It was endorsed in 1942 after the US entered World War II, and grew out of the general work of the Uranium Committee, set up by Roosevelt in 1939. It was headed up by the Berkeley-based physicist J. Robert Oppenheimer, and involved a multinational team including Enrico Fermi and teams of scientists from Britain and Canada spread across some 30 sites. Oppenheimer was fortunate in also being able to draw upon a wealth of talent from among the many scientists who had fled Europe under the threat of fascism in the 1930s.

In 1943, a remote top-secret laboratory was established at Los Alamos, near Santa Fe, New Mexico, which functioned as a focused site for research and for building the first nuclear weapons. The first nuclear test explosion was detonated on 16th July 1945. This was the prototype for the plutonium fission bomb that would be dropped over Nagasaki on 9th August. Three days earlier, an untested uranium isotope bomb had been exploded over Hiroshima. The world had entered the nuclear age.

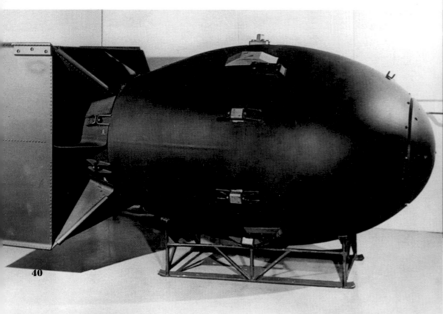

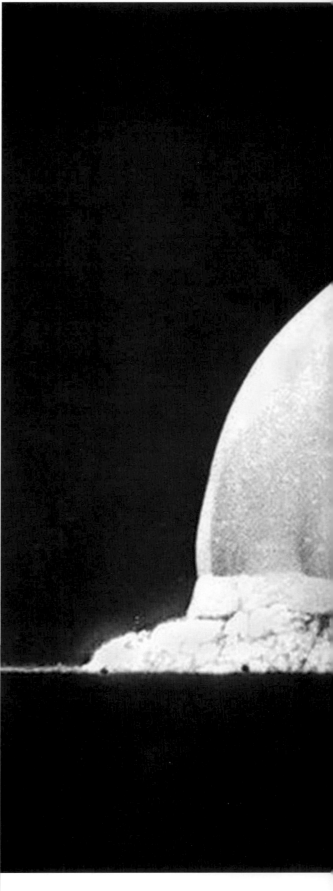

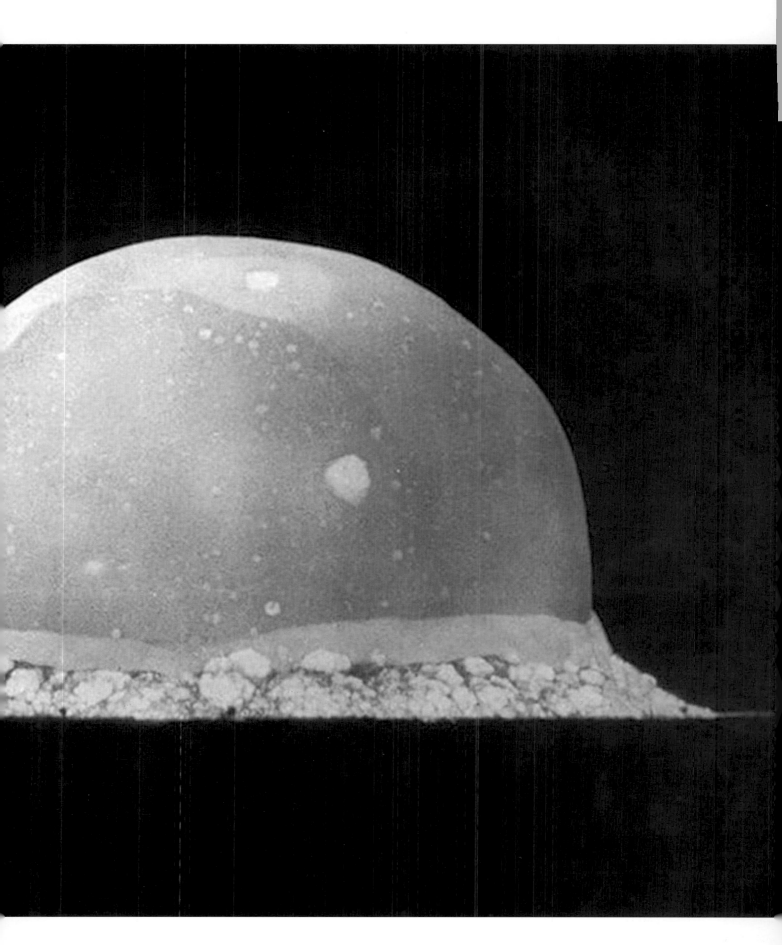

1945-1946

1945 The USA begins direct bombing of Japanese cities from captured islands.

1945 Roosevelt, Churchill and Stalin, meet at Yalta to discuss the post-war division of the Nazi "Greater German Reich" (Feb.)

1945 US landings on Iwo Jima and Okinawa secure land bases for continued direct bombing attacks against Japanese Home Islands. First "Thousand Bomber" raid on Japan.

1945 US President Roosevelt dies. Democratic Vice-President Harry S. Truman (1884–1972, to 1953) assumes command (April).

1945 Germany surrenders to Allied forces at Lunenberg Heath near the River Elbe, Germany. End of World War II in Europe (May).

1945 Stalin, Truman and Churchill meet at Potsdam (July).

1945 Allied scientists detonate first atomic bomb near Alamagordo, New Mexico (July).

1945 USAAF detonates uranium isotope bomb over Hiroshima, Japan (6th Aug.).

1945 USAAF detonates plutonium fission bomb over Nagasaki, Japan (9th Aug.).

1945 Soviet Union declares war on Japan, launches offensive in Manchuria (9th Aug.).

1945 VJ Day: Japanese formal surrender to US-led Allied forces. End of World War I (15th Aug.).

1945 Ho Chi Minh declares Vietnamese independence from France.

1945 Establishment of United Nations in New York.

1946 Beginning of first Indo-China war as France attempts to regain control of Vietnam, Laos and Cambodia after Japanese occupation (to 1954).

1946 Civil war in Greece between monarchists and Soviet-sponsored communists (to 1949).

1946 USA begins nuclear testing programme at Bikini and Eniwetok atolls in the Pacific.

1946 Philippines granted independence by the USA. Remains heavily under US influence.

1946 Civil war in China begins between Communist and Nationalist factions, hitherto united to defeat Japan.

1946 Juan Perón becomes populist dictator in Argentina.

1946 Stalin clamps down on "profiteering" peasants; confiscates land and savings.

THE SPOILS OF WAR

The unconditional surrender first of Germany in May 1945, then of Japan in August, was not unanticipated by the Allies, who had been planning and politically manoeuvring for some time.

The main prize was control of territory in Europe and plans for the reconstruction of the shattered continent. By the time of the German surrender, with Soviet forces blanketing central Europe from the Elbe to Trieste, Stalin was in a strong position.

As agreed at the Potsdam Conference, Germany and Austria were divided by the Allies into zones occupied by America, Britain, France and the USSR. Berlin lay deep in the Soviet zone, but was similarly divided, with agreed air and road corridors to give the Western Allies access to the city.

The Soviet Union's lack of commitment in the Pacific until the US atomic bomb attacks on Japan had effectively ceded that hemisphere to the United States.

Attempts by various European powers to reclaim their former colonial holdings after four years of Japanese occupation were almost immediately met by nationalist movements, often communist-inspired.

GOUZENKO, VOLKOV AND THE MAN IN THE MIDDLE

One of the first signs of mistrust between the wartime Allies was the case of Igor Gouzenko, a cipher clerk at the Soviet embassy in Ottawa who walked away from work on 5th September 1945 with over 100 classified documents and attempted to defect. Initially ignored, and narrowly escaping arrest by Soviet embassy security police, he was finally successful. The documents revealed the extent to which Soviet intelligence had penetrated the West and identified numerous double agents and spies, including code names for senior figures in MI5 who might be working for the Soviets.

A few days earlier, in Istanbul, a NKGB officer named Konstantin Volkov offered to defect, promising a treasure trove of files. As a taster, he said he had the names of two senior British Foreign Office staff and seven others in the British intelligence community who were all in fact Soviet agents. In a matter of hours Volkov and his wife were spirited back to the Soviet Union. At his trial in Moscow before execution Volkov admitted that he had a list of 314 Soviet agents that he was prepared to betray. Almost certainly among these was the British double agent Kim Philby, then a senior MI5 counter-intelligence officer, and it was Philby who tipped off his Soviet master to remedy the situation. It was a close thing for Philby, who then went on to rubbish the value of Gouzenko's intelligence. But what each case revealed was how entrenched the realities of Cold War espionage had become by the end of World War II.

ABOVE: *In the wake of the war enormous numbers of Europeans, displaced by the hostilities, attempted to find their way home. Lack of transport and food and a brutal winter saw many die on the road This Polish woman has just realized that her child has died.*

LEFT: *American and Soviet soldiers chatting among the ruins of Hitler's capital, July 1945. Such camaraderie would not last for long.*

THE YALTA AND POTSDAM CONFERENCES

These two critical conferences at the end of World War II proved the seedbed of the Cold War. In February 1945 at Yalta, a seaside resort on the Crimean Black Sea coast, the "Big Three" Allied leaders, Stalin, Churchill and Roosevelt, met for the last time to discuss plans for the final defeat of Germany and how Europe, and especially Germany, would be governed. Roosevelt was a sick man, but wrested a concession that Stalin would attack Japan. They also discussed setting up the United Nations which, like the League of Nations a quarter of a century earlier, was conceived to avoid any possible repetition of global conflict. (The first meeting of the United Nations was to happen on 25th-26th April 1945 in San Francisco, where the Charter of Nations was agreed, as were the permanent members of the Security Council – USA, USSR, Britain, France and China.) Churchill left Yalta under few illusions about Stalin's ambitions to extend Soviet domination over as much of Europe as possible. Within two months Roosevelt, who did not distrust Stalin as much as Churchill, would be dead.

The Potsdam conference convened on 17th July 1945, nine weeks after the German surrender, a few miles southwest of Berlin. Once again Stalin and Churchill attended, the latter with Clement Attlee, who would be elected British Labour Prime Minister in the course of the conference. The other newcomer was Harry S. Truman, formerly US Vice-President, who had taken over the Oval office upon Roosevelt's death. It was Truman who informed Stalin that the Western Allies were now in possession of a "super weapon" (the successful Trinity test of the plutonium fission bomb had taken place on

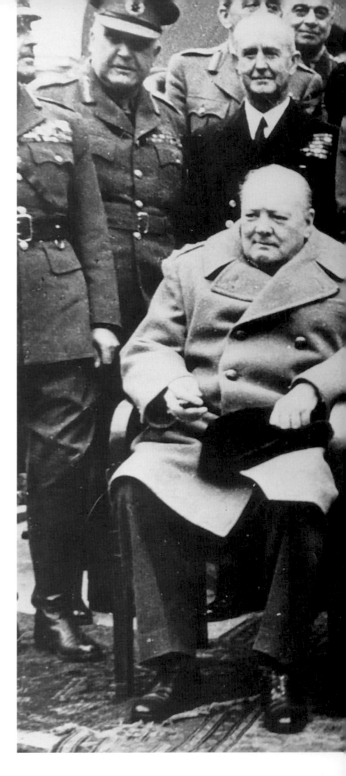

the day before the conference opened). Stalin was furious, although he already knew about US progress on nuclear research through spies within the Manhattan Project. The future borders of Europe were discussed and further concessions made to Stalin. An unconditional surrender demand to Japan was agreed, threatening the complete destruction of Japan's

armed forces and demolition of the Japanese Home Islands. It was rejected by Tokyo, and in mid-conference Truman secretly authorized the use of nuclear weapons against Japan. Unlike his predecessor, Truman recognized only too well the potential threat posed by Stalin's ambitions, and the destructive power of the nuclear weapon was the ace up his sleeve.

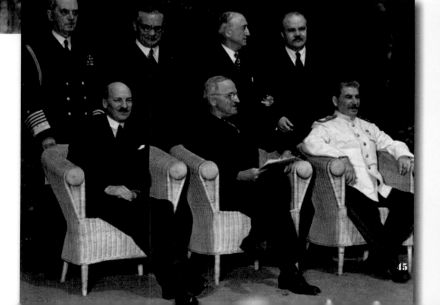

HIROSHIMA AND NAGASAKI (AND LONDON)

BELOW: *The aftermath of the first V-2 rockets to land, unannounced, in Chiswick, on 8th September 1944. Pilotless bombs, the V-1 (or Doodlebug) had begun to rain on London from June 1944. Over 9,000 were launched. Its successor, the V-2 was a ballistic missile developed by the German aero-physicist Werner von Braun, which began to be used by Germany in late 1944. Over 3,000 were launched against London and advancing Allied troops in Belgium. Although by no means as destructive as the firestorm raids or the atomic bombs which the Allies deployed over their enemies, the German V-weapon assault offensive carried another uncertain message for the future – that of delivery by rocket. London was the first city to undergo assault by ballistic missiles.*

The explosion of the first and only two atomic bombs ever to be used in warfare over the Japanese cities of Hiroshima (6th August 1945) and Nagasaki (9th August 1945) almost brought an end to World War II. But it was the Soviet invasion of Manchuria, launched on the day before the Nagasaki bomb was dropped, which finally brought Japan to its knees on 15th August.

The deployment of the atomic bombs nevertheless sent a message around the world. Over 120,000 people were killed outright, and a further 30,000 shortly after the explosions. Both cities were flattened, only a handful of gutted ferro-concrete structures left standing. Although more had died during the firestorm raids on Tokyo and Japan's five other main industrial ports, the fact that the destructive payload could be delivered by a single aircraft was a salutary warning about the potential nature of warfare in the future.

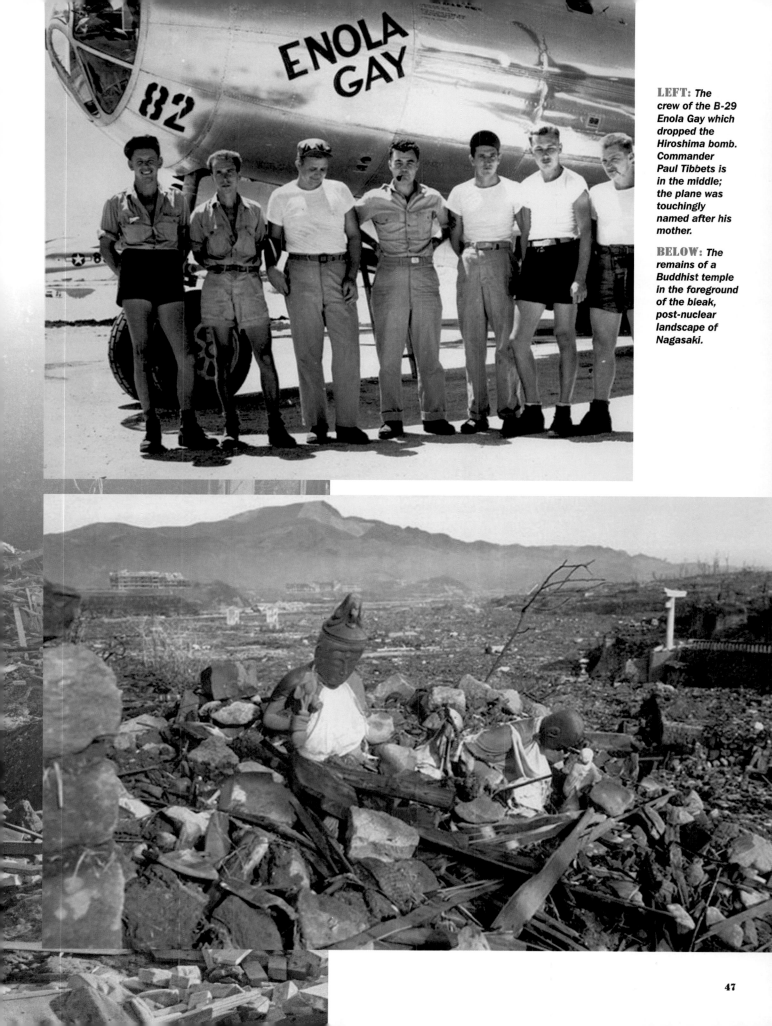

LEFT: *The crew of the B-29 Enola Gay which dropped the Hiroshima bomb. Commander Paul Tibbets is in the middle; the plane was touchingly named after his mother.*

BELOW: *The remains of a Buddhist temple in the foreground of the bleak, post-nuclear landscape of Nagasaki.*

47

1947-1948

1947 Britain withdraws from colonial control of South Asia; India partitioned into Hindu India and the two states of Muslim Pakistan. Burma granted independence.

1947 Opposition parties in Hungary dissolved.

1947 US President Truman promulgates the "Truman Doctrine" use limited US means to prevent spread of communism.

1947 Invention of transistor (USA).

1948 Soviet–sponsored regimes established in Czechoslovakia, Poland and Hungary.

1948 Communist Marshal Tito of Yugoslavia withdraws from Soviet alliance. Albania severs relations with Yugoslavia.

1948 Ceylon granted independence by Britain.

1948 Beginning of Malayan Emergency, the Communist Party of Malaya (CMP) calling for resistance to reassumption of colonial control by Britain following Japanese occupation (to 1960).

1948 USA announces Marshall Plan; US aid to rebuild Europe totalled $11.8 billion.

1948 Soviet blockade of land routes to West Berlin broken by the Berlin Airlift. Blockade continues to May 1949.

1948 Following British withdrawal from mandated territories in the Middle East (1947), Jewish state of Israel established in former Palestine. The following day, five neighbouring Arab states invaded, but were eventually repulsed. Over 750,000 Palestinian Arabs go into exile.

THE TRUMAN EFFECT

The immediate post-war years remained ones of hardship for many, with rationing of food and other essentials to continue for many years in Europe. There were massive movements of peoples, especially Germans repatriating from the Reich's conquered lands. For the USA, now war-weary, the problem of containing communism in the continent presented a new challenge.

A major step in European recovery was the approval of the Marshall Plan, proposed in 1947, which provided $13,000 billion of material and financial aid to Europe between 1948 and 1952. The plan was conceived by Secretary of State George C. Marshall and Dean Acheson of the US State Department (and Marshall's successor in 1949) specifically to counter the spread of communism in Europe.

President Truman's attitude towards the Soviet Union, known as the "Truman Doctrine", was announced to the US Congress in March 1947. It assumed that Soviet ambitions for world domination could henceforth be countered only by the threat of violence, and it committed the US to a strategy of containment of Soviet expansion. In Truman's own words, it was designed "to support free peoples who are resisting attempted subjugation by armed minorities or by outside pressures". The doctrine was provoked by the civil war in Greece between communist guerrillas and the elected royalist government, and saw the USA providing aid and support to defeat the Greek Communist

Whatever the weather
We must move
together

Party (KKE). Similarly, the USA saw Turkey under pressure from the USSR to retain control of the Dardanelles sea passage: the USA sent warships and $1 billion of aid to bolster Turkey. But the first real tests of the doctrine were with the Soviet blockade of Berlin in 1948 and the outbreak of the Korean War two years later.

LEFT:
Unlike his predecessor, Franklin D. Roosevelt, President Truman, after meeting Stalin at Potsdam, was under no illusions about Soviet intentions for the domination of Europe and he took determined steps to counter them.

OPPOSITE LEFT:
A Marshall Plan sticker, just to remind the lucky recipients where their supplies came from.

LEFT:
The Marshall Plan, though hardly popular among tax-paying voters in the USA recovering from a draining four years of warfare, was heavily publicized. This offer of aid was rejected, under pressure from Moscow, by all Eastern European states, although this poster invited the USSR to participate.

THE COMMUNIST TAKE-OVER IN EUROPE

There was little the Western Allies could do to hinder the Soviet Union's conversion or coercion of the states it had occupied in Eastern Europe in the closing stages of the war. It had been clear from 1944 that the conclusion of the war in Europe would see a westward advance of Soviet influence. The USSR absorbed the Baltic states of Latvia, Lithuania and Estonia, grabbed a sizeable chunk of eastern Poland, and simply swallowed up Bessarabia, Northern Bukovina and Ruthenia. In East Germany, a Socialist Unity Party was set up in 1946 and a communist government installed the same year in Bulgaria. However, Stalin was at first tentative with former sovereign states. Elections in the newly recreated Poland and in Hungary in 1945 and 1946 were relatively free, but opposition parties were dissolved in both countries in 1947. The briefly restored king of Romania was forced to abdicate in 1947. A communist coup occurred in Czechoslovakia in 1948, and in 1949 the German Democratic Republic was established. National socialist leaders such as Gomulka in Poland (1949) and Kádár (Hungary, 1950) were removed from office (although both would stage political returns in the 1950s). Effectively, by 1950, Eastern Europe from the river Elbe to the borders of Greece was under the direct control of Moscow. Yugoslavia, under the partisan leader Marshal Tito, remained free, breaking with the USSR in 1948; Albania went its own way under an independent communist dictatorship, and the communist uprising that threatened Greece was suppressed in 1949 with Western support. The "Iron Curtain", which former British premier Churchill had predicted in 1946, had indeed been drawn across Europe.

THE FIRST ATOMIC SPIES

A number of individuals became involved in supplying nuclear research secrets to the Soviet Union during and immediately after the war. Most were recruited by Soviet spy rings or couriers – few actively sought to make contact.

The first to be unmasked was Alan Nunn May (1911–2003). Cambridge-educated, and a member of the Communist Party, he worked as a physicist on the British Tube Alloys project. During World War II he was involved in research for the Manhattan Project at a British nuclear development centre near Montreal in Canada. It was there that he was approached by Soviet military intelligence (GRU), and, along with copies of confidential papers, he passed microscopic samples of Uranium 233 and 235 to his Soviet contact. His activities were revealed by the Soviet defector Gouzenko after May had returned to London. It seems May had been paid $700 (which he burned) stuffed into two bottles of whisky for his troubles. He was sentenced to ten years' hard labour in 1946, and released in 1952. He died in Cambridge, unrepentant.

Potentially more damaging was the German refugee and theoretical physicist Klaus Fuchs (1911–1988), whose Communist Party activities in Germany as a student had led him to flee the country, but were also on record. With May he had worked on the British Tube Alloys project, and transferred to the USA in 1943, eventually working at Los Alamos by 1944, where he witnessed the Trinity test. Although there is evidence that he was passing secrets east from as early as 1941 (before Germany's invasion of Russia) his most active period was between 1947 and 1949, when he was back in the UK working at the nuclear research centre at Harwell, when he fed his masters details

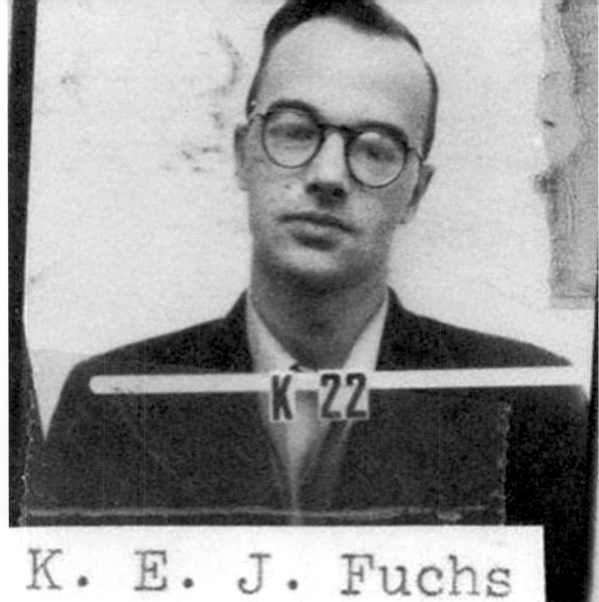

K. E. J. Fuchs

LEFT:
Klaus Fuchs's security identification photo while working at Los Alamos.

of the hydrogen bomb. A mild-mannered, single, retiring man, he rapidly crumbled when interrogated by the leading MI5 spycatcher William Skardon. He was tried in camera in 1950 and sentenced to 14 years' imprisonment. He was released in 1958, and migrated to East Germany.

The May incident had caused the USA to be more cautious about sharing its nuclear secrets with its closest ally. The Fuchs case confirmed its suspicions, which were strengthened by the apparent defection in 1950 of Bruno Pontecorvo, an Italian refugee atomic physicist who had worked in research at both Montreal and Harwell. But for the Americans, the worst was

yet to come. In 1951 a more substantial atomic spying network was revealed in its own back yard, that of the Rosenbergs (see page 75).

It has to be said that many of the more prominent early atomic spies, although technically traitors and indeed recipients of money for their services, nevertheless remained ideologically committed not only to their Leftist sympathies (often nurtured in the anti-fascist years before World War II), but also convinced that it was immoral for America not to share its secrets with its wartime ally in the east, an ally bearing much of the brunt of the war.

The real value of the information supplied to the Russians remains a matter of debate.

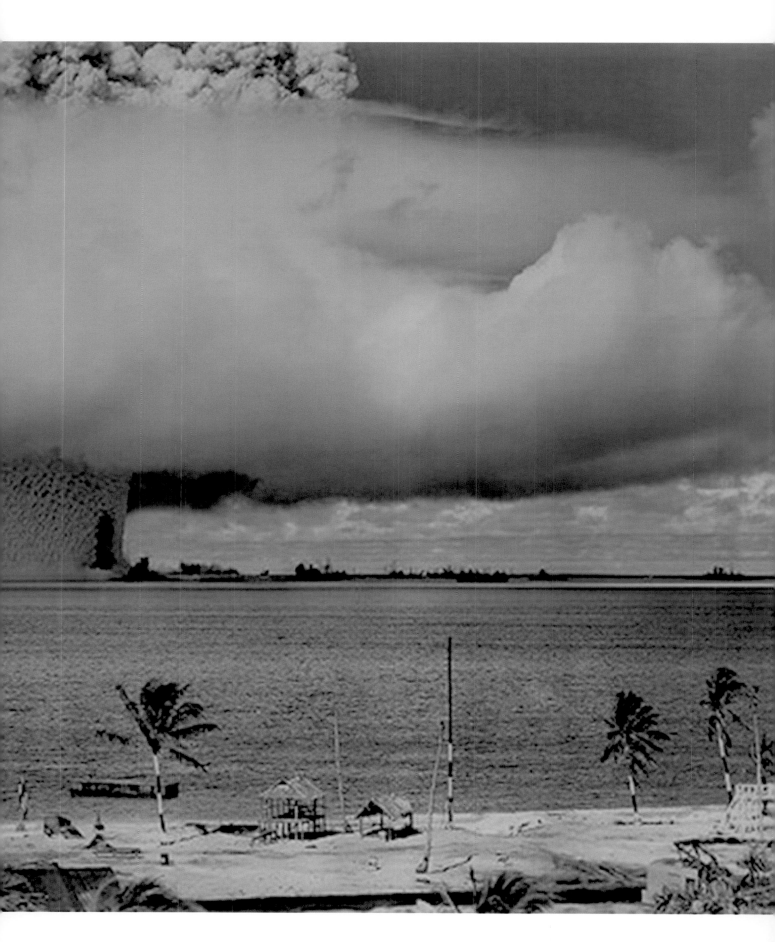

THE BERLIN BLOCKADE

In March 1948, the Western Allies decided to combine their zones of occupation into a single economic unit, paving the way to the creation of West Germany. In a calculated attempt to intimidate the West, Stalin ordered a land blockade of Berlin, which began in June. Although road and rail access was now closed down, Britain, France and America frustrated the blockade by launching a sustained airlift of essential supplies to Gatow, Texel and Templehof airfields in their respective sectors.

The Soviet blockade was relaxed in May 1949, although the airlift continued until September.

The success of the airlift avoided what might have become an armed confrontation if the besieged population had come to harm. But from this point on Berlin was truly a divided city.

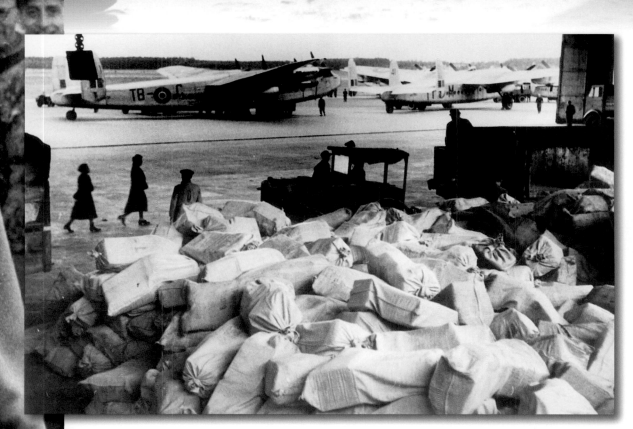

ABOVE:
The world's largest cargo plane, the Globe Master, being unloaded at Gatow airport, August 1948.

LEFT:
RAF Avro Yorks at Gatow preparing to depart, having delivered essential food and medical supplies.

55

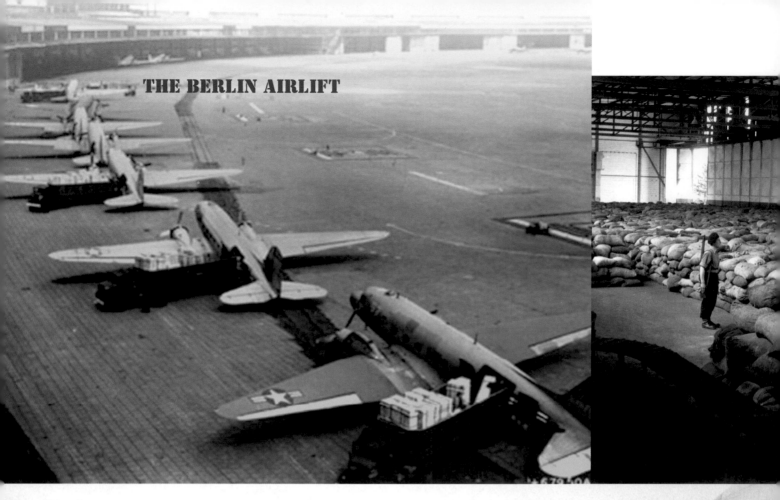

THE BERLIN AIRLIFT

ABOVE:
American C-47 Skytrains, or Dakotas, the packhorse of many campaigns during World War II, queuing to unload at Templehof airport during the Berlin Airlift.

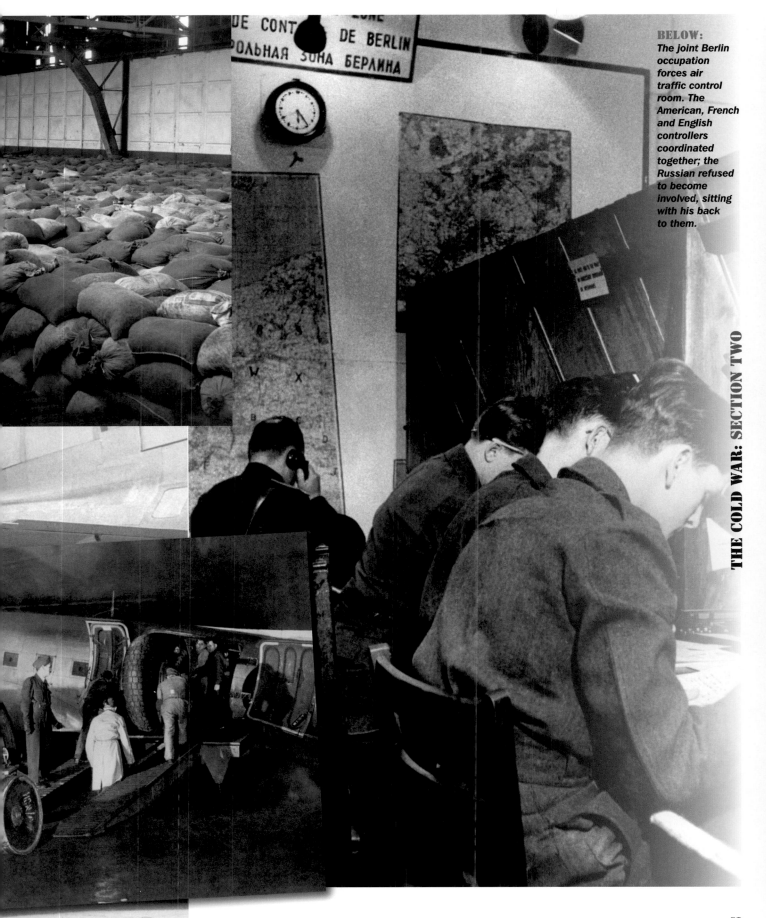

DE CONT ZONE DE BERLIN
РОЛЬНАЯ ЗОНА БЕРЛИНА

BELOW:
The joint Berlin occupation forces air traffic control room. The American, French and English controllers coordinated together; the Russian refused to become involved, sitting with his back to them.

1949-1950

1949 Soviet-occupied Eastern Germany formally established as a Soviet satellite state, the German Democratic Republic (GDR).

1949 North Atlantic Treaty Organization (NATO) formed in response to increasingly tense East–West relations. The first NATO signatories were the USA, the UK, Ireland, Norway, Denmark, the Netherlands, Belgium, Luxembourg, France, Portugal and Italy. Geographically and strategically advantageous, Greece and Turkey were pressured into joining in 1952, while West Germany was admitted in 1955, and Spain in 1983.

1949 COMECON (Council for Mutual Economic Assistance) established in Eastern bloc.

1949 USSR tests its first atomic bomb.

1949 Dutch East Indies granted independence.

1949 Apartheid introduced as official policy in South Africa.

1949 Truman wins second term as US President. Signs Mutual Defense Assistance Act.

1949 Communists under Mao Zedong emerge victorious from years of civil war and Japanese occupation. People's Republic of China established. Chinese Nationalists under Chiang Kai-Shek retreat to Taiwan.

1950 Trial of Klaus Fuchs for atomic spying.

1950 US senator McCarthy alleges that over 250 communists are working in the State Department. Beginning of "witchhunt".

1950 Korean War begins. Chinese forces support North Korean forces.

1950 US military advisers aid French in Vietnam.

1950 Mao Zedong launches large-scale collectivization programme in China. Execution of millions of landowners.

1950 China invades Tibet.

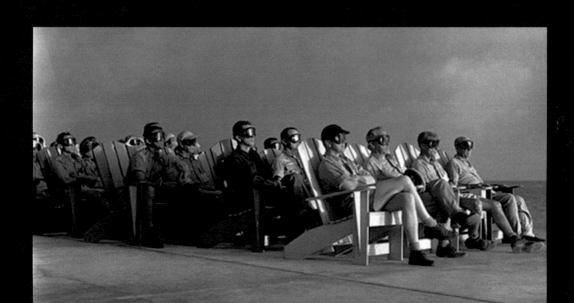

THE SOVIET ATOMIC BOMB

Stalin had been alerted in 1942 by his scientific advisors that little had been published concerning nuclear fission in learned journals since its discovery in 1939. The immediate concern of combatting the German invasion delayed the start of the Soviet project until the following year. A team was set up under Igor Kurchatov, which included Yakov Zeldovich, Yuli Kharoton and the future Soviet dissident Andrei Sakharov. By 1944, Stalin was well aware that the Americans had stolen a march on the technology (partly because of information received from spies within the Manhatttan Project).

Soviet scientists later claimed that the information supplied by nuclear spies such as Klaus Fuchs, did little more than verify their own findings, but it would not be until 1949 that the Soviet Union was in a position to test its first nuclear weapon, code-named First Lightning, at Semipalatinsk in Kazakhstan, on 2nd August, a similar device to the plutonium bomb the USAAF had exploded over Hiroshima. The USSR was not in a position to produce a hydrogen bomb until the mid-1950s. But the fact was that by the beginning of the 1950s the country could see itself matching the USA in terms of strategic strike power.

OPPOSITE LEFT: *Among the victims of the Cold War were those servicemen ordered to 'observe' nuclear tests, which in many cases resulted in illness in later years. These enthusiastic volunteers on the deck of a US aircraft carrier might be at the cinema. It probably was not a good idea to sit in the front row.*

THE COMMUNIST VICTORY IN CHINA

Although the Chinese Nationalists, led by Chiang Kai-shek, and the Chinese Communists under Mao Zedong had fought together against the Japanese from 1936 to 1945, a power struggle erupting into civil war broke out between them almost immediately. Largely isolated in Manchuria in northern China (but here with access to Soviet support) the Communists seemed to be losing the struggle until 1948. With a massive recruitment of peasant support the Communists took Xuzhou and then Beijing in January 1949. The Nationalists were

Children who fight for the Reds in China war

Pressed into service with the Communist armies now ravaging China are many boys and young women.

At an age when most youngsters are still playing with toy weapons, the Communist children-in-arms are swaggering along with grenades and pistols in their belts.

Left are two typical members of the Red Army—a young girl officer and a boy soldier with a rifle almost as big as himself.

These pictures were taken when the Reds took Shamchun, less than three miles from the British troops on the borders of Hong Kong territory.

Field-Marshal Sir William Slim, Chief of the Imperial General Staff, arrived in Hong Kong on a tour of inspection yesterday.

A garrison officer told him that as far as defence preparations were concerned "there's not a skeleton in the whole cupboard."

RIGHT:
Mao Zedong's policy of total mobilization – involving women and children in the revolutionary struggle – won him the Chinese civil war. It also established a template for freedom fighters for the next half century.

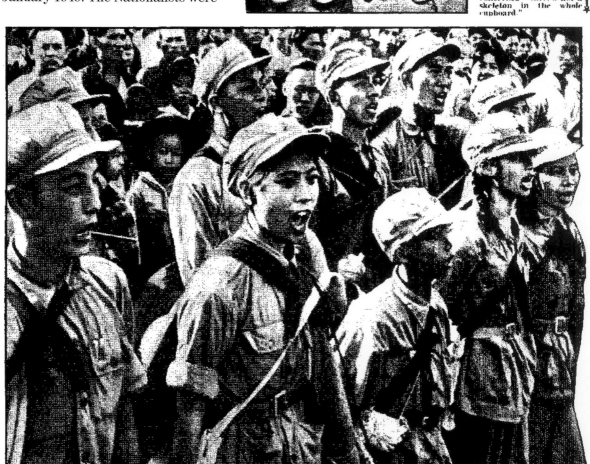

Communist troops, some of them women, shout slogans in honour of their commander, Mao Tse Tung, after their arrival at Shamchun.

in flight, retreating to the island of Taiwan in May 1950. Taiwan is still the seat of the Chinese Nationalist government. The People's Republic of China was proclaimed in October 1949, and the Middle Kingdom entered a new centrally controlled, nationalized economy, and a deeply defensive and threatening mindset for the next half century.

He will be
The EMPEROR of CHINA

MAKE a note of the almost unpronounceable name of Mao Tse-tung. It belongs to a stocky, cheese-faced Chinese. By next year he'll be as well known as Stalin.

Fifty-four-year-old Mao, a farmer's son, will probably within six months be the Red dictator of 400 million people in China.

His men are tightening their grip on the twin capitals of China, Nanking and Peking, and nearing the great seaport of Shanghai.

Competent observers predict that it is only a matter of months before Mao's men control the rich, fertile valley of Yangtsze-kiang, the rice-bowl of China.

What sort of man is this squat Mao, elected chair- man of the Chinese Communists eighteen years ago, who walks among his troops wearing a quilted cotton uniform, a sheepskin jacket and a cloth cap?

He is often called "General" Mao, but he is not a military man, although he enforces his political ideas right behind his advancing Red soldiers.

He has operated for ten years from the market town of Yenan, 1,500 miles north of Shanghai, where most of the 30,000 inhabitants live in caves.

Mao's cave is fitted with wooden tables and primitive furniture, but it is not so uncomfortable as it sounds. It is cool in the hot Chinese summer and warm in the biting winter.

From there Mao visits his men in a rickety wooden cart drawn by two mules. Sometimes he travels on a spindly, half-starved horse followed by a string of pack animals.

MAO, graduate of Peking University, joined the Chinese Communist Party in Shanghai after the First World War, when it had only fifty members—professors, students, and a handful of trade unionists.

He sprang to the top when he suggested that peasants should lead the revolution instead of the theorising intellectuals from the cities.

Mao, the farmer's son, prepared a scheme to split up estates and divide them between the land-hungry peasants. This has been a corner-stone of his party's policy ever since —and the greatest attraction to the peasants to support the Communists.

Mr. Mao, Communist husband of a film star, will soon rule 400,000,000 Chinese.

IN between his serious political pre-occupations, Mao has taken time off for love. He has been married three times. His first wife was killed by Chiang's troops. His second went to Moscow when the Japs took Shanghai.

Then, among the refugees straggling north from the Japs, came a beautiful, almond-eyed Shanghai film star, anxious to do her bit with the guerrillas.

She met the cloth-capped leader and they fell in love. Mao divorced his wife, who was still in Moscow, and the actress moved into his cave.

Now they have a small daughter, aged six. . . .

By JOHN DEANE POTTER

COMMANDER of Mao's victorious armies is sixty-year-old General Chu, a regular army officer, son of a prosperous Chinese merchant.

After a few years of army service, Chu decided he could do better for himself. He set himself up in the border province of Yunnan as a war lord, extracting protection money from the peasants.

Chu at this time—shortly after the First World War —was a typical Chinese war lord, an opium smoker, a keeper of nine concubines.

In 1923 he tired of this life of bandit luxury and took a trip to Europe, where he suffered a political change of heart. In Germany, he joined the Communist Party, and when he came back to Shanghai, he linked up with Mao. Between them, they have run the Chinese Communists ever since.

Chu, when he joined the Communist Party, took to austerity, cured himself of opium addiction, pensioned off his concubines, and married a respectable Communist girl.

With his military experience, he rapidly became the leader of the guerrilla forces.

At the beginning, he had 50,000 men scattered all over China with one rifle between two soldiers. Now his army of over 1,000,000 is well equipped with Japanese arms and battle-trained troops.

Drinking whisky in his club, the European business man in China is worried *What will happen to foreign trade when General Chu's troops arrive in Shanghai?*

But Mao and Chu are long-sighted men who—although they wish to impose full Communism on China—realise it can't be done in their lifetime. They know that China can't stand on her own feet for fifty years without foreign trade.

They will continue to trade with the capitalistic countries of the West — probably more than Chiang Kai-shek did.

So the British business men hang on hopefully — believing that when Communism comes to China there will be a sizable chink in the Iron Curtain.

REDS UNDER THE BED

The resurgence of US industrial strength as a result of World War II saw a concomitant rise in the strength and power of labour unions. The Communist Party of the United States (CPUSA) had seen its membership increase rapidly, largely because of its opposition to fascism before and during the war. This, linked to a growing but ill-defined fear of "communist infiltration", was seen by many in the US Republican Party in post-war years as a call to arms. The House Committee on Un-American Activities (HUAC), established in 1938, had used the broadly worded Smith Act, which practically made any deviation from patriotism a crime, to prosecute Nazi sympathizers in the US during World War II; it now focused its activities on communism.

The HUAC's profile increased when it began an investigation into the Hollywood film industry in 1947. Screenwriters, producers, directors and even actors were subpoenaed, and asked the standard question: "Are you now or have you ever been a member of the Communist Party of the United States?". Many pleaded the Fifth Amendment, but non-cooperation was deemed an admission of guilt. The Hollywood Ten were only the first to be indicted for contempt of court. What ensued was a practice of blacklisting suspected communists, not just in Hollywood but in many US industries.

In 1948, the HUAC also responded to an allegation by the self-confessed former communist journalist Whittaker Chambers that a State Department and UN official, Alger Hiss, had been a communist. The scandal heightened public anxiety that communism was virally infecting the highest offices. Hiss denied the claim, but was found guilty of perjury and briefly imprisoned.

On the dark side during this period, J. Edgar Hoover deployed his FBI agents on an obsessive cycle of observation and disruption of anybody suspected of far-Left leanings including illegal wire-tapping, burglaries and intercepting mail. Much of this material Hoover hoarded as ammunition for the future.

More publicly, the Republicans found their white knight in the unlikely figure of Wisconsin Senator Joseph Raymond ("Joe") McCarthy, who in 1950 announced that he had evidence that the State Department was riddled with 205 communist infiltrators. He went on to head his own investigations until discredited in 1954, but not before his name had become synonymous with anti-communist hysteria.

RIGHT:
McCarthy was a bully and publicity seeker, and played on general fears concerning communist fifth columnists.

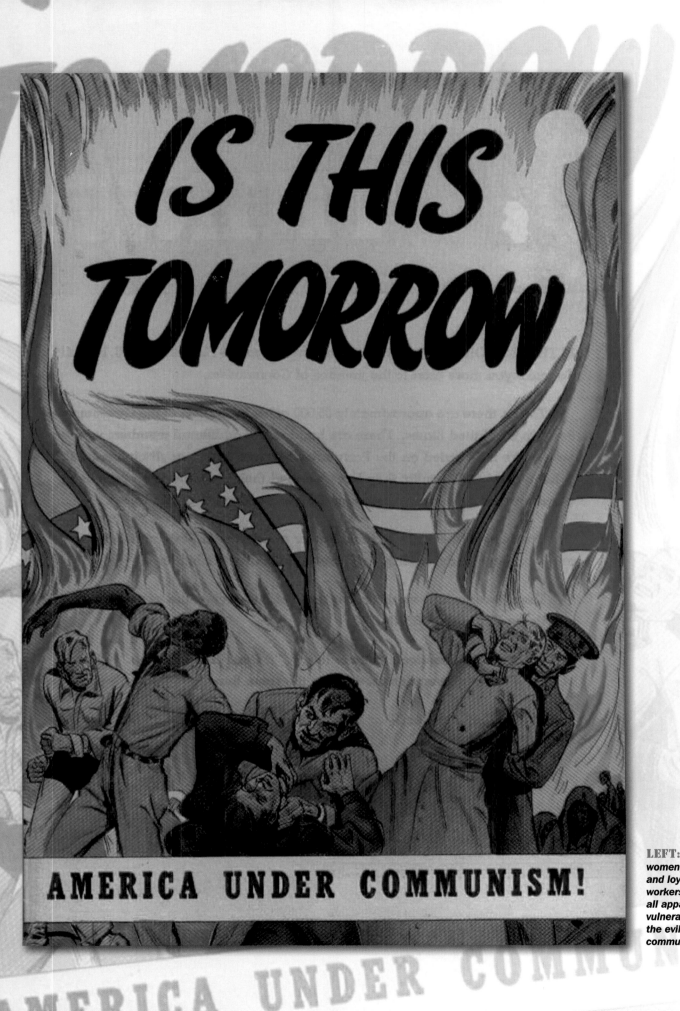

IS THIS TOMORROW

AMERICA UNDER COMMUNISM!

LEFT: *American women, priests and loyal workers were all apparently vulnerable to the evils of communism.*

I MARRIED A COMMUNIST

Hollywood, ever eager for new sensational stories, latched on to Cold War themes very rapidly. One aspect of the *film noir* vogue at the time were "social conscience" movies. Among the more notable of these was Frank Sinatra's *The House I Live In* (1945), dealing with social prejudice, which brought him under the glare of the FBI and McCarthyite spotlight. More gung-ho were *Iron Curtain* (1948, based on the Gouzenko defection), *Red Danube* (1949, a ballerina trapped by Soviet agents), The *Big Lift* (1950, a romance set during the Berlin Airlift), *I Was A Communist for the FBI* (1951, pseudo-documentary) and *Diplomatic Courier* (1952). The 1950s *I Married a Communist* probably has the best title of all of them, with a scheming commie Latino (Gomez) blackmailing an American shipping executive (Ryan). Terrifying.

HER BEAUTY served a mob of terror whose one mission is to destroy!

RKO PRESENTS

I MARRIED a Communist

starring

LARAINE DAY · ROBERT RYAN · JOHN AGAR

with **THOMAS GOMEZ · JANIS CARTER**

Executive Producer **SID ROGELL**

Produced by **JACK J. GROSS** · Directed by **ROBERT STEVENSON**

Screen Play by **CHARLES GRAYSON** and **ROBERT HARDY ANDREWS**

A World Divided
1951-1956

The outbreak of war between communist and Western forces in Korea announced that, with the "ultimate" nuclear weapons now possessed by both Cold War camps, any future conflict was unlikely to be on European soil but would rather be played out, cften by proxy, in peripheral territories around the world – a pattern that would hold for the next 40 years. So the bloody burden of East–West ideological rivalry would be increasingly born by civilian populations not hugely concerned with grand ideals, but rather with the matter of day-to-day survival.

The race to acquire nuclear weapon technology was succeeded by a race to secure bases from which to launch them, and both camps entered a scramble to sign up treaty agreements and defensive alliances that would provide them with security cordons.

At the same time, the early 1950s brought another uncomfortable truth to public scrutiny: spying and the penetration of security was occurring at almost every level, among senior diplomats and nuclear scientists down humble embassy staff and factory workers. Almost no one was beyond suspicion.

The years of paranoia had begun.

LEFT: *A Korean mother and child in front of an abandoned tank. The Korean War announced that the "hot wars" of the Cold War were likely to be fought on the margins ,and the price paid by the innocent.*

1951-1952

1951	Iranian prime minister Mossadeq nationalizes oil.
1951	Libya granted independence from Italy.
1951	USA commits to defend Japan against communism. Implements plans for restructuring Japanese economy on free market capitalist model.
1951	Vatican severs diplomatic links with China.
1951	Rosenberg atomic spy ring exposed.
1951	ANZUS pact signed between USA, Australia and New Zealand.
1952	Military revolt in Egypt; republic established (1953).
1952	Mau Mau rebellion against British colonial rule in Kenya (to 1956).
1952	Formation of the European Defence Community to counter-balance the build-up of Soviet military forces in Eastern Europe.
1952	Almost 1 million East Germans migrate to West Germany.
1952	Britain develops atomic bomb.

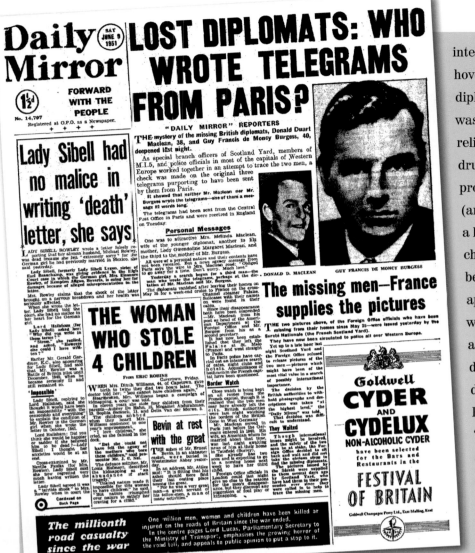

DEFECTION OF BURGESS AND MACLEAN

One of the first real alerts that the Soviets had penetrated British post-war security at a senior level occurred when Donald Maclean (1913–1983) and Guy Burgess (1910–1963) disappeared in May 1951. Both had been part of the Cambridge "Apostles" group in the 1930s, along with Kim Philby (the "Third Man") and Anthony Blunt (the "Fourth Man"), and like them had been recruited to the Soviet cause, probably by John Cairncross (the "Fifth Man").

Maclean became a Foreign Office high flier, serving in London, Paris and Washington (where he had access to Manhattan Project intelligence). Burgess hovered around the diplomatic service, but was regarded as less reliable, something of a drunk, a gossip, and a probable homosexual (and equally probably a lover of Blunt), but a charmer and useful go-between. When it became apparent that Maclean was about to be detected, as a result of papers delivered by the Soviet defector Gouzenko, Philby alerted Moscow "Centre", who in turn alerted Blunt, and the two were spirited away behind the Iron Curtain having booked seemingly innocent cross-Channel day-return ferry tickets to France. Burgess did not intend to defect, but was probably coerced as he was too much of a security threat to leave behind. Maclean had no choice.

They did not "officially" reappear in the Soviet Union until 1955. Burgess died in Moscow having been denied permission to visit his dying mother by the British Foreign Office. Maclean delivered his funeral oration.

Burgess and Maclean were only the first to be exposed in the group of British Establishment traitors, known by MI5 as the "Magnificent Five". MI5 knew their Soviet code names, but not their identities Their full story would only gradually emerge over the next 30 years.

LEFT: *The news of the disappearance of the two diplomats caught the attention of the press, but it would be years, indeed decades, before the full story became clear.*

OPPOSITE LEFT: *Concern over the proliferation of nuclear weapons had begun by the early 1950s. In April 1954, British MPs Anthony Greenwood (third from right) and the then Anthony Wedgwood-Benn (later Tony Benn, and in this photograph, uncharacteristically far right) felt sufficiently upset to promote the supporters of The Hydrogen Bomb Challenge outside the House of Commons.*

THE KOREAN WAR

At the Japanese surrender in 1945, the Soviet Red Army had conquered the Korean peninsula as far south as the 38th Parallel. US forces immediately moved into the southern part of the country. Attempts to reunify the country failed due to early Cold War mutual suspicion. Eventually, in 1949, the United Nations oversaw elections in the South, which were won by a Korean Nationalist, Syngman Rhee, while a People's Republic was established under Soviet sponsorship in the North, under the Korean communist leader Kim Il-Sung. At this point, both superpowers withdrew their occupying forces.

Reluctantly sanctioned by Stalin, and convinced that the USA would not retaliate, the North launched an invasion of the South in June 1950; within three months the South Korean army had been driven to a pocket around Pusan on the southeast of the peninsula. The offensive was seen as a direct challenge to US credibility, and President Truman, only too aware of the recent communist victory in China, and of the proximity of Korea to US-occupied Japan, initially offered air and naval support to bolster the South Koreans, but by September both US and UN ground troops began to arrive. General Douglas MacArthur, commander of the US occupation forces in Japan, was appointed Supreme Commander of the UN forces.

A spectacular amphibious attack by US forces against Inchon, just south of the 38th Parallel and near the South Korean capital of Seoul, helped to force the North Koreans back far within their own territory. Truman then charged MacArthur with reunifying Korea. It nearly worked. Stalin was not going to be drawn into the rapidly evolving conflict, but China, fearful of American positions being established on their Yalu river border with North Korea, decided to respond. Under the

guise of a "volunteer force" the Chinese People's Liberation Army crossed the Yalu in October 1950, and within six weeks UN/US forces were forced back south of the 38th Parallel.

Over the winter months protracted fighting stabilized the front line more or less along the former North–South demarcation line. MacArthur advocated an all-out US drive into Manchuria and, possibly as a result of this enthusiasm was relieved of his command in April 1951. The USA's overseas resources were now stretched thin, fortifying Europe and occupying the Western Pacific, and further antagonism of the Chinese – and potentially the Soviet Union – was not deemed useful. Truman adopted a defensive policy of US self-restraint in line with the Western Allies "Limited War" doctrine, which he had helped to develop.

The war ground to a halt, but peace negotiations continued until July 1953, negotiations which merely reflected the stalemate that persists today: the partition of Korea into a communist North and a nominally

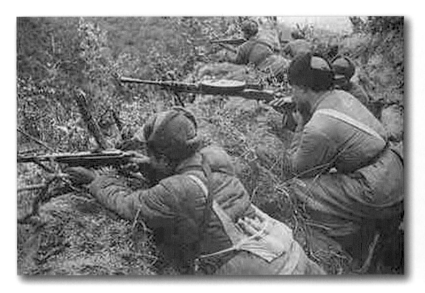

democratic South along the heavily fortified armistice line straddling, once again, the 38th Parallel.

The conflict had been costly – in Cold War terms one of the worst – the North Koreans and Chinese losing some 1.5 million people, partly due to their "human wave" tactics in the face of US superiority in arms and equipment, and a further million or so killed by US bombing. The UN/US suffered 94,000 casualties, one-third more than in Vietnam.

ABOVE: *The Chinese troops, considerably less well equipped than the Americans, were nevertheless tenacious. By 1951 the Korean War had frozen into entrenched positions. The enormous number of Chinese casualties were largely a result of their "wave attack" offensives, similar to those on the Western Front in World War I.*

LEFT: *General Douglas MacArthur overseeing the Inchon landings in September 1950. His aggression was soon to be curbed by US President Truman.*

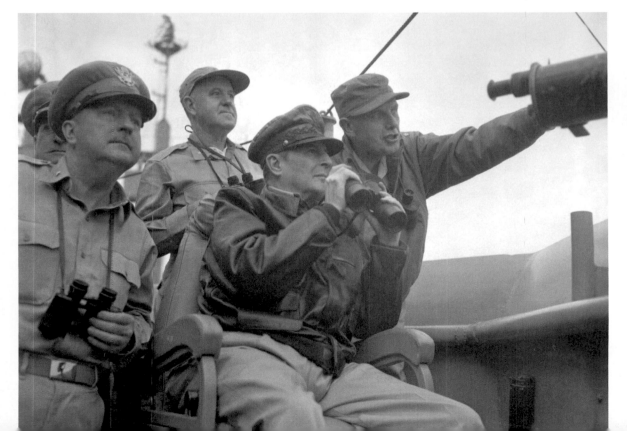

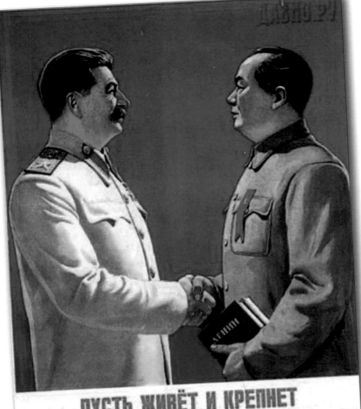

ПУСТЬ ЖИВЁТ И КРЕПНЕТ
НЕРУШИМАЯ ДРУЖБА И СОТРУДНИЧЕСТВО
СОВЕТСКОГО И КИТАЙСКОГО НАРОДОВ!

A WORLD DIVIDED: THE AGE OF BIPOLARITY

An alliance between the Soviet Union and the fledgling People's Republic of China, not always an easy one, meant that the Western Allies, self-proclaimed bastions of the "free world", were now confronted by about half the world's population in the opposing camp. The situation became known as the "Age of Bipolarity".

Nevertheless, it was the communist bloc that was encircled, hemmed in on the Eurasian continent, with little access to seaways. When Dean Acheson and John Foster Dulles were successive US Secretaries of State, the USA built a series of regional alliances that not only drew in countries on the immediate communist perimeter but also allowed them to establish nuclear bases, sometimes in the most far-flung locations, which enabled them to reach any target within the communist bloc.

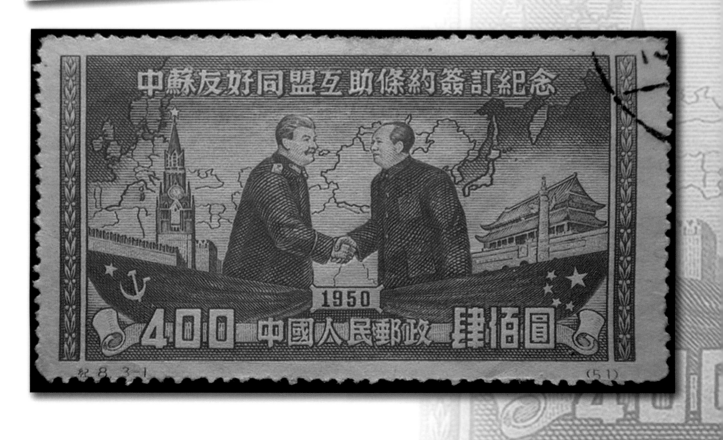

THE DOMINO EFFECT

In the meantime, in many European colonies in Southeast Asia, mostly occupied by Japan during World War II, there was continuing pressure for independence, and many nationalist movements were bolstered by communist support. By 1954, following a seven-year attempt to re-establish colonial control culminating in a disastrous defeat by North Vietnamese forces at Dien Bien Phu, France relinquished its control of what had been French Indo-China. A peace conference in Geneva divided the territory into the independent states of Laos, Cambodia and a partitioned Vietnam. For the next two decades much of the focus of the Cold War would lie here, as America sought to defer what it came to call a "Domino Effect" – the collapse of the region into communist hands.

1950

中國人民郵政

Drama of Dien Bien Phu

FORTRESS FALLS TO 30,000 REDS

THE shell-shattered Indo-China fortress of Dien Bien Phu fell to fanatical Red Vietminh troops yesterday, after fifty-seven days' siege.

But French Premier Joseph Laniel told his Parliament that the French strong-point Isabelle, two and a half miles away, is still holding out.

The Vietminh put 30,000 troops into a final twenty-hour attack on the Fort.

There was no retreat for the 10,000 French paratroopers, Foreign Legion men, and Vietnamese inside.

A 'Last Ditch' Order

Among the defenders was Mademoiselle Genevieve de Galard-Terraube, a slim, twenty-nine-year-old nurse who has been tending the wounded. She was the only woman in Dien Bien Phu.

As shrieking, drink-maddened Reds hurled grenades only 300 yards away, General Christian de Castries, the gallant French commander of the Fort, issued a dramatic "last ditch" order.

He told artillerymen at the strongpoint Isabelle to fire directly on his OWN command post if the shrieking drink-maddened Red rebels reached it.

Blowing bugles and shouting fanatical Red soldiers shot from their waterlogged trenches and went at the French garrison with grenades and bayonets.

General de Castries's headquarters was their obvious objective.

The attack was made on three fronts — north-east, east and south-west.

Hordes of Reds were still coming forward after eight hours fighting.

The battle raged so furiously said a French spokesman that there was not a moment even to think of how heavy the losses were on both sides.

"This was the supreme bid of the Vietminh to wipe out the fortress before the Geneva Conference makes any move to settle the conflict by negotiation," he added.

1953-1954

1953 General Dwight D. Eisenhower (1890–1969), former commander-in-chief of Allied forces in Europe, succeeds Truman as US President (Republican, to 1961).

1953 Anti-Soviet rebellion in East Berlin suppressed.

1953 Strikes and rioting in Poland.

1953 Ian Fleming, ex-UK Naval Intelligence officer, publishes first James Bond book, Casino Royale.

1953 USSR withdraws diplomatic relations with Israel.

1953 Execution of Rosenbergs on charges of spying in USA. Widespread condemnation.

1953 F-100 fighter goes into production in USA. First supersonic warplane.

1953 Death of Stalin. Nikita Khrushchev (1894–1971) takes control in USSR after brief power struggle. CHEKA head Beria murdered.

1954 Geneva Conference: France withdraws her colonial forces from French Indo-China after defeat by North Vietnamese communist nationalists at Dien Bien Phu. Laos, Cambodia and Vietnam all become independent from the "Union of France". Separate states of North and South Vietnam created, reflecting the division of Korea in 1953.

1954 South East Asia Treaty Organization (SEATO) formed at instigation of USA.

1954 US intervention in Guatemala ousts reformist government.

1954 Nautilus, world's first nuclear-powered submarine, launched (USA).

1954 USA agrees to support Chinese Nationalist government in Taiwan.

1954 Egyptian monarchy deposed following military coup (1952); Gamel Abdel Nasser becomes prime minister.

1954 CIA sponsors military coup in Iran.

1954 Beginning of Algerian revolt against French colonial rule.

THE ROSENBERGS

Julius (1918–1953) and Ethel (née Greenglass,1915–1963) Rosenberg were, like many other atomic spies, Jews with European connections, and former Communist Party members. Although more active in setting up an active spy ring than others, their allegiance to the communist cause was based on a belief that a wartime ally should have access to war-winning information.

Later Venona decrypts make it clear that Julius was the main motivator. But it was Ethel who recruited her brother, David Greenglass, a machinist within the Manhattan Project, who passed documents to her. Another member of their ring was Morton Sobell, who was tried alongside the Rosenbergs. A further member of the Los Alamos ring, Theodore Hall, only emerged from the shadows in the 1990s.

It was the network that had let them down. Various couriers were identified, such as Harry Gold, a chemist of Russian origin who had been recruited as a Soviet spy in 1934. Gold had also been in contact with Klaus Fuchs at Los Alamos. It was largely Fuchs's confession to MI5 in 1950 that led to the downfall of the Rosenberg ring.

The Rosenbergs went to the electric chair in 1953, amidst much international controversy, and remain the only Soviet spies to have been executed in the West in peacetime.

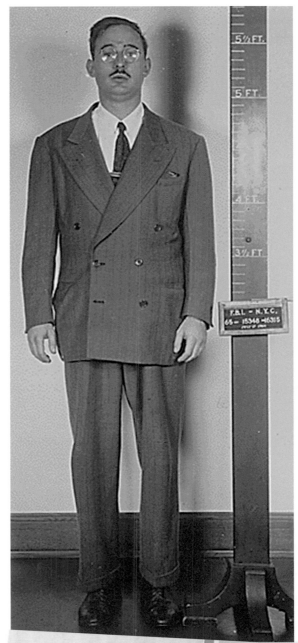

LEFT:
Julius Rosenberg in an identification photograph after his arrest. Venona decrypts have made it clear that Julius acted as little more than a courier, supplying the Russians with limited amounts of information passed to him from his brother-in-law from the Manhattan Project

BELOW:
Although there was little hard evidence against Ethel Rosenberg (left), it was no coincidence that the source of the intelligence the Rosenbergs supplied to the Soviet Union was her brother, David Greenglass (right).

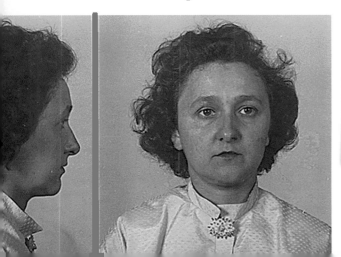

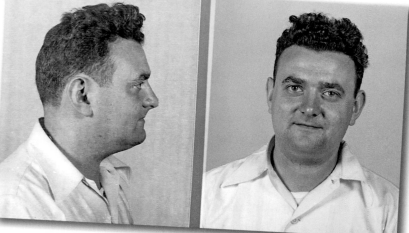

a power struggle. Although nominally the USSR was run by the Presidium of the Supreme Soviet, the fact is it had been a dictatorship for a generation.

Beria, the most probable assassination conspirator, was rapidly liquidated, but it would be two years before Stalin's successor, Khrushchev, emerged as the power to be reckoned with – two years in which US President Eisenhower's hawkish Secretaries of State rewrote the ground rules of the Cold War.

THE DEATH OF STALIN

After over 20 years of autocratic rule, years which had seen vicious purges of the Soviet Communist Party, economic plans that had cost millions of lives, and yet a costly victory in the Great Patriotic War against Germany, Stalin's death from a stroke at the age of 75 threw the Soviet Union into disarray. Even his closest associates, such as Lavrenty Beria (head of the Cheka secret police), Georgy Malenkov, Nikolai Bulganin, Vyacheslav Molotov and Nikita Khrushchev had lived in daily fear of his volatile temperament. With his passing (quite probably the result of wolfarin poisoning), there ensued

RIGHT:
Moscow's Red Square in the snow, people queue to see Stalin lying in state at the Kremlin.

CROCODILE TEARS

MR. CHURCHILL, the Prime Minister, sends his " regret and sympathy."

Mr. Attlee, the Leader of the Opposition, sends his " sympathy and anxiety."

Mr. R. A. Butler, the Chancellor of the Exchequer, says he is " sorry to hear the news."

Alone among these cautious condolences President Eisenhower extends " The thoughts of America to all the peoples of the Soviet Union, the men and women, boys and girls, in the villages, cities, farms and factories of their homeland " and expresses his wish for peace to " Russia's millions sharing our longing for a friendly world."

The President does not praise Marshal Stalin.

Nor does he join the formal diplomatic sorrow. But the glycerine tears go on and the cardboard mourning and the sawdust grief is pumped out nonstop.

I am made of much more callous stuff.

I have no regret for Mr. S. I have no sympathy for Mr. S. And I am not in the slightest bit sorry to hear the latest news about Mr. S.

So granite-hearted am I about J. V. Stalin, that I feel not the faintest twinge of grief over the Secretary of the Central Committee of the Communist Party of the Soviet Union.

There's uncouth indifference for you !

But I'll tell you a funny thing. I met another man who's just as bad.

Not only did he not feel regret, sympathy and anxiety, but he was downright pleased.

He said that the news had made the day for him and that he proposed to have a drink on it. I was just pondering on man's inhumanity to man when I met someone else with a tremendous grin lighting his face up until it glowed with sheer warm pleasure.

'The Best News . . .'

He was positively gloating over the symptoms. This character was actually rejoicing over the desperate nature of Stalin's illness.

He was joined by another chap who remarked brutally that it was the best news he had had since petrol rationing ceased.

I must move in singularly hardened circles. Out of at least a hundred people who have mentioned the matter, not a single one expressed grief.

They weren't grateful to the great Russian for his immense kindnesses in Eastern Europe which are now sending refugees swooning with pure joy into Western Berlin at the rate of nearly 3,000 a day.

They weren't delighted with his wise and kindly role in Malaya and Korea and Indo-China. And one of them—he was a Pole—had the downright impertinence to query Uncle Joe's benevolence over the great battle for Warsaw in 1944.

The Poles, on August 8, under General Bor, you may remember, rose against the Germans and put up one of the bravest and greatest fights in history. By September 12 they began to run out

Continued on Back Page

77

THE EISENHOWER YEARS

There remains something of a mixed perception of Eisenhower's presidency. A former soldier who had overseen the reconquest of Europe during World War II, he was a popular choice for the Republican ticket in the 1952 presidential elections, despite Truman's undoubted abilities at handling the opening episodes of the Cold War. He also inherited a rapidly growing economy, courtesy of four terms of Democratic administration. In addition, by the 1950s he seemed an open, rather unassuming man, fond of family values, with few axes to grind. But during Eisenhower's watch, successive US Secretaries of State Dean

BELOW: *Eisenhower's military credentials made him the ideal Cold Warrior.*

RIGHT: *Youth culture (and dissatisfaction) came to the fore during the Eisenhower administration, exemplified by the 1955 film* **Rebel Without a Cause.**

THE STAR SENSATION OF 'EAST OF EDEN'

JAMES DEAN IN "REBEL WITHOUT A CAUSE"

ALSO STARRING NATALIE WOOD

...AND THEY BOTH CAME FROM GOOD FAMILIES!

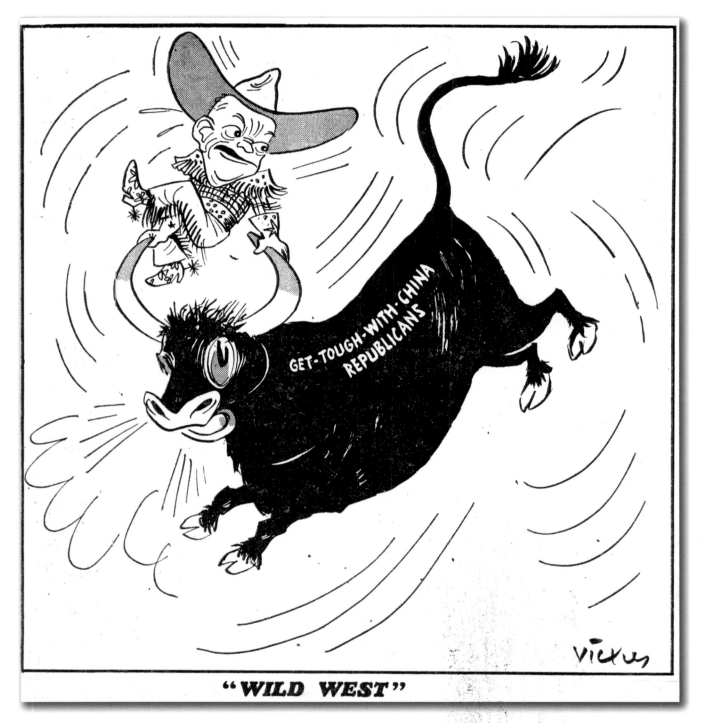

"WILD WEST"

Acheson and Allan Foster Dulles would wind up tension by creating a diplomatic and proactive *cordon sanitaire* around the communist bloc.

At the same time, the degree of popular American anti-communist fear, whipped up by the likes of Joe McCarthy, subsided into a resentful acceptance of the prevailing condition. The atmosphere was captured on the one hand by the overt consumerism now made available to mainstream American society, and on the other by a growing recognition that there was discontent among large pockets of Eisenhower's America: African Americans, more recent immigrant minorities and a new teenage generation were knocking on the White House door, demanding change.

ABOVE: *The Texan president was frequently criticized for not being tough enough in his foreign policy; during his presidency both Russia and China did much to gain the upper hand in the Cold War.*

PARANOID ANDROID

In the 1950s science fiction films frequently played on Cold War fears, often treating an alien threat as a metaphor for fears of Soviet intentions against the West. These included such wonderful titles as *Red Planet Mars* (1952).

One of the earliest, and most successful, cast a different light on the matter: *The Day the Earth Stood Still* (1951) saw a alien traveller, accompanied by a robot, visiting Earth in his flying saucer to deliver a warning to the governments of the world concerning nuclear weapons and the need for peaceful cooperation rather than the age-old resort to war.

The more insidious possibility of innocent people being converted into zombie-like automatons provided the plot for *Invasion of the Body Snatchers* (1956); although the producers denied any allegorical intention, the film was widely seen as a parable about communist infiltration.

SPY FICTIONS

The "Golden Age" of spy fiction, in the early decades of the 20th century, had focused on the "Great Game" (Kipling's *Kim*, 1901), anarchist activities (Conrad's *The Secret Agent*, 1907), or the threat posed by Germany in the two world wars, such as John Buchan's *The Thirty-nine Steps* (1915).

Eric Ambler created a new, rather seedy vision of the world of espionage in *The Mask of Dimitrios* (1939) and *Journey Into Fear* (1940), while his contemporary Graham Greene dabbled in spy fiction with novels such as *Ministry of Fear* (1943). It was not until 1953 that former Naval Intelligence officer and journalist Ian Fleming launched a fictional spy with a licence to kill, James Bond, in his entertaining *Casino Royale*. The Bond novels were not immediately successful, but with Ambler and Greene, Fleming effectively began the Cold War spy novel genre. Many of Bond's adversaries were in the pay of the Soviet counter-intelligence organization SMERSH.

In the early 1960s a former secret service man, John le Carré, created the character of George Smiley, an unassuming Cold Warrior who would later feature in *Tinker, Tailor, Soldier, Spy* (1974), *The Honourable Schoolboy* (1977) and *Smiley's People* (1979). The novels appeared to provide astonishing insights into the way the secret services operated. Smiley made a brief appearance in le Carré's breakthrough novel, *The Spy Who Came in From the Cold* (1963) and its follow-up, *The Looking-Glass War* (1965).

At much the same time, Len Deighton developed a more down-at-heel, grittily realistic spy in the working class Londoner Harry Palmer (*The Ipcress File*, 1962). Deighton's novels, and the films made of them, anticipated the genre that moved glumly along through the later 1960s and 1970s with bestsellers such as Noel Behn's *The Kremlin Letter* (1968).

1955-1956

1955	Warsaw Pact established as a communist military alliance in opposition to NATO.
1955	West Germany admitted to NATO. Pre-war state of Austria restored.
1955	Baghdad Pact between Iran, Iraq, Turkey and Pakistan sponsored by USA as anti-Soviet defensive league.
1955	Argentina: populist government of Perón falls to military coup.
1955	Soviets begin to supply arms to Egypt.
1955	US armed intervention in Iran.
1956	Polish revolt suppressed.
1956	Revolt in Hungary led by Imre Nagy against communist rule; crushed by Warsaw Pact forces.
1956	Beginnings of Rock 'n' Roll in USA.
1956	Khrushchev delivers "Secret Speech" to Soviet Party Congress, criticizing Stalin's long regime.
1956	Second Arab-Israeli war.
1956	Suez Crisis: Anglo-French forces fail to stop occupation and nationalization of Suez Canal by Egypt. USA refuses any support.
1956	France grants independence to Morocco and Tunisia.
1956	Japan admitted to United Nations.
1956	USA resumes atomic bomb tests in Pacific.
1956	Polish October: Attempt by Wladislaw Gomulka to launch a "new socialism" in Poland leads to a degree of liberalization.
1956	Fidel Castro begins armed insurgency against US-backed Battista government in Cuba.

A RASH OF PACTS

The USSR, now under the control of Nikita Khrushchev, responded to the creation of the West's NATO alliance in 1949 by creating one of its own: the Warsaw Pact (officially the Eastern European Mutual Assistance Pact) was signed in 1955, needlessly binding together the countries that the Soviets already controlled in Eastern Europe. The organization was disbanded in 1991.

For the West, one weak link in its security cordon around the USSR was the Middle East. The Baghdad Pact was agreed between the USA, UK, Iran, Iraq, Pakistan and Turkey. In response, the Soviets began to supply aid to Syria in 1955, and was soon to do so to Nasser's new republic of Egypt (eventually funding the building of the Aswan dam), and to Iraq following its revolution in 1958. The Baghdad Pact was replaced by CENTO (the Central Treaty Organization) in 1959.

ROCK 'N' ROLL

One aspect of the Eisenhower years was the beginning of youth culture, most obviously in the form of the explosion of popular Rock 'n' Roll music, derived in large part from black rhythm and blues, or 'race music'. While many of the songs were about youthful love, dance and rebellion, several picked up on themes more associated with the American folk and blues traditions, with elements of political and social awareness. Homer Harris's 'Atomic Bomb Blues' is self-explanatory, while Memphis Willie Borum's 'Overseas Blues' less so, but was also concerned with atomic weapons. 'Sad News from Korea' by Lightnin' Hopkins anticipated the sort of anger that would be expressed a decade and a half later in the many songs about Vietnam.

Rock 'n' Roll also celebrated modernity in all its forms, including an early fascination with space. Quite what Jerry Lee Lewis was actually singing about in 'Great Balls of Fire' will probably remain a mystery, but it sounded apocalyptic. while Billy Lee Riley's 1957 record 'Flyin' Saucers Rock 'n' Roll' accorded with the popular obsession with things extra-terrestrial.

OPPOSITE LEFT: *Alan Freed's promotion of rock 'n' roll caught the zeitgeist, with spinning discs orbiting an uncertain world.*

LEFT: *Jerry Lee Lewis captured the spirit of youthful exuberance at the height of the Eisenhower years.*

THE SUEZ CRISIS

Britain and France regarded Egypt's nationalization of the Suez Canal zone in 1956 with considerable alarm. With their encouragement, Israel attacked first, after which British and French troops landed in force. There was international outcry, the USSR condemning the move as imperialist aggression, while the USA (in part agreeing with the Soviets) refused to support the move. UN peacekeeping troops moved in to cover the British withdrawal. The debacle ended in a humiliating climb down for Britain and France, and British Conservative Prime Minister, Anthony Eden, who had presided over the disaster was forced to resign, although the Conservatives managed to cling on to power for a further eight years. The crisis clearly indicated the effective impotence of the formerly all-powerful European imperial nations.

RIGHT: *British troops directing traffic in the Canal Zone.*

BELOW: *The aptly named cruiser HMS Cleopatra and minelayer HMS Manxman at Port Said.*

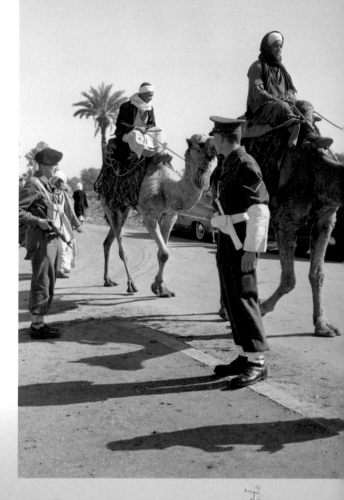

LEFT:
Bombs intended for Egypt being loaded on to Canberras at an RAF airbase in Cyprus.

BELOW LEFT:
A British Centurion tank supporting troops searching the "Arab Town" quarter of Port Said. Caches of Soviet weapons were discovered.

DON'T SHOOT THE PIANIST — HE'S DOING HIS BEST...

TORY HOUSEWIVES CHOICE

"... Besides, he's the best pianist we have!"

LEFT: The gloomy tone of Vicky's cartoon at the height of the Suez crisis seemed to anticipate Conservative Prime Minister Anthony Eden's resignation after the British withdrawal from Suez.

LEFT BOTTOM:
An Egyptian cartoon of Egypt's Gamal Nasser kicking out the British. Nasser would emerge from the crisis as one of the dominant non-aligned leaders in the Middle East, courted and supplied with arms and aid by the USSR.

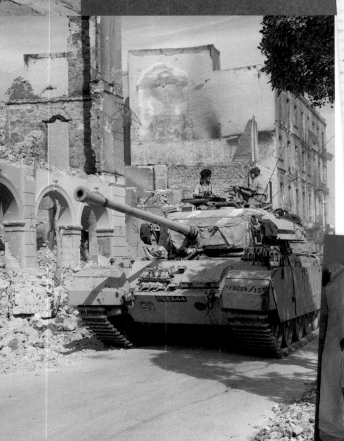

To Hell

THE HUNGARIAN UPRISING

Khrushchev's denunciation of Stalin in his "Secret Speech" to the 20th Party Congress in 1956 appeared to send a signal that democratization might be at hand in the Eastern bloc. Although the implications were first leapt on by Gomulka in Poland, with some success, it was in Hungary that open revolt broke out on the streets.

Elements of economic liberalization had occurred in Hungary during the premiership of Imre Nagy (1953–1955). He had been summarily replaced by a more hard line communist, Rákosi, but student and worker demonstrations demanding democracy forced Rákosi from office, and Nagy was recalled. János Kádár was appointed general secretary of the Hungarian Socialist Workers' Party. Nagy withdrew restrictions on the formation of political parties, and released the anti-communist primate Cardinal Mindszenty. Nagy announced that Hungary would withdraw from the Warsaw Pact, and become a neutral state. Kádár opposed these moves, and formed a counter-government in the east of the country, gaining immediate Soviet support. Russian tanks entered Budapest and, in November 1956, Nagy was deposed. During bitter street fighting, over 700 Soviet soldiers and 2,500 Hungarians were killed. More than 200,000 Hungarian nationalists fled to the West. Nagy was executed in 1958. The uprising had proved that the USSR would respond to any insubordination with brute force.

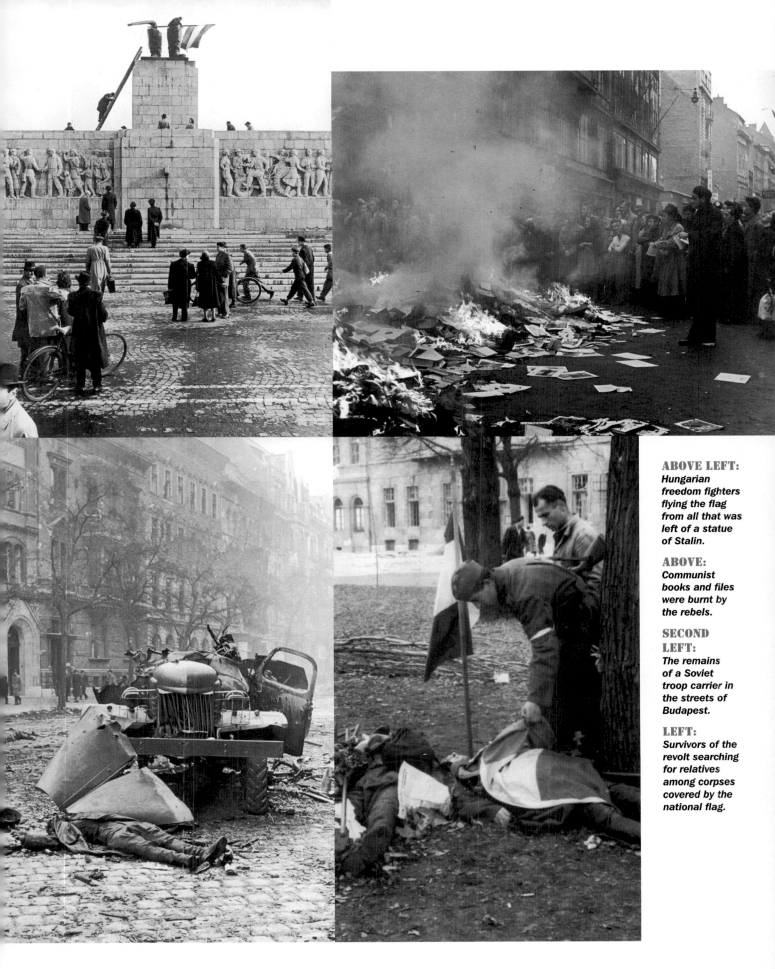

ABOVE LEFT:
Hungarian freedom fighters flying the flag from all that was left of a statue of Stalin.

ABOVE:
Communist books and files were burnt by the rebels.

SECOND LEFT:
The remains of a Soviet troop carrier in the streets of Budapest.

LEFT:
Survivors of the revolt searching for relatives among corpses covered by the national flag.

THE COLD WAR: SECTION THREE

RIGHT:
The avuncular
Khrushchev was
regarded with a
certain affection
in the West until
his stand-off
with America
over Cuba.

KHRUSHCHEV'S RUSSIA

In many ways Stalin's successor, Nikita Khrushchev, found himself in a difficult position. Partly this was due to his background and character. Originally a steel worker, he became a Soviet commissar during the civil war against the Bolsheviks. He supported Stalin during the great purges of the 1930s, and conducted his own in the Ukraine. He had seen action during World War II at the pivotal siege of Stalingrad. Once safely in power, by 1955 he attempted to reform the Stalinist model of government by terror, and to restructure the Soviet economy to improve the everyday lives of Soviet citizens (measures which largely failed). Confronted by the reality and cost of the nuclear arms race, he cut spending on conventional forces, whilst also diverting money to the Soviet space programme. He cordially entertained UK Prime Minister Harold Macmillan in Moscow, and met with the new US President John F. Kennedy in Vienna in 1961.

Despite these measures, his period in power saw the most overheated moments of the Cold War, not least the suppression of the Hungarian revolt in 1956, the Sino-Soviet split in 1960, the construction of the Berlin Wall in 1961 and the Cuban missile crisis in 1962. Regarded as an aging, weak reformer by his associates, he was forcibly retired by 1964.

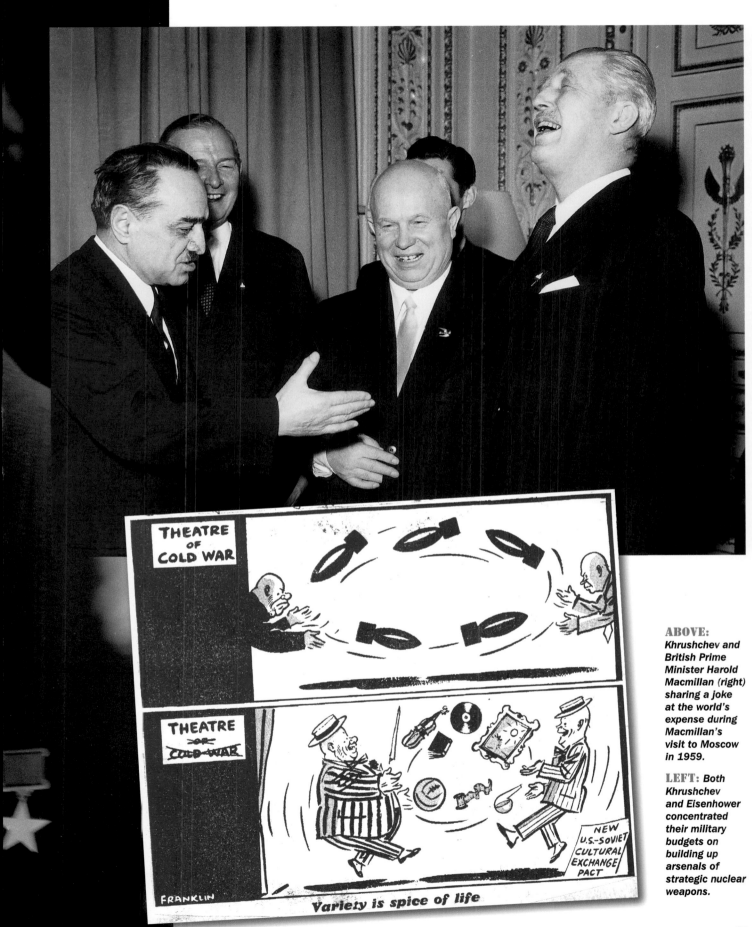

THEATRE OF COLD WAR

THEATRE ~~OF COLD WAR~~

NEW U.S.-SOVIET CULTURAL EXCHANGE PACT

FRANKLIN

Variety is spice of life

ABOVE: *Khrushchev and British Prime Minister Harold Macmillan (right) sharing a joke at the world's expense during Macmillan's visit to Moscow in 1959.*

LEFT: *Both Khrushchev and Eisenhower concentrated their military budgets on building up arsenals of strategic nuclear weapons.*

Racing to Oblivion
1957–1962

With the Soviet development of the hydrogen bomb in 1954, and the creation of the Warsaw Pact in 1955, the superpowers now seemed to be manoeuvring on a level playing field.

However, the USSR added a new vertical dimension to the game when they successfully launched Sputnik I, stealing a march on the Americans in the space race, an advantage they would follow up in 1961 by getting the first man into space. The idea also of "spies in the sky" meant that everybody felt they were being watched.

This demonstration of technical superiority was only the tip of a more chilling iceberg, as both adversaries accumulated huge arsenals of strategic weapons. The Americans had already established a security ring and had constant air and submarine patrols bearing nuclear warheads; the only way the USSR could afford to respond was by building more.

The age of diplomatic "pactomania" that had dominated the early 1950s was moving into one of overbearing belligerence. People began to feel that their fate had been wrested from their hands.

LEFT: *A solitary scene in East Berlin, 1961.*

1957-1958

1957	Ghana becomes first sub-Saharan African state to declare independence from Great Britain.
1957	Civil war between North and South Vietnam begins.
1957	Malaya granted independence by Britain; continuing British support against communist insurgents.
1957	Treaty of Rome: creation of the European Economic Community (EEC) bolsters economic recovery in Western Europe.
1957	British colonial forces withdrawn from Malaya, after long struggle against nationalist and communist forces. Malayan independence.
1957	Promulgation of the "Eisenhower Doctrine" affirming US commitment to containing spread of communism, and support for those resisting communism.
1957	Sputnik: First man-made Earth satellite launched into space by the Soviet Union.
1957	Both the USSR and USA test Intercontinental Ballistic Missiles (ICBMs) designed to deliver nuclear warheads.
1957	Mao Zedong launches "Great Leap Forward" economic reform in China. Attempt at land reform and modernization of industry results in further famines (the "Three Hard Years" from 1959) and 20-30 million deaths (to 1961).
1957	USA increases military budget in response to Soviet advances in rocket fuel technology.
1957	USA begins underground testing of nuclear weapons in Nevada.
1957	First nuclear reactor for electricity production (USA).
1958	Syria and Egypt establish the United Arab Republic to counter Israel and its Western supporters (dissolved 1961).
1958	Foundation of International Atomic Agency Commission (IAEA) in Vienna.
1958	First microchip developed (USA).
1958	North American Space Agency (NASA) set up. Launches first US man-made satellite, Explorer I.

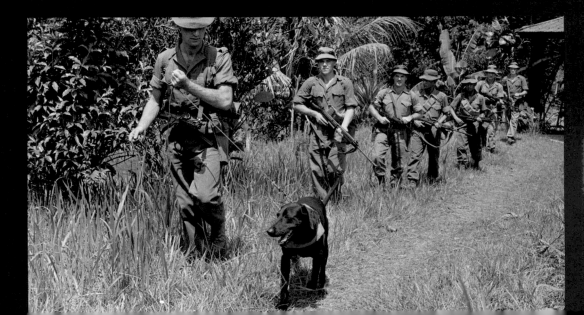

THE MALAYAN EMERGENCY

Unlike France and the Netherlands, after World War II Britain managed to re-establish control of its colonies in Southeast Asia, and even extend it into the Sarawak section of Borneo. This was not without resistance. The Communist Party of Malaya (CPM) launched a guerrilla campaign in 1948 demanding independence. Britain responded with a hefty military and political counter-offensive, whilst negotiating a medium-term plan to grant independence to non-communist Malay nationalists. In the event, Malay was granted independence in 1957, although Britain continued to supply men and support to the new Federation of Malaysia until the so-called "emergency" was subdued in the early 1960s, although CPM activities in the more remote parts of Borneo were to continue for many years.

LEFT: The CPM operated in remote jungle areas, forcing troops into hazardous patrols, prefiguring the nature of the war in Vietnam.

RIGHT:
The Daily
Mirror's *Vicky
drew an ironic
parallel between
the satellite in
space and the
Soviet treatment
of their satellite
states in Eastern
Europe.*

BELOW:
*A replica of
Sputnik 1.*

THE LAUNCH OF SPUTNIK

With the launch by the Russians
of the world's first man-made
space satellite, Sputnik I, in
October 1957, the possibility of
space travel came one step closer,
as did the prospect of remote
sensed surveillance. Two failed
attempts by the Americans to get
a satellite into space only added
to the Soviet's glee. Further
ignominy was to follow, four years
later, when, following various dogs
and monkeys, the Soviet Union
launched a man, cosmonaut Yuri
Gagarin, into earth orbit on 12th
April 1961.

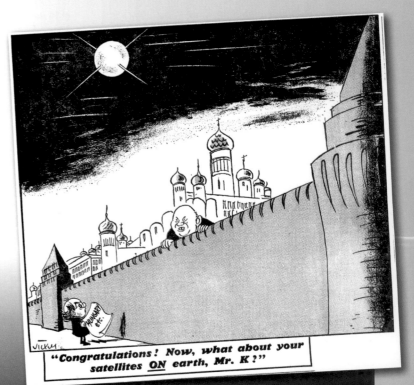

"Congratulations! Now, what about your satellites ON earth, Mr. K?"

PROGRESS REPORT

WE CAN SPLIT THE ATOM...

WE CAN FLY FASTER THAN SOUND...

WE SHALL LAUNCH EARTH SATELLITES...

WE CAN GUIDE MISSILES...

...BUT...

SPACE FRENZY

The over-heated science fiction fantasies of the early 1950s gained a gloss of reality when the USSR launched the first man-made satellite into space; the cartoonists had a field day.

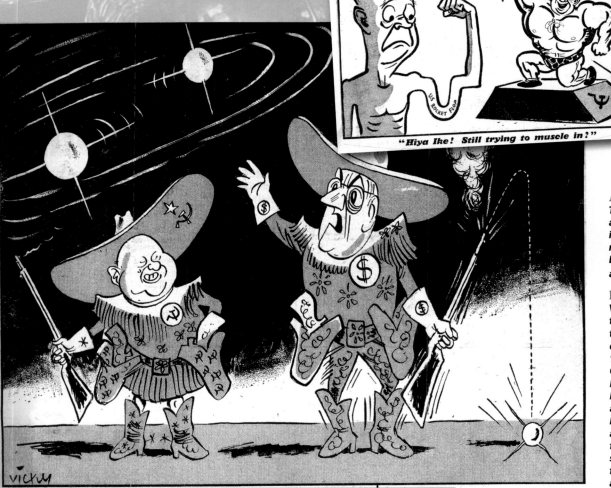

SPACE GYM

"Hiya Ike! Still trying to muscle in?"

ABOVE:
The Russian advantage in the space race portrayed Eisenhower as a loser.

LEFT:
Vicky caught the temper of the time with his cartoon entitled 'Anything You Can Do I Can Do Better', with both Khrushchev and John Foster Dulles as cowboys, following the second US failure to launch a space satellite.

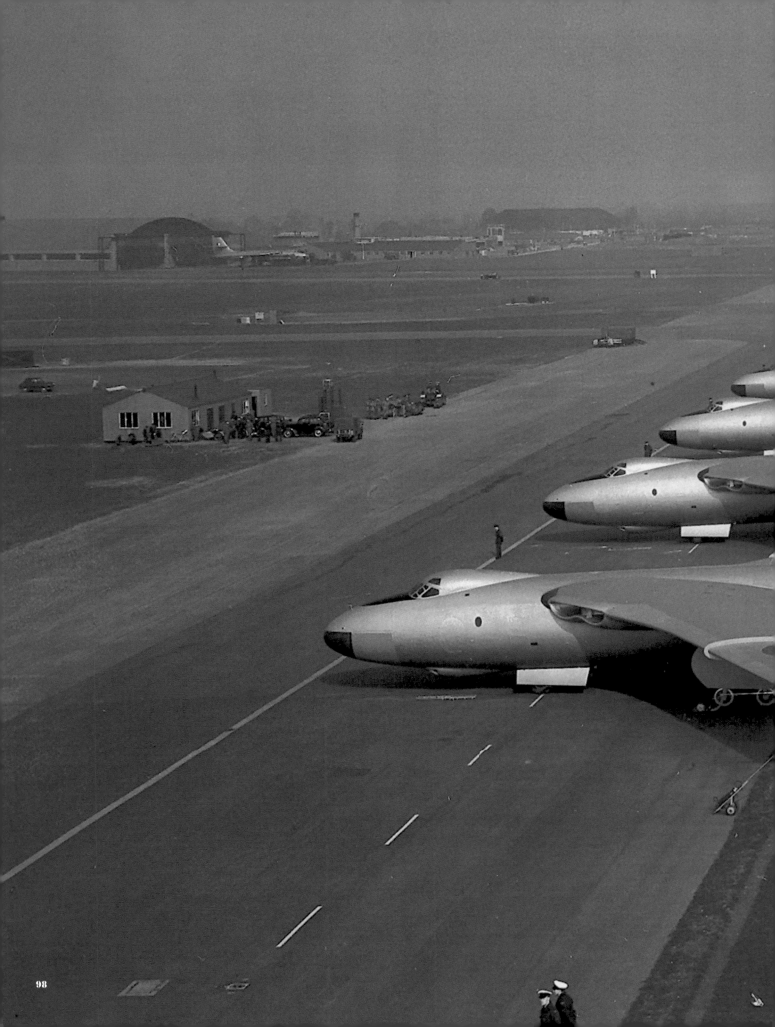

LEFT:
The Vickers Valiant B1 V Bomber force at RAF Marham in Norfolk in 1956. These aircraft were at the vanguard of Britain's defence system until overtaken by the Avro Vulcan by the end of the 1950s.

MOUNTING ALARM

The stockpiling of strategic nuclear weapons by both superpowers became a matter of public concern in the late 1950s. With the stationing of nuclear warheads in Europe, and the announcement that planes carrying nuclear payloads flew regularly over European airspace, what appeared to be secret had become public knowledge.

WORLD FASHION CRAZE

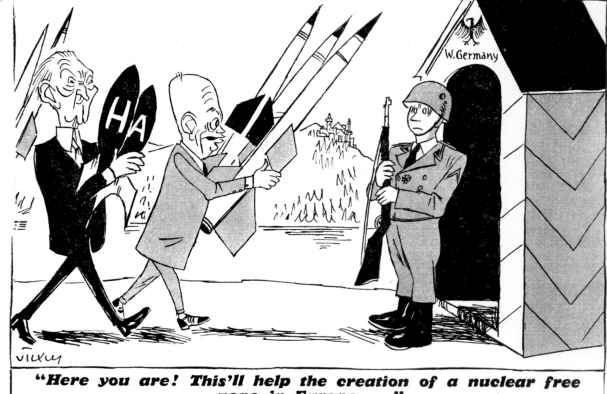

"Here you are! This'll help the creation of a nuclear free zone in Europe . . ."

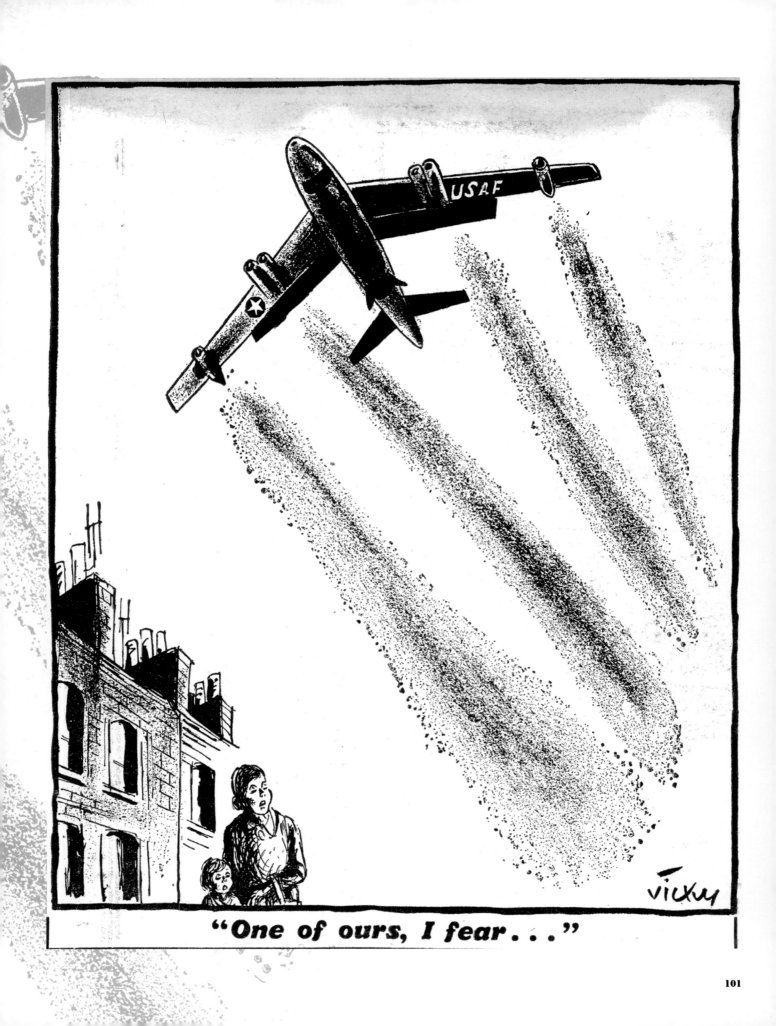

"One of ours, I fear . . ."

1959-1960

1959 Fidel Castro's left-wing revolutionary forces finally enter Havana, ousting the US-backed Battista government in Cuba; body politic and economy is reorganized along Soviet lines, and Castro aligns Cuba with the Soviet bloc. Receives substantial Soviet aid.

1959 China suppresses nationalist uprising in Tibet.

1960 Border dispute between Russia and China over the Amur and Ussuri rivers leads to armed confrontation and ideological and political split.

1960 US U-2 high altitude spy plane, piloted by Gary Powers, shot down in Soviet airspace by ground-to-air missile.

1960 Foundation of European Free Trade Association (EFTA) in Geneva to counterbalance the EEC. Founding members included Norway, Sweden, Denmark, UK, Portugal, Switzerland and Austria.

1960 The "Wind of Change": 15 African nations declare independence from colonial control.

1960 Foundation of Organization of Petroleum Exporting Nations (OPEC) to control the price of oil; founding nations include Saudi Arabia, Iraq, Iran, Kuwait, Venezuela, Algeria and Libya.

1960 Katanga attempts to secede from former Belgian Republic of Congo. Beginning of a series of civil wars, to unfold over the next 45 years.

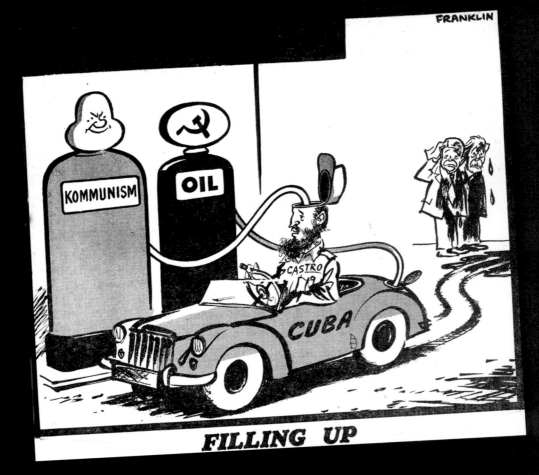

FILLING UP

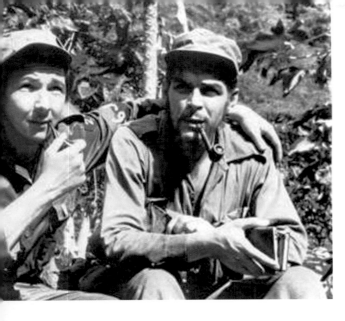

THE CUBAN REVOLUTION

In 1959, with a Leftist guerrilla army numbering only 5,000, Fidel Castro entered Havana and deposed the US-backed Batista government. They had been waging a hill war in the backlands of the island for several years, and Castro himself had attempted coups in 1953 and 1956. Upon seizing power Castro suspended the Cuban constitution and nationalized all US businesses on the island, announcing that the nation would now develop along Marxist-Leninist lines. The USA responded by breaking diplomatic relations, casting Castro into the arms of the Soviet bloc, and effectively creating a cuckoo in the nest in America's back yard.

CND AND THE ALDERMASTON MARCHES

The Campaign for Nuclear Disarmament (CND) was founded in 1957, growing out of earlier British peace movements such as the Peace Pledge Union (PPU, founded in 1949), Operation Gandhi (1952), and the Direct Action Committee.

CND focused its activities on a series of 52-mile marches between the Atomic Weapons Research Establishment at Aldermaston in Berkshire and Trafalgar Square in London. The first took place over the Easter weekend, 1958, and the event was repeated annually until 1963, when violence broke out. By then the events attracted thousands of supporters. A one-day rally was held in 1964, but the full marches were revived in 1965, 1972 and 2004.

103

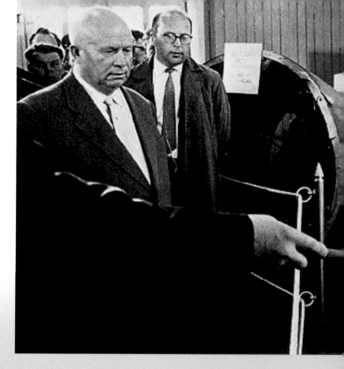

THE U-2 INCIDENT

The downing by the USSR of a US Lockheed
U-2 spy-plane, piloted by Gary Powers, using
a ground-to-air missile on 1st May 1960 was a
major flashpoint in the Cold War.

Powers safely ejected from his plane and
was tried and imprisoned, sentenced to 10
years for espionage. He was released in a
prisoner exchange deal in 1962, but not before
the Soviets had made the most of the incident.
America claimed Powers had been on a weather
forecasting mission and had crash landed due
to a technical failure.

The Americans had been using the plane
since around 1956, but nominally under CIA
rather than US Air Force control. The KGB were
aware of this, but powerless to intervene. The
intelligence gained from U-2 missions revealed
that the USSR were continually falsifying their
maps – a habit developed during World War
II. Cities which, from aerial reconnaissance,
obviously existed did not appear on official
maps, and those that did were regularly
mislocated. The practice was not abandoned
until the 1980s.

THE COLD WAR: SECTION FOUR

RIGHT: *The
US Lockheed
U-2 spyplane
(nick-named
"Dragon Lady")
was developed
to take high-
altitude
surveillance
photographs.
Capable of being
launched from
land bases and
aircraft carriers,
it flew at 70,000
feet (21,000
m) way above
Soviet fighter
and anti-aircraft
capabilities. In
various forms
the U-2 was in
service until the
late 1980s.*

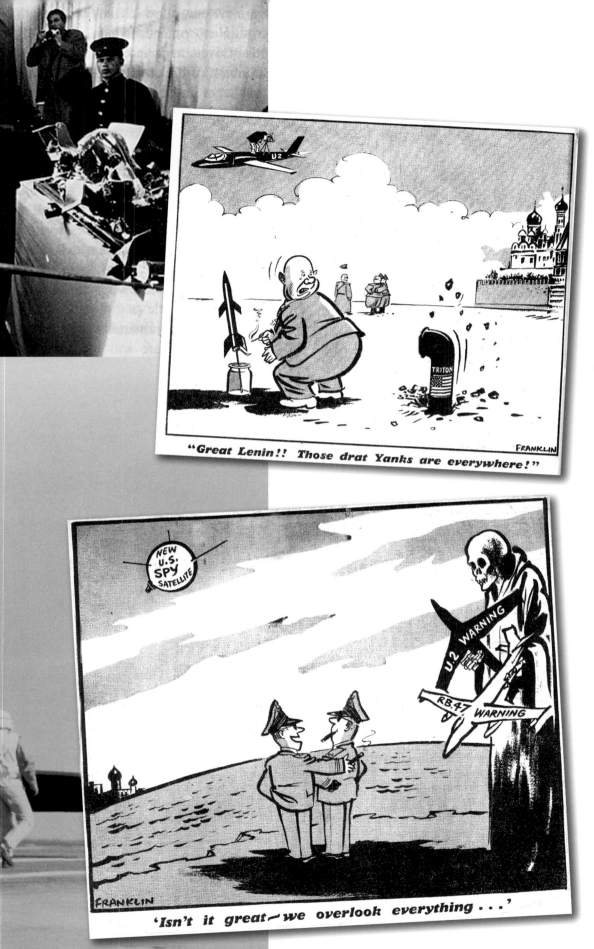

"Great Lenin!! Those drat Yanks are everywhere!"

'Isn't it great—we overlook everything . . .'

LEFT: *Despite the seriousness of the incident, the press transformed the embarrassment into an opportunity to poke fun at Soviet paranoia, not just about US spy planes, but about nuclear-powered submarines. The Soviet press responded by showing photos of Khrushchev inspecting the mangled remains of Powers's plane.*

BELOW LEFT: *The Americans could still comfort themselves with the thought that they retained surveillance superiority over the Russians.*

RIGHT &
BELOW:
*An exercise
at the Civil
Defence Range
in Croydon,
South London. A
post-apocalypse
village was
constructed in
order to train
civil defence
officers.*

CIVIL EMERGENCIES

What would happen in the event of a
nuclear strike? In addition to the massive
expenditure on strategic weapons, the
Western powers spent many fortunes
on (as it turned out) equally redundant
measures to provide emergency
accommodation for key government
officials and weapons stockpiles.

In Britain, the Civil Defence Corps was
revived in 1948, and trained to respond
to a nuclear attack. In 1953, a series of
Regional Seats of Government (RSG)
were constructed, and over the next 20
years, bunkers such as Kelvedon Hatch
in Essex were built deep underground.
They were designed only to keep an
operating government in action; it was
assumed that the civilian population
would have been wiped out. Civil defence
exercises in the event of a nuclear
strike were undertaken in the UK from
the early 1950s, and even in the 1960s
schools were still encouraged to perform
absurd nuclear strike drills, involving
hiding under desks or moving to cellars.
In traditionally neutral Switzerland, by
the 1970s it was said that enough Alpine
bunkers had been built to accommodate
most of the Helvetian population.

When, in 1967, Peter Watkins's film
for the BBC, *The War Game*, broadcast
something of the truth about what could
happen should a nuclear strike occur,
there was much public consternation. It
was clear that not much could be done to
protect the civilian population. By 1968
the RSG programme was being wound
down because it was too costly to support.

OPPOSITE
RIGHT:
*A nuclear
command and
control bunker
built under a
block of flats
at Gypsy Hill in
South London.
The location of
RSG bunkers
was a closely
guarded secret.*

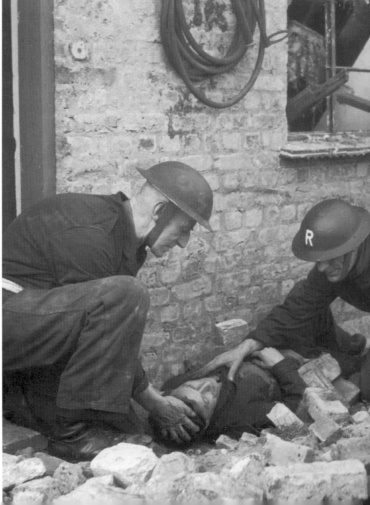

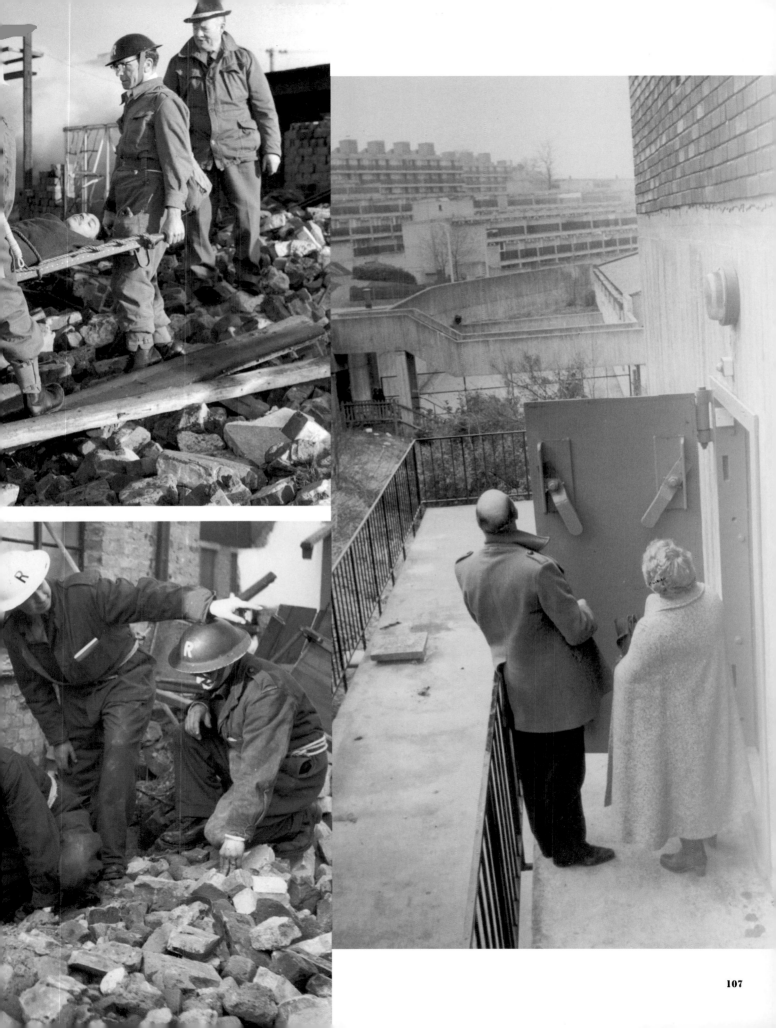

1961–1962

1961 John F. Kennedy (1917–1963) becomes youngest ever US President (Democrat, to 1963); promises a "New Frontier" for America.

1961 Bay of Pigs: 1,500 CIA-sponsored Cuban exiles fail to invade Cuba, with covert US air support.

1961 Soviet Union launches first man, Yuri Gagarin, into space.

1961 Berlin Wall built, a concrete and barbed wire frontier dividing the city into Eastern and Western zones.

1961 US President John F. Kennedy visits Europe, supports West Berlin, and meets Soviet Premier Nikita Khrushchev in Vienna.

1961 Civil Rights movement formally initiated in the US southern states.

1961 Yemen civil war splits country into socialist Yemen Arab Republic and (British) Yemen Protectorate.

1961 South Africa leaves British Commonwealth and declares itself an independent republic.

1961 Organization for Economic Cooperation and Development (OECD) established in Paris.

1961 Kwajalein (Marshall Islands) developed as US missile range.

1962 US military advisers posted to South Vietnam to support the government in face of communist North.

1962 John Frankenheimer's film of Richard Condon's novel *The Manchurian Candidate* released. It features post-Korean War mind control, and is later seen as foreshadowing John F. Kennedy's assassination the following year.

1962 Border clash between Indian and Chinese forces over disputed territories in Arunachal Pradesh and Aksai Chin.

1962 Launch of first James Bond film, *Dr. No.*

1962 US–Cuban missile crisis. Soviet plans to establish missile bases in Cuba bring world to first major nuclear crisis.

1962 General Ne Win leads military coup in Burma; introduces policy of "Buddhist Socialism". Industries nationalized, country withdraws into isolation.

1962 France grants Algeria independence following protracted guerrilla war (from 1954) in which terrorist attacks also occurred in France itself.

'Ready .. steady .. '

THE BAY OF PIGS

In an ill-judged attempt to dislodge Castro's communist regime in Cuba, the CIA backed an attempt invade the country in April 1961. With covert US air and sea support, 1,800 Cuban exiles landed on an inlet on the south coast of the island, and for three days resisted until they were overwhelmed. Most were captured, many executed, and a low-point in US–Cuban relations established, which has never been reversed. The new Kennedy administration washed its hands of the incident.

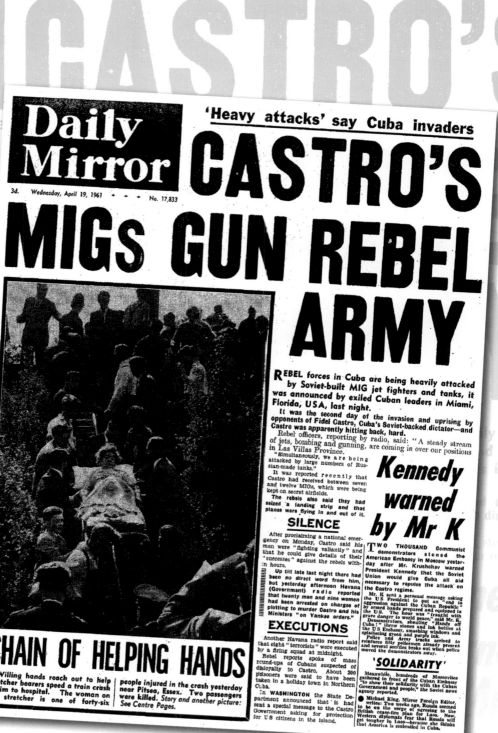

THE COLD WAR: SECTION FOUR

THE WIND OF CHANGE

In 1957, the British colony of Ghana in West Africa declared its independence. In 1960, in what UK Prime Minister Harold Macmillan famously dubbed "the wind of change", a further 15 European colonial holdings became independent, marking not just the final death throes of imperialism, but opening a new Cold War chapter in the struggle for potential territorial control.

RIGHT:
Macmillan and Khrushchev arriving at the Joint Institute of Nuclear Research at Dubna. There's nothing like intimidating your potential enemies.

СОЮЗПЕЧАТЬ

COURTING THE WEST

Soviet diplomacy in the early 1960s was cordial but firm. Soviet premier Khrushchev looked sufficiently benign when British Conservative Prime Minister Harold Macmillan visited Moscow, and indeed when he met the new, and much younger President of the United States in Vienna in 1962. Kennedy made much of his visit to Europe, delivering his famous "Ich bin ein Berliner" speech in the now isolated city. When Macmillan returned from his trip to Moscow, he recorded in his diary "There's no doubt the Russian standard of living will be far higher than ours in 10 years time." Kennedy left Vienna under no such illusions.

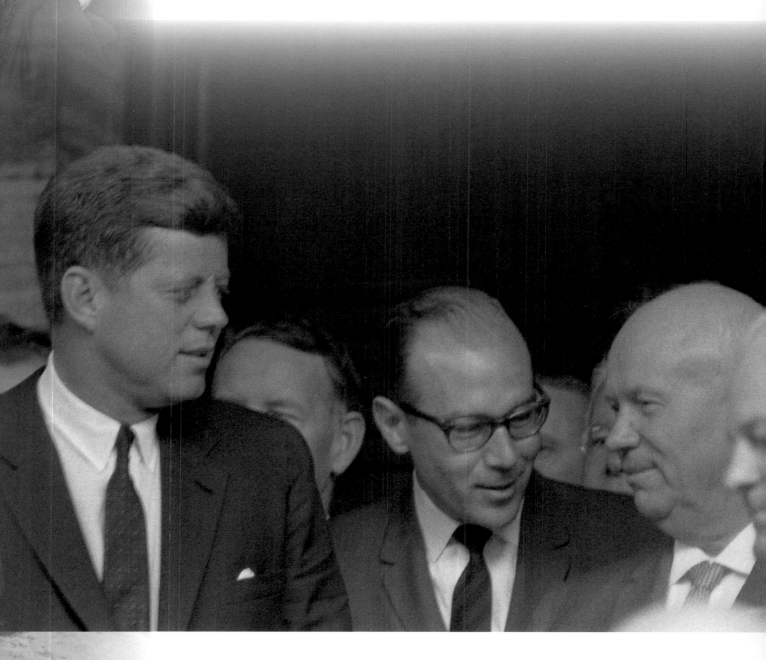

THE WALL GOES UP

A major fissure in the poker-face stand-off between the superpowers which had persisted for several years came about in Berlin. Over the previous decade hundreds of thousands of East Germans had escaped to the West. The East German nerve cracked. On 13th August 1961 they closed most of the occupation sector crossing points in the city, and threw up a crude breeze block and barbed wire barrier, heavily armed. From now on Berlin would be divided, and anyone attempting to cross the new "No Man's Land" – later known as the "death strip" – would be shot, blown up by mines or electrocuted on the perimeter fence. The wall sealed the Iron Curtain.

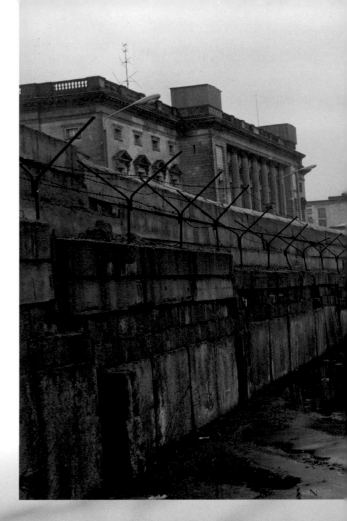

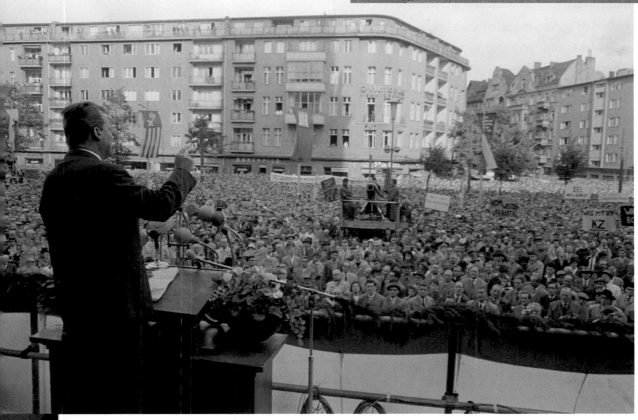

RIGHT:
Upon Blake's (far left) return to London following three years' captivity in North Korea, he was welcomed as a hero, and resumed his activities for MI6.

RIGHT:
Upon Blake's (far left) return to London following three years' captivity in North Korea, he was welcomed as a hero, and resumed his activities for MI6.

BELOW RIGHT:
Blake's mug-shot. Despite his sentence, Blake remained unrepentant.

THE CURIOUS CASE OF GEORGE BLAKE

The most notorious double agent of the period was Dutch-born George Behar (b. 1922), later known as George Blake. After his father's death in 1936 he lived in Cairo, where his communist sympathies were fostered by a cousin. At the outbreak of World War II Blake was back in Holland, acting as a runner for the Dutch Resistance, but escaped to England in 1940 where he worked for SOE, translating intercepted German signals and documents. After the war he was involved in interrogating former Nazi officers, and was recruited to MI6 in 1948.

In 1950, he was posted to Seoul to establish an intelligence network in Korea. He was captured by the North Koreans, and during his internment he was "turned", although he later claimed that witnessing Korean villagers being bombed by American planes had already converted him to the communist cause. He was released in 1953 and, in an extraordinary lapse of security, was posted to Berlin as a case officer, charged with recruiting Soviet double agents. Over his nine-year posting in Berlin Blake is thought to have supplied details of around 400 MI6 agents to his Eastern masters, effectively destroying MI6's operations in Central and Eastern Europe, and informed GRU of the existence of the CIA mole P. S. Popov, who was executed as a result.

Blake was arrested in 1961 after he was exposed by a Polish defector, Michael Goleniewski. He was sentenced to 42 years in prison – the longest sentence ever handed down

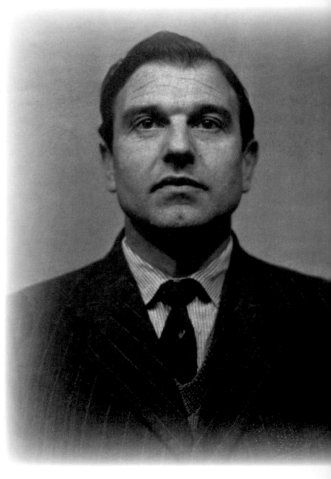

"TO BETRAY, YOU FIRST HAVE TO BELONG. I NEVER BELONGED."

in a British court for espionage.

In 1966, Blake escaped from Wormwood Scrubs with the help of three former inmates: two anti-nuclear campaigners, Michael Randle and Pat Pottle, and Sean Bourke. He travelled to the Soviet Union, where he continued to be involved in counter-intelligence.

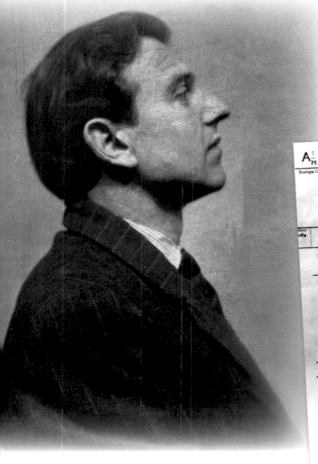

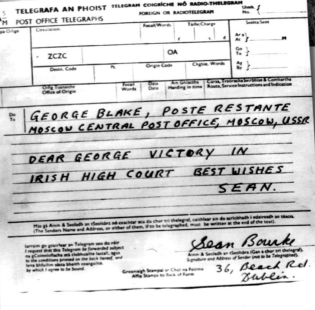

ABOVE:
Blake and his accomplices took advantage of building work on the perimeter wall of Wormwood Scrubs to effect his escape.

LEFT:
Sean Bourke sent Blake a congratulatory telegram upon his arrival in Moscow.

RIGHT:
The Krogers' house in Ruislip: suburban spy HQ.

BELOW LEFT:
Numerous household articles containing secret chambers for microfilm were discovered among Lonsdale and the Krogers' possessions.

BELOW RIGHT:
The Krogers celebrating their release, en route to Moscow, 1969.

THE PORTLAND RING

One of the most highly publicized spy scandals of the era emerged from London's leafy suburbia. In 1960, the CIA were informed by a mole that information was being passed to the Soviets from the Underwater Weapons Establishment at Portland, Dorset. MI5 were informed, and their investigation revealed a network of agents including a civil servant, Harry Houghton, a deep cover Russian spy, Konon Molody, who had assumed the identity of a Canadian, Gordon Lonsdale, and two Americans, Morris and Lona Cohen, posing as booksellers under the names Peter and Helen Kroger. Houghton and his mistress Ethel Gee, a filing clerk at Portland, passed documents, films and photographs to Lonsdale, who in turn delivered it to the Krogers. Lonsdale appeared to be a businessman dealing in bubble gum machines, jukeboxes and gambling machines; he travelled widely in Europe and was something of a playboy. He probably passed some of the material he received directly to Soviet contacts. When the Krogers' house in Ruislip was raided,

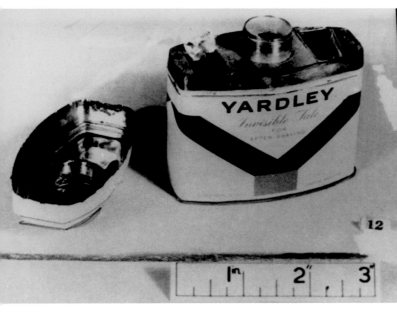

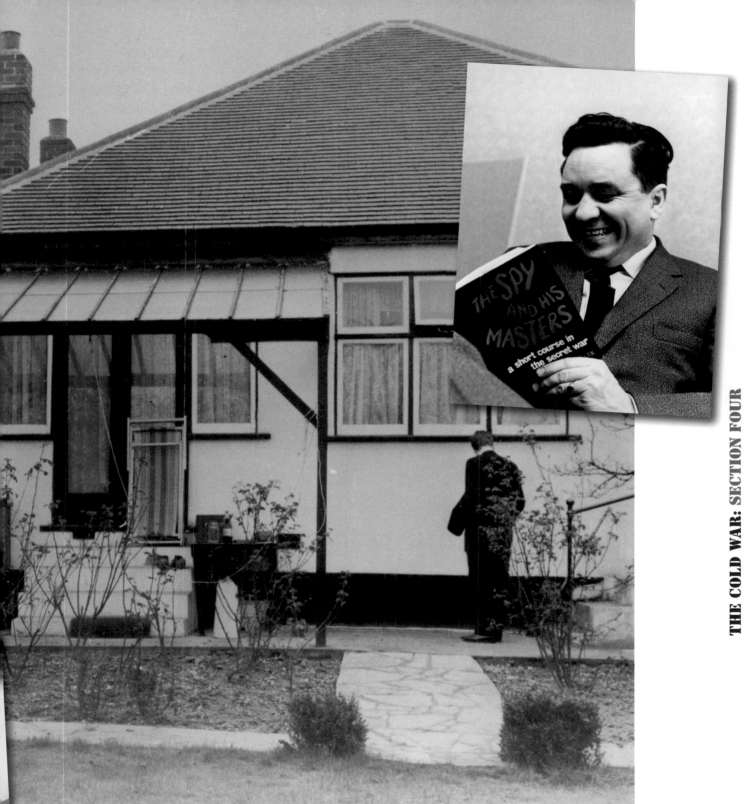

microdots and a long-wave radio transceiver were discovered along with large quantities of cash. The group were arrested in 1961, and tried *in camera*. Houghton and Gee received 15 years imprisonment but served only 10; the Krogers were sentenced to 20 years, but were exchanged in 1969 for the British businessman Gerald Brooke. The mastermind Lonsdale got 25 years, but was exchanged in 1964 for the British spy Greville Wynn.

ABOVE:
An amused Lonsdale in East Berlin after his exchange. He never revealed any details when interrogated or at his trial.

THE CUBAN MISSILE CRISIS

The Cold War's most dangerous episode occurred in October 1962. Following the Cuban revolution in 1959, Cuba's new leader Fidel Castro had aligned the nation with the Soviet bloc. The USA imposed a trade embargo, and the USSR opened a preferential trade agreement. It received sugar and tobacco in return for limited supplies of consumer products, industrial plant – and arms.

As the tension of the West's *cordon sanitaire* around the Eurasian communist bloc tightened, the Soviet premier Khrushchev realized that there was an opportunity to offset the USSR's strategic disadvantage by developing military bases on the island. By 1962, five missile and air bases had been established. They had also been

observed by US remote-sensed pictures. It was clear that Soviet ballistic missiles could, at short notice, strike New York, Washington, Chicago and Dallas. The Americans imposed a naval quarantine around Cuba. After meeting Kennedy in Vienna the previous year, and following the Bay of Pigs debacle, Khrushchev was certain that Kennedy would back down. He was wrong, and faced with an ICBM strike ultimatum by Kennedy (a missile reach which the USSR had still yet to achieve), after a tense few days, the USSR withdrew their missiles. The crisis had taken the world to the verge of nuclear conflict, but had also proved America's determination not to be intimidated by Soviet threats. The punitive US trade embargo against Cuba would persist for another half century.

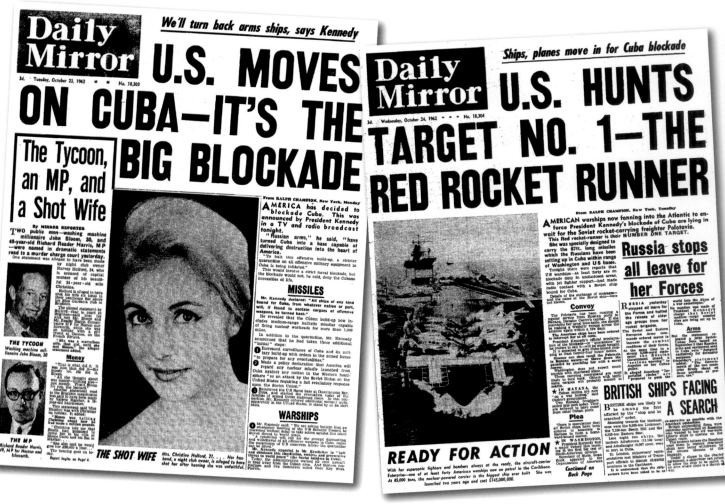

Daily Mirror

3d.　Monday, October 29, 1962　No. 18,308

Now.. hopes of world disarmament talks

CUBA PEACE MOVES—THE TWO Ks AGREE

3 sailor boys in rescue

THREE schoolboy sailors yesterday made a desperate bid to save three men and a woman struggling in a heavy sea.

They dragged one man into their dinghy exhausted. Another man swam to safety but the third man and the woman were drowned.

The boys, Robert Cowan, 14, his brother David, 13, and their pal Keith Sandeman, 15, all of Havant, Hants, were sailing their 14-foot dinghy in Chichester Harbour, Sussex.

Capsized

They saw the four people struggling in the water near a capsized rowing boat.

The man the boys saved

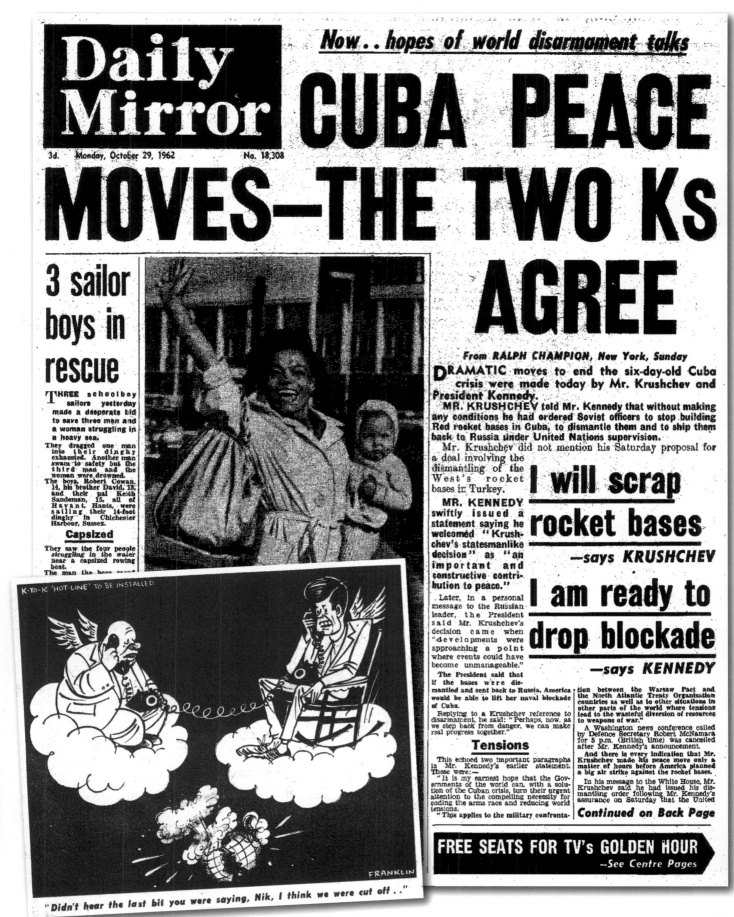

"Didn't hear the last bit you were saying, Nik, I think we were cut off . ."

K-TO-K 'HOT-LINE' TO BE INSTALLED

FRANKLIN

From RALPH CHAMPION, New York, Sunday

DRAMATIC moves to end the six-day-old Cuba crisis were made today by Mr. Krushchev and President Kennedy.

MR. KRUSHCHEV told Mr. Kennedy that without making any conditions he had ordered Soviet officers to stop building Red rocket bases in Cuba, to dismantle them and to ship them back to Russia under United Nations supervision.

Mr. Krushchev did not mention his Saturday proposal for a deal involving the dismantling of the West's rocket bases in Turkey.

MR. KENNEDY swiftly issued a statement saying he welcomed "Krushchev's statesmanlike decision" as "an important and constructive contribution to peace."

Later, in a personal message to the Russian leader, the President said Mr. Krushchev's decision came when "developments were approaching a point where events could have become unmanageable."

The President said that if the bases were dismantled and sent back to Russia, America would be able to lift her naval blockade of Cuba.

Replying to a Krushchev reference to disarmament, he said: "Perhaps, now, as we step back from danger, we can make real progress together."

Tensions

This echoed two important paragraphs in Mr. Kennedy's earlier statement. These were:—

"It is my earnest hope that the Governments of the world can, with a solution of the Cuban crisis, turn their urgent attention to the compelling necessity for ending the arms race and reducing world tensions.

"This applies to the military confrontation between the Warsaw Pact and the North Atlantic Treaty Organisation countries as well as to other situations in other parts of the world where tensions lead to the wasteful diversion of resources to weapons of war."

A Washington news conference called by Defence Secretary Robert McNamara for 5 p.m. (British time) was cancelled after Mr. Kennedy's announcement.

And there is every indication that Mr. Krushchev made his peace move only a matter of hours before America planned a big air strike against the rocket bases.

In his message to the White House, Mr. Krushchev said he had issued his dismantling order following Mr. Kennedy's assurance on Saturday that the United

Continued on Back Page

I will scrap rocket bases
—says KRUSHCHEV

I am ready to drop blockade
—says KENNEDY

A World Gone MAD
1963-1968

The fall-out from the Cuban missile crisis proved one thing for certain: the world was full of uncertainties. But one certainty that hooked the public's imagination was the concept of Mutually Assured Destruction (or MAD), a sinister reality revealed by Stanley Kubrick's 1964 film *Dr. Strangelove*. The concept was simple: if either of the superpowers launched a nuclear strike against the other, modern technology was such that there would still be time to launch a retaliatory attack resulting in the annihilation of both participants, and probably the entire world.

That said, after the removal of Khrushchev from office in 1964, there was a moderation of Soviet foreign policy, although the same year saw China gain nuclear potential, and it was perceived that the focus of militant communism had shifted east, in turn drawing the West, and especially America, into a desperate attempt to combat Chinese influence in Southeast Asia.

These awesome realities provoked a social backlash – at least in the West. A new generation, born around the end of World War II, and later to be known as the "Baby Boomers", burst indignantly on the Cold War scene. Having grown up under the threat of the mushroom cloud, they were keen to escape its shadow. They announced a counter-culture, one centered around peaceful non-cooperation and general non-conformism.

Whatever their ideals, the spreading US military commitment in Southeast Asia and increasing concerns about other "wars by proxy", especially in the Middle East, gave the counter-culture realistic targets for protest.

LEFT:
A photograph on the set of Stanley Kubrick's chillingly satirical film Dr. Strangelove, *when disagreements among the US President's war cabinet degenerate into a custard pie slinging battle minutes before doomsday.*

1963-1964

1963	Organization of African Unity (OAU) set up.
1963	Ex-MI5 and MI6 operative John Le Carré (David Cornwell) publishes *The Spy Who Came In From The Cold*; beginning of a 40-year series of novels which appeared to reflect the inner reality of espionage and counter-intelligence.
1963	Stanley Kubrick's doomsday satire film *Dr Strangelove: Or How I Stopped Worrying and Learned to Love the Bomb* released. Alerts public to reality of Mutually Assured Destruction (MAD).
1963	USA and USSR agree to halt atmospheric testing of nuclear weapons.
1963	Assassination of US President Kennedy sparks numerous conspiracy theories ranging from Eastern Bloc involvement to US-organized crime revenge. Kennedy succeeded by vice-president Lyndon B. Johnson (1908–1973, Democrat, to 1969).
1964	US Congress approves US military support for South Vietnamese puppet government. Gulf of Tonkin agreement allows US air strikes over North Vietnam.
1964	Nominal independence declared in Romania.
1964	Khrushchev removed from power following the failure of his economic liberalization policy; succeeded by Leonid Brezhnev.
1964	57 East Germans escape to West Berlin through tunnel.
1964	Publication of *The Thoughts of Chairman Mao*; a copy given to every member of Chinese Communist Party.
1964	India-Pakistan war over control of Kashmir.

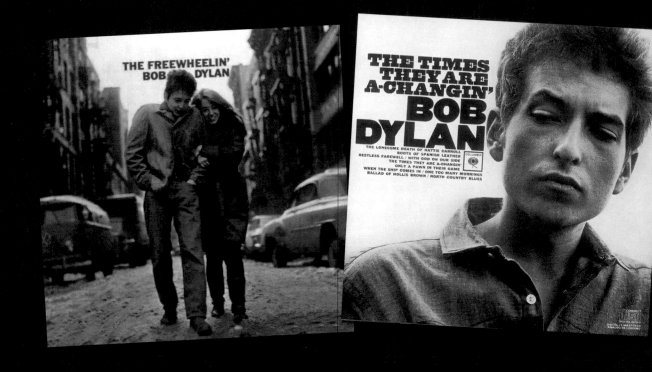

PROTEST IN MUSIC

The folk music revival of the late 1950s and early 1960s found a *raison d'être* not only in supporting the Civil Rights movement, but also in protesting against nuclear weapons. A great protest era song was 'Hiroshima, Nagasaki Russian Roulette' by Jim Page, later covered by Christy Moore.

The album *Songs Against the Bomb* was released in 1960 on behalf of Britain's CND movement. It included songs by Ewan McColl and Pete Seeger such as 'Brother Won't You Join the Line?' and 'The Crooked Cross'. John Brunner's 'The H-Bomb Thunder' became the unofficial anthem of the CND movement.

The biggest star of the "protest" movement, however, was Bob Dylan. The sleeve notes for the album *Bob Dylan* (1962) reflected the work of a young man obsessed with traditional American folk songs, many looking back at socially motivated artists such as Woody Guthrie and Blind Lemon Jefferson. But in his follow-up albums, *The Freewheelin' Bob Dylan* (1963) and *The Times They Are A-Changin'* (1963) Dylan revealed a concern for Cold War issues most obviously in songs such as 'Blowin' in the Wind', 'Masters of War', 'A Hard Rain's A-Gonna Fall', 'Talking World War III Blues' and 'Only a Pawn in their Game'.

PHILBY DISAPPEARS

The "Third Man" of the Cambridge Five was identified shortly after he defected in 1963. Kim Philby had been an MI5 officer since 1941 and had been in a crucial position as liaison officer in the British embassy in Washington from 1949 to 1951. Under suspicion as a double agent after the defection of his Cambridge University contemporaries Maclean and Burgess, he was invited to resign. He went on to become a journalist, becoming the foreign correspondent for the left-leaning *Observer* newspaper, with postings in locations such as Beirut. In 1963, despite publicly protesting his innocence, he suddenly disappeared, becoming a Soviet citizen and a general in the KGB.

"ET TU, BRUTE!"
(Julius Caesar, assassination scene, Act 111)

FRANKLIN

BELOW LEFT:
Dylan with part-time girlfriend and fellow protest singer Joan Baez in London, 1965, after his repudiation of the folk/protest label. They had regularly performed anti-war songs such as 'With God On Our Side' together.

BELOW:
Philby (right) held a press conference at his mother's flat in London in July 1963 in an attempt to clear his name.

LEFT:
The Mirror joyfully celebrated another foul-up by Macmillan, whose Foreign Office in 1956 had given the Observer a security clearance to employ Philby.

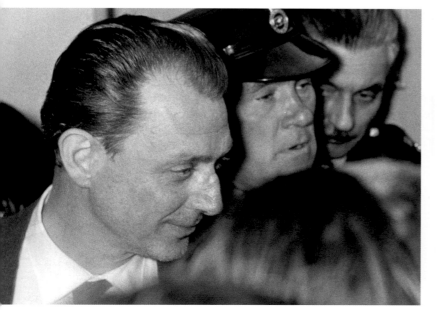

THE COLD WAR: SECTION FIVE

THE PROFUMO AFFAIR

Yevgeny Ivanov was an assistant Soviet attaché in London in the early 1960s. He was popular, good looking and a guest at parties thrown by Stephen Ward, a society osteopath. Ward was famous for inviting beautiful and available young women to gatherings, some held at glamorous locations such as Lord Astor's country retreat, Cliveden House. Among them was a 1960s good time girl Christine Keeler. It was alleged that she became Ivanov's mistress. Keeler had also briefly been the lover of the married British Secretary of State for War, John Profumo.

In 1963, Profumo's affair with Keeler hit the headlines. The tabloids made the most of it, and investigated Ward's parties. Soon other names were in the news – a friend of Keeler's, Mandy Rice-Davis, claimed to have had an affair with Lord Astor. The press sniffed out the potential Soviet spy–honey trap angle (although there was little solid evidence). Profumo was forced to resign after being questioned and lying in the House of Commons about his affair. His wife forgave him, but his Parliamentary days were over. Conservative Prime Minister Harold Macmillan resigned on the grounds of ill-health soon after the publication of the Parliamentary report on the scandal. Within weeks there was a Labour election victory. Ivanov was called back to Moscow, always denying any honey trap angle. Ward committed suicide whilst being tried for living on immoral earnings; the two girls meanwhile revelled in their notoriety.

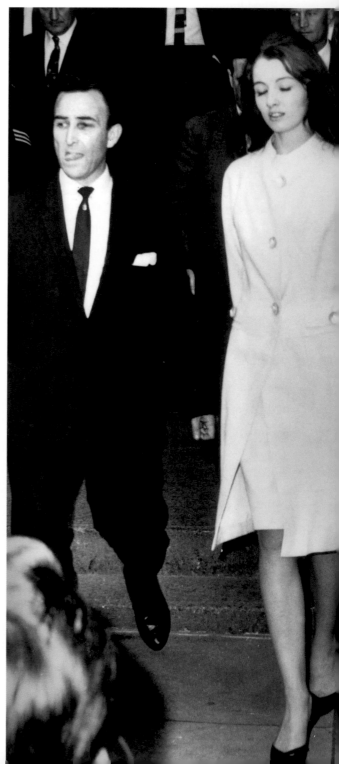

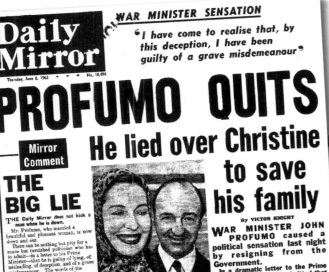

Daily Mirror

3d. Thursday, June 6, 1963 — No. 18,494

WAR MINISTER SENSATION

"I have come to realise that, by this deception, I have been guilty of a grave misdemeanour"

PROFUMO QUITS

He lied over Christine to save his family

By VICTOR KNIGHT

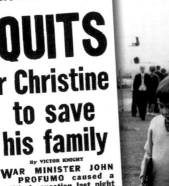

Christine Keeler

Mirror Comment

THE BIG LIE

THE Daily Mirror does not kick a man when he is down.

Mr. Profumo, who married a beautiful and pleasant woman, is now down and out.

There can be nothing but pity for a suave but tarnished politician who has to admit—in a letter to his Prime Minister—that he is guilty of lying, of misleading, of deception, and of a grave misdemeanour. The words of the confession were chosen by Profumo himself.

God knows he was never a good Minister: it seems now that he is not a very important man. But there is guilt in many a human heart, and skeletons in many a cupboard.

The question is:

What the hell is going on in this country?

Morals

All power corrupts—and the Tories have been in power for nearly twelve years. They are certainly enduring their full quota of fallen idols, whited sepulchres, and off-white morals.

In the Commons, when Mr. Profumo made his personal statement in March, he sounded whiter-than-white, and the Press sounded blacker-than-black.

Mr. Profumo said:

"I shall not hesitate to issue writs for libel and slander if scandalous allegations are made or repeated outside the House."

There was a song that day in the

Continued on Page Two

WAR MINISTER JOHN PROFUMO caused a political sensation last night by resigning from the Government.

In a dramatic letter to the Prime Minister Mr Profumo admitted that he lied to the Commons about his association with red-haired model Christine Keeler.

This admission finally clears away the cloud of rumour and suspicion which has hung over the political scene for more than three months.

The first public hint of a scandal building up around 48-year-old Mr. Profumo came during the Commons debate in the early hours of March 22.

There Labour M.P.s referred to rumours surrounding 21-year-old Miss Keeler, who was then a missing witness in an Old Bailey shooting case.

A few hours later Mr. Profumo made a personal statement to the Commons in which he denied that there

was anything improper in his association with Miss Keeler. And he threatened to take legal action against anyone spreading these rumours.

Prime Minister Harold Macmillan and other senior Ministers were in the Commons and there were cheers as Mr. Profumo finished his statement.

Also listening to him in the

Continued on Back Page

BEFORE THE STORM

Smiling happily, before the storm broke . . . Mr. John Profumo pictured with his beautiful wife, former actress Valerie Hobson. Now he is a Minister no longer. And his political career is in ruins.

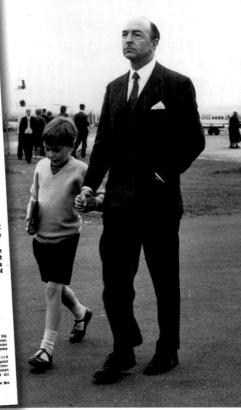

LEFT: *In the glare of the media spotlight, Profumo kept his cool. Whether any breach of security occurred remains uncertain – notorious "Spycatcher" Peter Wright, who interviewed Keeler on behalf of MI5, suspected she knew too much.*

BELOW: *Keeler and Mandy Rice-Davis arriving for the premiere of Scandal (1987), a film about their escapades.*

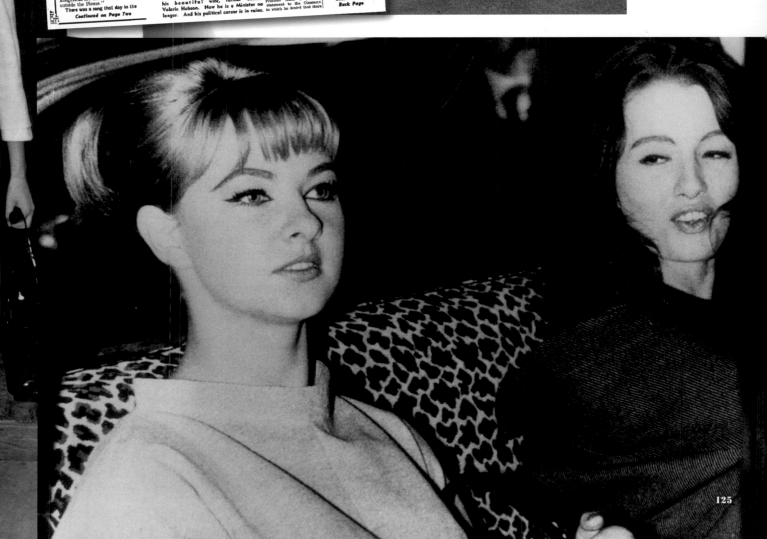

THE ASSASSINATION OF KENNEDY

The events in Dealey Plaza, Dallas on 22nd November 1963 proved to be another Cold War low point. Quite who set up the assassination of the popular young president of the USA still remains unclear almost half a century later. That the alleged gunman, Lee Harvey Oswald, had visited the USSR, attempted to defect in 1959, and had stayed there until 1962, pointed a finger towards some sort of covert Soviet plot, possibly involving brainwashing. The fact that

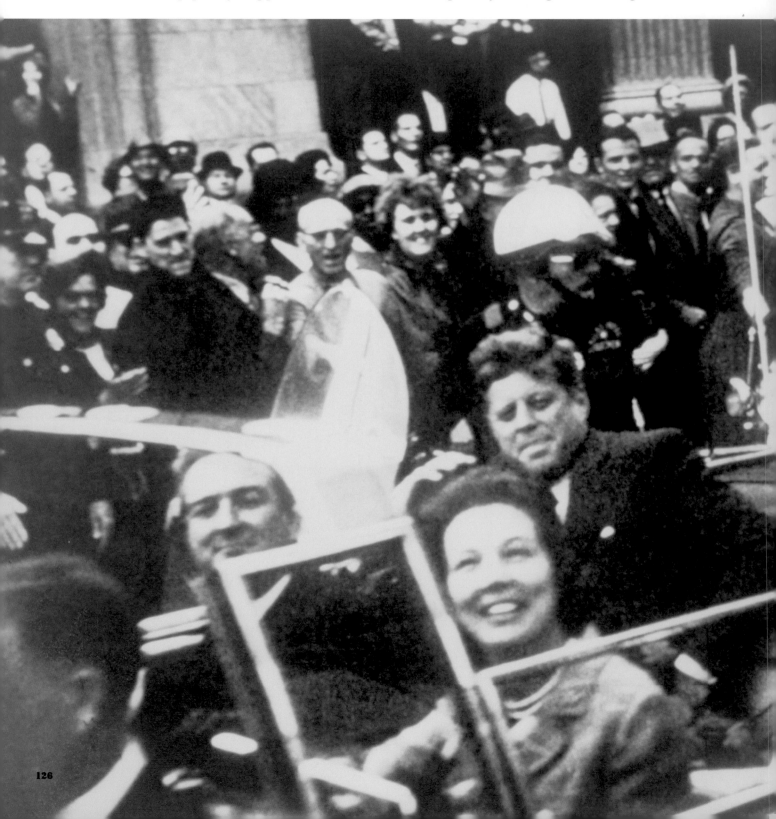

Oswald was gunned down by a minor local low-life mobster, Jack Ruby, two days after Kennedy's shooting suggested US organized crime involvement. Successive formal investigations have proved inconclusive.

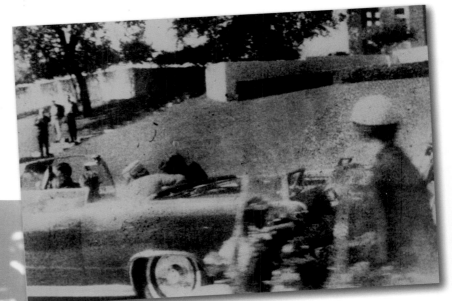

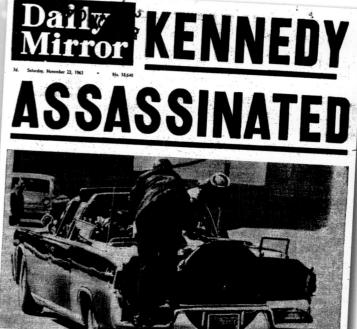

Daily Mirror

3d. Saturday, November 23, 1963 · No. 18,640

KENNEDY ASSASSINATED

Seconds after the shot . . . Mrs. Kennedy bends over her dying husband. Standing on the car bumper is a Secret Service man.

Jackie holds dying husband

THE world was horror-struck last night by the news that America's President John F. Kennedy was dead—shot down by a hidden assassin.

Mr. Kennedy, only forty-six and the leader of the West, was riding in an open car with his wife Jackie in Dallas, Texas.

A bullet ripped through his head. He fell forward, and his 34-year-old wife cradled his head in her arms.

As the car raced to a nearby hospital, Jackie kept crying: "Oh, no!" Her clothes were spattered with blood.

Mr. Kennedy lived only twenty-five minutes after he was hit. In hospital, surgeons opened his throat to relieve breathing and to give him blood.

But he died—at about 1 p.m. local time, 7 p.m. British time. And shocked millions throughout the world heard the announcement soon afterwards.

Texan Governor John Connally, 46, who

was in the Presidential car, was also hit by one of the assassin's three shots. After an operation his condition was satisfactory.

Waiting

Last night, police were questioning a Texan who had once defected to Russia. They had found a rifle with a telescopic sight. And they said that the assassin had been eating fried chicken at a sixth-floor window while waiting for the President.

Mr. Kennedy was the fourth United States President to be assassinated.

Automatically, Vice-President Lyndon B. Johnson, 55, takes over at the White House.

Last night, as he was sworn in as President in the plane taking Mr. Kennedy's body to Washington, world leaders spoke with deep emotion of the youngest man ever to be President of the United States.

Full dramatic story by RALPH CHAMPION, Chief of the Mirror's American Bureau—see Back Page.

Daily Mirror

Kennedy drama . . Oswald shot dead

3d. Monday, November 25, 1963 · No. 18,641

MOMENT OF VENGEANCE

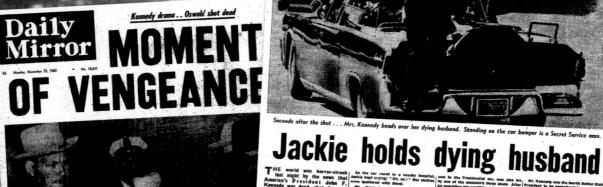

A KILLER STRIKES . . . the avenger with a gun pushes forward and squeezes the trigger. Lee Harvey Oswald, suspected of assassinating President Kennedy, slumps, shot in the stomach. A stetson-hatted Dallas detective glowers unbelievingly and helplessly at the killer, who was later named as Dallas night club owner Jack Ruby.—FULL STORY, BACK PAGE

DR. STRANGELOVE AND THE MANCHURIAN CANDIDATE

Two films defined the critical Cold War era.

John Frankenheimer's film of Richard Condon's 1959 thriller novel *The Manchurian Candidate* (1961) exemplified Cold War fears about mind control. A US infantry patrol is captured during the Korean War and its members brainwashed. Years later one of them, disturbed by nightmares, investigates and finds that his superior officer has become a "sleeper agent", destined to assassinate the US President when activated by seeing a Queen of Diamonds playing card. An unlikely scenario, but one which played to the McCarthyist fears of the early 1950s. The film acquired greater notoriety after the assassination of President Kennedy in 1963.

Stanley Kubrick's 1963 film *Dr. Strangelove or: How I Learned to Stop Worrying and Love the Bomb* seemed more to the point, despite its surrealist touches such as having actor Peter Sellers playing three of the lead roles. Co-scripted with satirist Terry Southern, Kubrick created a nightmare scenario in which a demented US commander authorizes a nuclear attack on Russia. It proves unstoppable because of "security" fail-safe measures, and the scene shifts to ones of hysterical panic as the leaders of the two superpowers desperately attempt to avoid nuclear holocaust.

If you come in five minutes after this picture begins, you won't know what it's all about!

when you've seen it all, you'll swear there's never been anything like it!

Frank Sinatra
Laurence Harvey
Janet Leigh

The Manchurian Candidate

co-starring
Angela Lansbury Henry Silva James Gregory
Produced by GEORGE AXELROD and JOHN FRANKENHEIMER Directed by JOHN FRANKENHEIMER
Screenplay by GEORGE AXELROD Based upon a Novel by RICHARD CONDON Executive Producer HOWARD W. KOCH
An M. C. PRODUCTION RELEASED THRU UNITED ARTISTS

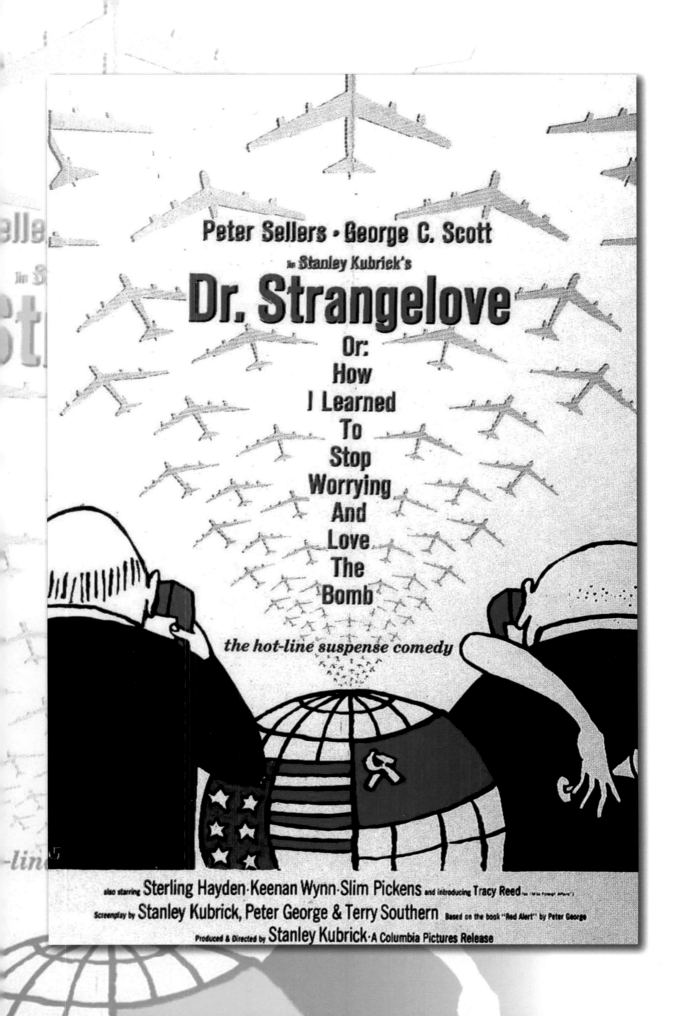

BELOW:
*The awesome
RAF Vulcan
bomber
remained on
Quick Reaction
Alert.*

THE ARMS BALANCE

By 1963 the arms balance had reached its first crescendo. Soviet investment in jet and space technology and its input to long-range weaponry, especially Intercontinental Ballistic Missiles (ICBMs), had given them an initial lead, while the West had concentrated on manned bombers, aircraft carriers and submarines, strategic weapon conveyors that had proved their worth in World War II. By the time of the Cuban missile crisis in 1962, the USA outstripped the USSR in nuclear power by a factor of 5:1.

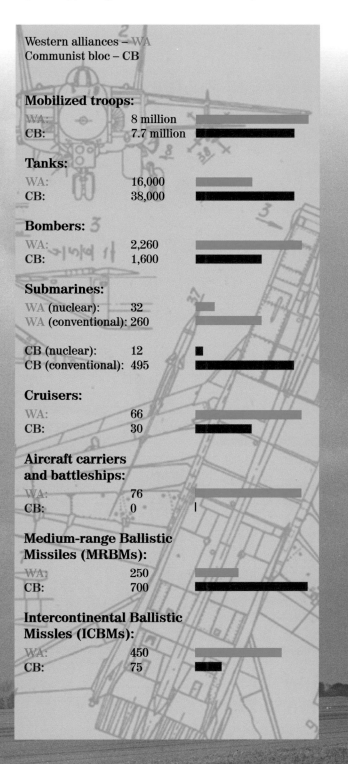

Western alliances – WA
Communist bloc – CB

Mobilized troops:
WA: 8 million
CB: 7.7 million

Tanks:
WA: 16,000
CB: 38,000

Bombers:
WA: 2,260
CB: 1,600

Submarines:
WA (nuclear): 32
WA (conventional): 260

CB (nuclear): 12
CB (conventional): 495

Cruisers:
WA: 66
CB: 30

**Aircraft carriers
and battleships:**
WA: 76
CB: 0

**Medium-range Ballistic
Missiles (MRBMs):**
WA: 250
CB: 700

**Intercontinental Ballistic
Missiles (ICBMs):**
WA: 450
CB: 75

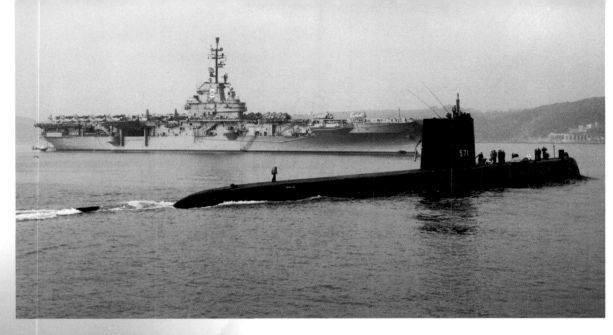

LEFT: *The first nuclear submarine, USS Nautilus, at Plymouth in 1957. Long-range submarines armed with nuclear warheads were to become the mainstay of Western Allied strategy by the early 1960s.*

MIDDLE LEFT: *By 1965, US Phantom jet fighters were becoming a regular feature of the skies over Europe.*

BELOW LEFT: *A Thor H-Bomb rocket at RAF Hemswell, Lincolnshire. These were being replaced by the end of 1963 by Polaris submarines carrying nuclear warheads.*

BELOW: *The spooky landscape of RAF Fylingdales on the Yorkshire Moors, one of a ring of US Ballistic Missile Early Warning System stations.*

1965-1966

1965 US troops committed to support South Vietnamese government; bombing of communist North Vietnam begins.

1965 Indonesian Communist PKI attempt coup, bloodily suppressed by army, over one million killed.

1965 English colonial presence in Africa ends with unilateral declaration of independence (UDI) by white government in Rhodesia.

1965 Former assassin Ferdinand Marcos takes control of the Philippines as bastion of US interests in Southeast Asia.

1966 Six-Day War: Israel conquers West Bank, Sinai peninsula and Golan Heights.

1966 France begins nuclear tests in Pacific Tuamotu islands.

1966 Mao Zedong launches "Cultural Revolution" in China (to 1970).

1966 Vertical take-off "jump jet" invented (UK).

THE CULTURAL REVOLUTION IN CHINA

Mao Zedong was over 75 when he introduced a reform in order to maintain the ideological purity of communist China. The Cultural Revolution mobilized thousands of students and a newly formed Red Guard to purge the People's Republic of any sign of dissidence or nonconformism.

The initiative cost the lives of millions. Mao's wife, Jiang Qin, and his nominated successor Lin Biao forced thousands of army personnel, teachers, doctors, university lecturers and scientists to recant and undertake peasant labour, or face execution. Heads washed down the Pearl River to the beaches of Canton and Hong Kong. By the time of Mao's death in 1976, the Revolution was still officially in force, and certainly inspired the bloodbath of Pol Pot's Khmer Rouge regime in Cambodia.

OPPOSITE LEFT: *Vietcong pilots being trained to use MiG fighters by Soviet air force personnel at an undisclosed location on the Russian steppes.*

LEFT: *The reality of the Cultural Revolution was very different from the vision promoted of Mao's happy, mobilized masses.*

MAY DAY PARADES

May Day, International Workers Day, was used by the Soviet Union to advertize its military capabilities in a show of arms in Moscow.

Alongside goose-stepping ranks of troops, gigantic missiles were wheeled through Red Square. With the coming of television the parades became a powerful propaganda tool.

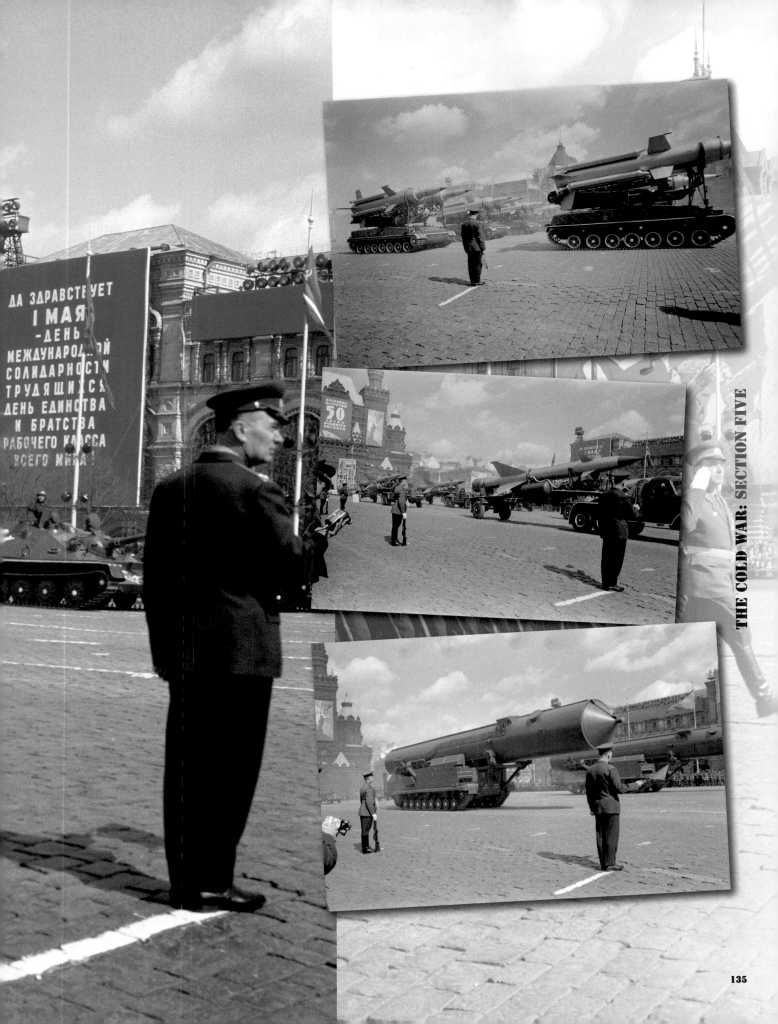

THE COLD WAR GOES HIP

Fashion and popular culture in the West had, by
the mid-1960s, managed to turn the dark hours
of the Cuban missile crisis into an iconographic
style. Courreges, Yves St Laurent and Mary
Quant created a futuristic look – dominated
by the mini-skirt – which seemed to define the
promise of a gleaming, democratic future. While
Ian Fleming's Bond books were for the most
part written in the 1950s, the films based on
them such as *From Russia With Love* (1963)
and *Goldfinger* (1964) were pure early 1960s
chic. Imitators such as Dean Martin's Matt Helm
and James Coburn's *Our Man Flint* flashed
only briefly across the screen. Len Deighton had
introduced his more down-at-heel spy Harry
Palmer in *The Ipcress File* (1965) and *Funeral
in Berlin* (1966), but his personification on
screen by dry Londoner Michael Caine added a
new, hip twist.

ABOVE: *James
Bond actor,
Sean Connery,
surrounded on
the set of You
Only Live Twice
(1967) by a new
phenomenon –
the Bond girls.*

RIGHT: *Many
Bond girls came
to a sticky end.
Shirley Eaton
was painted gold
by the villain in
Goldfinger.*

In America, TV shows like *I-Spy* and *The Man From* U.N.C.L.E. exploited the Cold War scenario to great effect, and even MAD magazine got in on the act, running a regular cartoon strip 'Spy Vs Spy'.

Patrick McGoohan's extraordinary TV series *The Prisoner* (1967–8) brought an Orwellian dimension to the idea of a secret agent kidnapped and imprisoned in the mysterious "Village"– but by whom? The show raised interesting issues concerning personal freedom and political allegiance: on which side was his chief adversary, the New Number Two?

The whole hip spy scenario was to be brilliantly shown in Mike Myers's affectionate satirical *Austen Powers* trilogy some 30 years later.

LEFT: *The perfect Cold War fantasy trio: ex-Nazi supervillain Auric Goldfinger (left), now in the pay of SMERSH, plans to irradiate America's gold reserve at Fort Knox, bringing the superpower to its knees. His murderous bodyguard Odd-Job (centre) is, naturally, Korean. Bond, who will thwart their plans despite his outfit, even makes playing a round of golf seem cool.*

LEFT: *Adam Diment's novel* The Bang Bang Birds *(1967) perfectly summed up the 1960s fascination with spying and fashion.*

BELOW: *Patrick McGoohan on the surreal set of The Prisoner.*

137

BELOW:
Much of the Vietnam war involved dropping combat troops by helicopter into rural areas suspected of harbouring the Vietcong. These "search and destroy" missions did little but harden Vietcong resistance and support for them among the villagers.

THE VIETNAM WAR

Vietnam had long been a focus of American concerns over the "Domino Effect" – the possibility that Southeastern Asian states would successively turn towards communism. Since the mid-1950s, the USA had invested heavily in supporting the South Vietnam government under Ngo Dinh Diem as part of its attempt to contain the spread of communism from the Vietcong north. By the early 1960s this had gradually inflated to full-blown military, air and naval support, initiated by the Kennedy administration. Ground troops were committed by Congress in 1964, which would lead to homeland conscription to support troop numbers. Under President Johnson, US bombing and covert military infiltration spread beyond Vietnam to Laos and Cambodia. Unlike the Korean War, this was a guerrilla war, a war without frontiers. Despite the commitment of over 540,000 ground troops and a carpet (and exfoliant) bombing campaign, the US made little progress. The resilience of the North Vietnamese, with Soviet backing, eventually forced the USA into an ignominious withdrawal in 1973 and a compromise between North

BELOW INSET: *US Defence Secretary Robert McNamara, who pursued an aggressive policy in Vietnam under both Presidents Kennedy and Johnson, a stance he later regretted.*

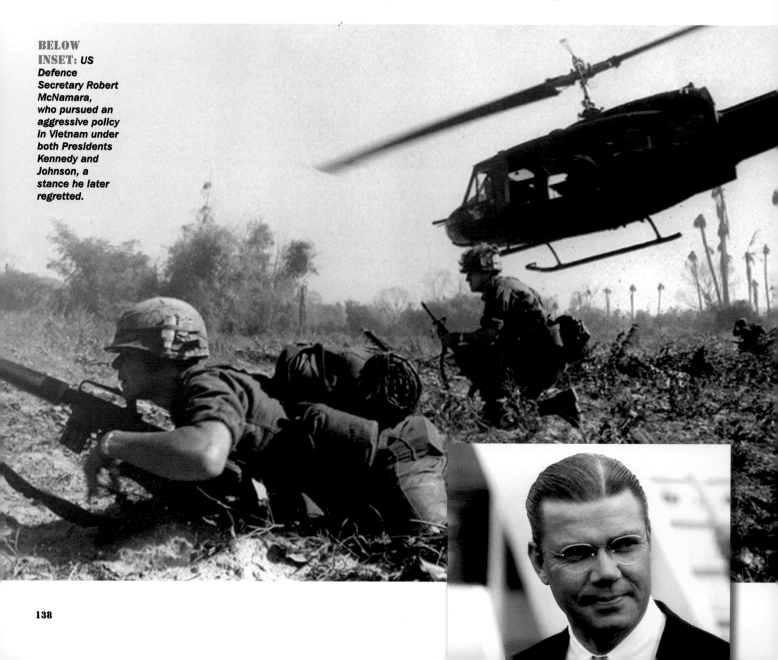

and South Vietnam. The South Vietnamese government in Saigon collapsed in 1975.

It has often been said that the Vietnam War was lost (by the Americans) due to press and TV coverage. The broadcast of the realities of such a war of attrition on a daily basis rapidly eroded public support for the war.

FRANKLIN

LBJ VIETNAM PEACE DRIVE

SHAKING THE OLIVE BRANCH

LEFT:
US President Johnson's decision to bomb not only North Vietnam but the country's neighbours drew international criticism.

+ S.O.S.

Dù là ai, Xin đừng bắn vào LÀNG CÔ-NHI
PLEASE, DON'T SHOOT
AT ORPHANS' VILLAGE

LEFT & ABOVE: *It was images such as these, of innocent women and children caught up in a war beyond their control and not of their choice that critically eroded support for America's continuing presence in Vietnam.*

1967-1968

1967	Secession of oil-rich state of Biafra provokes civil war in Nigeria.
1967	The "Summer of Love": widespread demonstrations in USA and Europe protesting against continuing US involvement in Vietnam War.
1967	Martial law imposed in Greece by right-wing military "Colonels" regime.
1967	Egypt defeated by Israel in Six-Day War.
1968	Nuclear Non-proliferation Treaty (NPT): Israel, Pakistan and India refuse to sign.
1968	Albania withdraws from Warsaw Pact.
1968	Widespread left-wing student demonstrations in Western Europe, mainly concerning US involvement in Vietnam.
1968	Assassination of Civil Rights leader Dr Martin Luther King Jr, possibly by US right-wing conspiracy.
1968	Tupamaros left-wing urban terrorist group established in Uruguay.
1968	The "Prague Spring" nonconformist communist reforms in Czechoslovakia leads to direct intervention by Soviet forces.
1968	Military junta takes control of Peru. Maoist Sendero Luminoso (Shining Path) develops anti-government guerrilla campaign, mobilizing rural native Quecha over next four decades.
1968	US troop commitment to Vietnam reaches over 500,000.

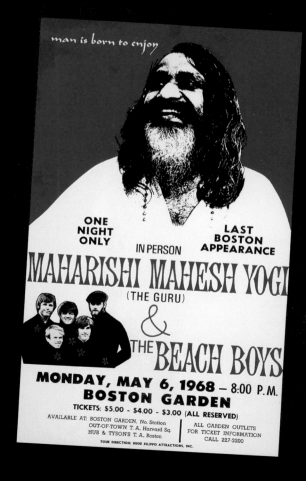

THE SIX-DAY WAR

Israel's continued existence proved a thorn in the side for its Arab neighbours. In 1967 a coordinated pan-Arab assault was launched against the state. The attack was comprehensively defeated by superior Israeli armour, artillery and air power in less than a week. Israel enjoyed covert US support and funding. It also managed to expand its territories, taking over Jerusalem, and invading the West Bank, the Syrian Golan Heights, the Gaza Strip, and the Sinai Peninsula. At this point the Palestinian Liberation Organization (PLO) began its 30-year terrorist campaign against Israel.

THE NUCLEAR NON-PROLIFERATION TREATY

The first step towards ending the cripplingly expensive build-up of nuclear weapons, which were never used, began. Talks were initiated between the superpowers in an attempt to ease this cycle of expenditure and threat. Inevitably, negotiations moved ponderously, neither side wanting to show their hand. In 1969, a new round of talks were initiated, but it would not be until 1970 that an agreement could be signed by the USA, the USSR and Britain. The other members of the then exclusive "nuclear club", France and China, refused to sign.

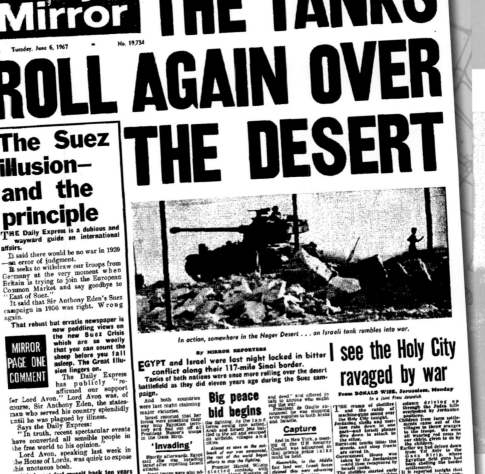

OPPOSITE LEFT: *Love and Peace invoked a variety of ideas, from surfing to embracing exotic religions and drug-induced psychedelia. These concepts, however, made little impression on the Cold War decision-makers.*

141

LOVE AND PEACE, MAN

In the West, especially in America, student unrest over Vietnam and the race riots that blighted many US cities, combined with the US West Coast "hippie" movement to produce the "Summer of Love". Avoiding the draft became a badge of honour; drugs were in the air, beards and hair were grown, "free love" was promoted – in fact any "straight" social norm that presented itself as an easy target was ridiculed by the counter-culture. While the stoned-out San Francisco band Grateful Dead made Bonnie Dobson's post-nuclear apocalypse song 'Morning Dew' a staple of their (often free, and free flowing) concerts, serious outbreaks of violent protest and rioting spread across the Atlantic to Europe.

Music was what brought the tribes of the counter-culture together. Venerated bluesmen found new material such as J. B. Lenoir's 'Vietnam Blues', and Lightnin' Hopkins's 'War Is Starting Again'. Younger artists also voiced their anger: Jefferson Airplane performed 'Uncle Sam's Blues' at the Woodstock festival in 1969 while Country Joe McDonald whipped the crowd into a singalong with his anthemic 'I'm Fixin' to Die Rag'.

Although the hippie movement was over by 1969, the shooting in 1970 of four students demonstrating at Kent State University, Ohio, by state troopers signalled the emergence of a new, more radicalized, youth movement.

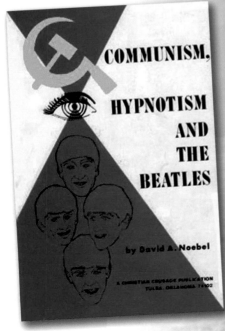

COMMUNISM,

HYPNOTISM AND THE BEATLES

by David A. Noebel

A CHRISTIAN CRUSADE PUBLICATION
TULSA, OKLAHOMA 74102

*The Argentinean
Marxist guerrilla
Che Guevara,
killed while
campaigning in
Bolivia, became
one of the icons
of the counter-
culture.*

LEFT: *Among
the more
high-profile
demonstrations
was the anti-
Vietnam rally
outside the
US Embassy
in Grosvenor
Square, London,
in March 1968.
Some 91
policemen were
injured and 200
demonstrators
arrested.
Elsewhere in
Europe, the
"Événements"
protests in
Paris and open
rioting in Berlin
produced an
atmosphere
in which the
assumptions
of an older
generation were
increasingly
rejected by
the young.*

THE PRAGUE SPRING

The freewheeling spirit of the summer of 1968 also produced a heady time in Czechoslovakia.

This artificial state, created in 1918 and restored in 1946, was the only one in Eastern Europe to form a natural corridor between the blocs, with a border in the east with Russia and in the west with Austria. In 1968, the Slovak first secretary of the Czech Communist Party,

ex-World War II Resistance fighter Alexander Dubček (1921–1992), introduced a liberalization campaign designed to open up better trade relations with the West (although he had tried to assure the Soviets that his reforms would not threaten socialism in his country). Crowds partied in the streets until, in August, Soviet tanks rumbled across the border and called closing time.

The violence was brief but telling. Dubček was briefly imprisoned, the reforms summarily were reversed.

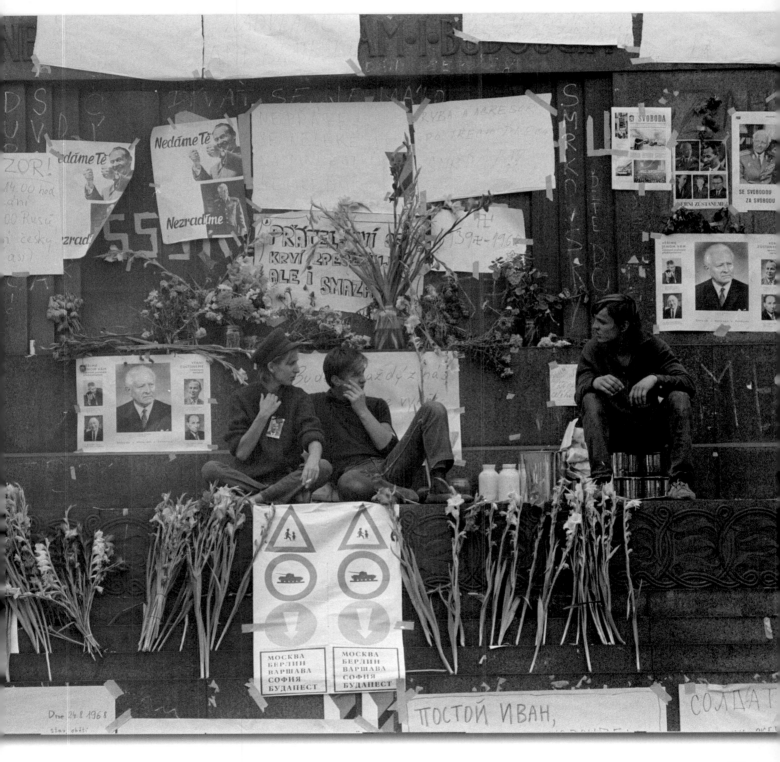

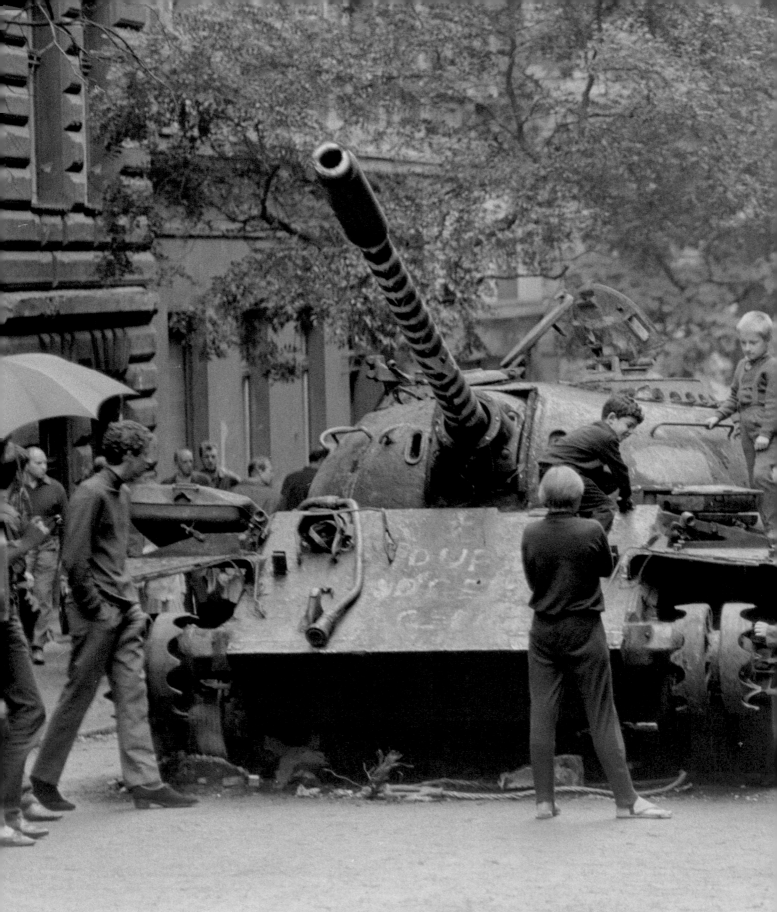

ABOVE: *Burnt out Soviet tanks on the streets of Prague. The heavy-handed crushing of the Prague experiment in socialist reform not only echoed events in Hungary in 1956 but reminded both hawks and peaceniks in the West that, as far as Brezhnev was concerned, any attempt at détente was a pipe-dream.*

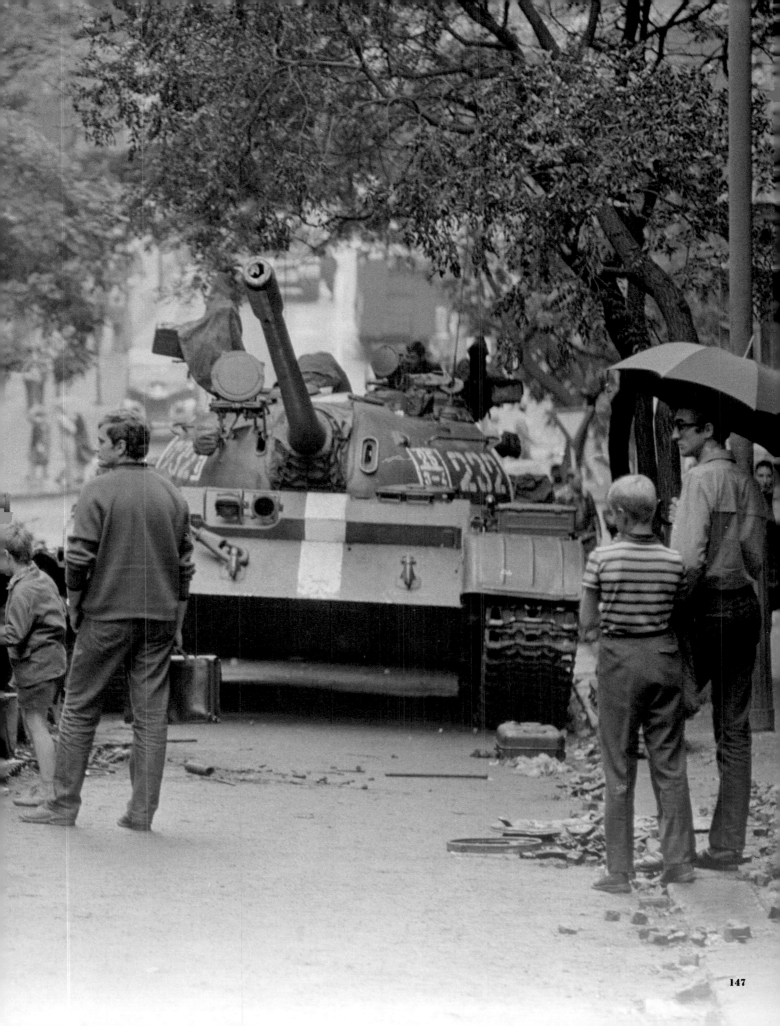

Stalemate
1969-1980

There is something about the sterility of the 1970s that leads one to look for an explanation. Was it that the excitement of the 1960s had quite literally burned out along with many of its doomed stars: JFK, Dr Martin Luther King, Robert Kennedy, Janis Joplin, Jimi Hendrix and Jim Morrison? The race to the Moon was over. Soon an American president, Richard Nixon, would be in danger of impeachment for criminal activities.

There would be no more heroes, as the punk band the Stranglers pointed out. It was as if the world was somehow held in suspension, drifting, as unaware of how to respond to a challenge as the BBC when the Sex Pistols started misbehaving on prime-time television. What to do?

The arms race reached its numerical peak by the 1970s, gross sums of money being spent on strategic weapons that would never be used, which eventually pushed the superpowers towards at least the idea of détente.

In the meantime, America was withdrawing, defeated, from Vietnam, but ongoing problems such as the face-off between Israel and its Arab neighbours dragged on. A fog of chaos descended, exemplified by terrorism on every front: the Irish Republican Army (IRA) sustained a vicious campaign of bombing in Ulster and on the British mainland; the Palestinian Liberation Organization (PLO) hijacked passenger planes; there was a massacre at the Munich Olympics; an outbreak of new anarchist groups such as the Symbionese Liberation Army in America, Germany's Baader Meinhoff (Red Army Faction) and Italy's Red Brigades seemed to be able to articulate their concerns only through violence.

It all seemed pointless, in a doomed world.

LEFT:
In many ways the Punk movement summed up the desperation of the 1970s. Under the still very real threats of the Cold War, paranoia had given way to nihilism, at least among the young.

149

1969-1972

1969	Richard M. Nixon (1913–1994) wins US presidential election (Republican, to 1974).
1969	'Nixon Doctrine' promulgated, committing to reduction of US involvement in Southeast Asia.
1969	Apollo II landing: first manned moon landing achieved by NASA.
1970	Allende elected as Marxist president of Chile.
1970	East Germany realigns border with Poland.
1971	Bangladesh secedes from Pakistan following civil war to become an independent state.
1972	SALT 1: Strategic Arms Limitation Treaty talks begin.
1972	Richard Nixon wins second term as US President.

SITTING IN A TIN CAN

The Moon landings in 1969 ignited a new, more introspective view of space culture. Film-maker Stanley Kubrick had once again anticipated this with his film *2001: A Space Odyssey* (1968), which, with its striking use of Richard Strauss's 'Thus Spoke Zarathustra', launched classical music to the top of the charts. It would not be a solo flight. On the American West Coast, the Byrds recorded their own 'Space Odyssey', and 'Mr. Spaceman', while the Grateful Dead included 'Cosmic Charlie' and endless variations of their improvisational 'Dark Star' in their numerous live shows. In England, following the Bonzo Dog Doo-Dah Band's hit 'I'm the Urban Spaceman', David Bowie would release *Space Oddity* (1960) and *The Man Who Sold the World* in 1970–1; his space obsession continued with 'Starman' and 'Life on Mars' and *The Rise and Fall of Ziggy Stardust and the Spiders From Mars* (1972). Bowie eventually got to play an alien in Nic Roeg's film *The Man Who Fell to Earth* (1976).

NIXON IN CHINA

The USA's failure to destroy Vietnamese resistance without recourse to nuclear weapons led the new Republican US President, Richard Nixon, to announce in 1969 a wind-down of US troops in Southeast Asia, with a view to a negotiated withdrawal. This was partly due to the sheer cost of fighting a clearly unwinnable war, an item on the US budget that was dwarfed by the expenditure on maintaining strategic bases and alliances, not to mention the continuing strategic arms build-up. With the help of Secretary of State Henry Kissinger, in 1971 Nixon embarked on a number of overtures

to his Cold War opponents, visiting Mao Zedong in China and the Soviet premier Brezhnev in Moscow. The relaxation of tension was reflected in the Four-Power Agreement concerning Berlin in the same year.

LEFT:
Dr Henry Kissinger, Nixon's Secretary of State, was a pragmatist who helped steer the way towards détente and the road out of Vietnam.

RIGHT:
The launch of Apollo 11: destination Moon.

BELOW:
German scientist Werner von Braun, credited with inventing the V-2 rocket bomb for the Nazis, was the man primarily responsible for the eventual American victory in the space race.

ONE SMALL STEP

The televised landing on the Moon of a manned NASA spacecraft was both an effective US propaganda coup and a demonstration of America's acquisition of technical superiority in the race to dominate space. The image of the Stars and Stripes planted on the surface of Earth's lunar satellite said it all, as did a presidential phone call to the first man to stand on the moon, Neil Armstrong.

The effort in terms of investment was one that, by the 1970s, the US could not afford to repeat. The space race effectively exited from the Cold War stage, replaced by a sharing of information and multinational collaborative efforts to send unmanned space probes out into the further reaches of the solar system. The Russians achieved the next step forward, by establishing a manned orbital space station, and NASA cordially responded by developing a space shuttle to deliver supplies and their own cosmonauts. But no more manned landings have taken place since 1969.

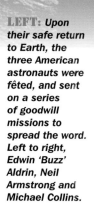

LEFT: *Upon their safe return to Earth, the three American astronauts were fêted, and sent on a series of goodwill missions to spread the word. Left to right, Edwin 'Buzz' Aldrin, Neil Armstrong and Michael Collins.*

BELOW &
OPPOSITE
TOP RIGHT:
*The press were
invited along to
observe, and
then publicize,
many war game
activities,
such as this
jamboree in
Norway in 1969.*

WAR GAMES

Among the more provocative Cold War activities of the 1960s and the 1970s were overt demonstrations of land, sea and air power, sometimes quite openly and freely publicized. These were known as 'war games'. Although they served a genuine training purpose, especially for land forces in combined operations, locations were often chosen that would be easily spotted and monitored by the 'opposition'. The noted Scottish historian of Russia in World War II, John Erickson, was once invited to command the Red Army in a tank exercise in Eastern Europe.

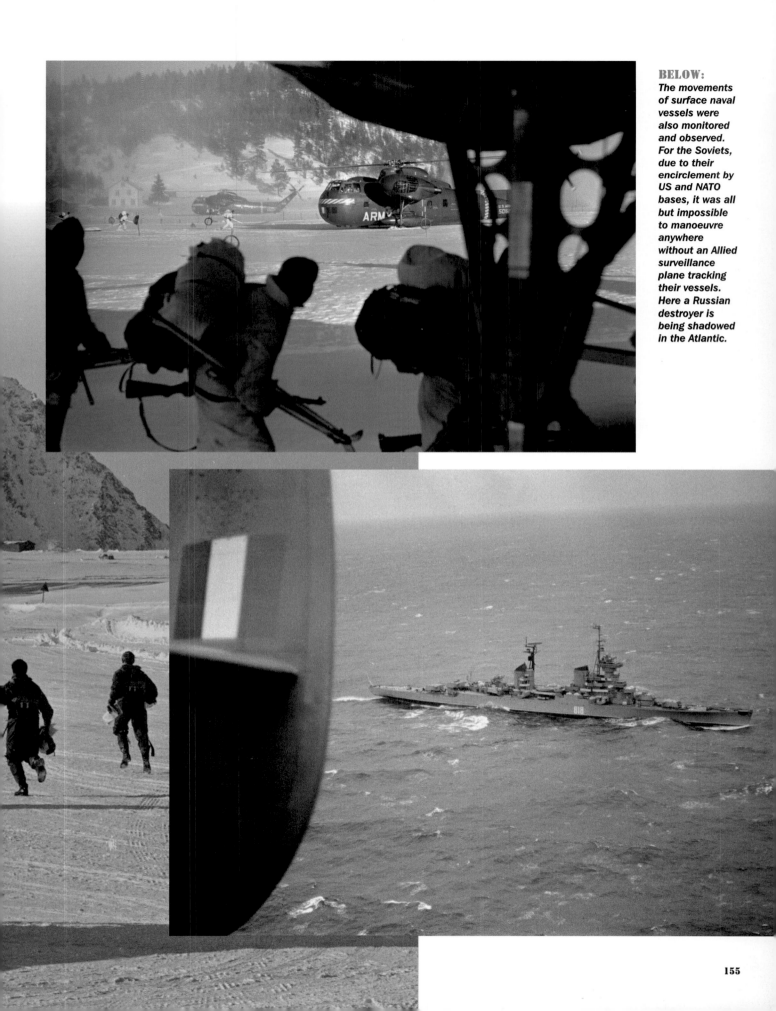

The movements of surface naval vessels were also monitored and observed. For the Soviets, due to their encirclement by US and NATO bases, it was all but impossible to manoeuvre anywhere without an Allied surveillance plane tracking their vessels. Here a Russian destroyer is being shadowed in the Atlantic.

1973-1976

1973 Chile: USA backs coup to topple elected Marxist government of Salvator Allende. Allende killed.

1973 Yom Kippur War; Arabs fail to defeat Israel, and subsequent hike in oil prices from Middle East causes economic crisis in the West.

1973 US ground troops withdrawn from Vietnam. Tentative peace agreement.

1974 Resignation of US President Richard Nixon following Watergate scandal. Vice-President Gerald Ford (1913-2006) takes control (Republican, to 1977).

1974 Ethiopia falls to Marxist revolutionary forces; Emperor Haile Selassie executed.

1974-75 Portugal grants independence to its African colonies of Guinea-Bissau, Angola and Mozambique following more than a decade of nationalist resistance.

1975 US-sponsored South Vietnamese government falls to communist forces. Remaining US personnel evacuated.

1975 The extreme communist Khmer Rouge, led by Pol Pot, take over Cambodia, renamed the Khmer Republic. 'Year Zero' policy introduced: systematic elimination or relocation to peasant labour of urban bourgeoisie.

1975 Indonesia annexes East Timor.

1975 Death of Franco; democracy restored in Spain.

1976 Death of Mao Zedong, Chairman of Chinese Communist Party; brief coup by the 'Gang of Four', led by his widow, Jiang Qing.

1976 Outbreak of Angolan civil war upon independence from Portugal (to 1988).

1976 US President Gerald Ford announces "There is no Soviet domination of Eastern Europe" in televised presidential debate.

1976 Soviet support for North Vietnamese sees establishment of the Socialist Republic of Vietnam.

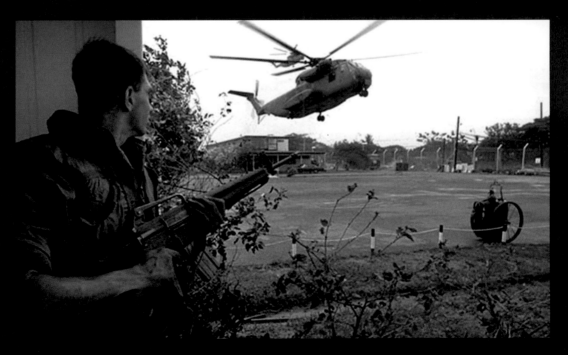

AMERICA EXITS VIETNAM

The fall of Saigon to North Vietnamese forces in April 1975 saw the final evacuation, mainly by helicopter, of the remaining US personnel in the city, leaving many Vietnamese fearing retribution. Saigon was renamed Ho Chi Minh city, and the Socialist Republic of Vietnam declared in July 1976. But peace still eluded the nation. Vietnam would go on to invade its neighbour Cambodia in 1978, ejecting the Khmer Rouge regime of Pol Pot and establishing a puppet government. Reports of mistreatment of ethnic Chinese in Vietnam provoked China into a punitive invasion of the north in 1979, which, along with internal socialist reforms, led to three-quarters of a million refugees – 'boat people' – fleeing the country.

OIL CRISIS

In October 1973, on Yom Kippur, the Jewish day of atonement, an unannounced attack on Israel was launched by Egyptian and Syrian forces. The Fourth Arab-Israeli War allowed Egypt to regain control of part of the

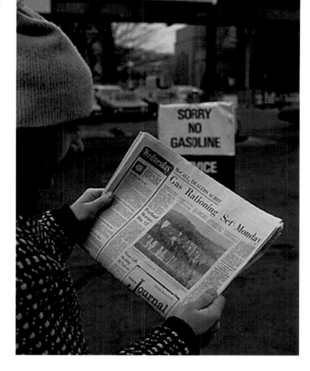

Suez Canal, but saw Israel consolidate its control of the Golan Heights. President Sadat of Egypt's appeals for both American and Soviet intervention provoked a diplomatic crisis, with both superpowers briefly on standby to retaliate should either intervene.

Arab frustration at the West's continuing support for Israel led to a restriction in the flow of oil from the Middle East. This precipitated a general fuel crisis that plunged the West, especially Europe, into an economic depression. It was an early example of the economic warfare strategies that began to develop as the Cold War declined.

OPPOSITE LEFT: *The final evacuation of US personnel from South Vietnam brought an end to one of the Cold War's longest 'hot wars'.*

LEFT: *As a result of the oil restrictions, fuel prices rose and fuel rationing was introduced.*

BELOW LEFT: *Refugees from Vietnam continued to spill out of the country until the early 1980s.*

THE COLD WAR: SECTION SIX

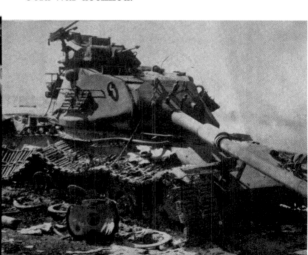

LEFT: *An Israeli M60 Patton tank destroyed during the three-week war.*

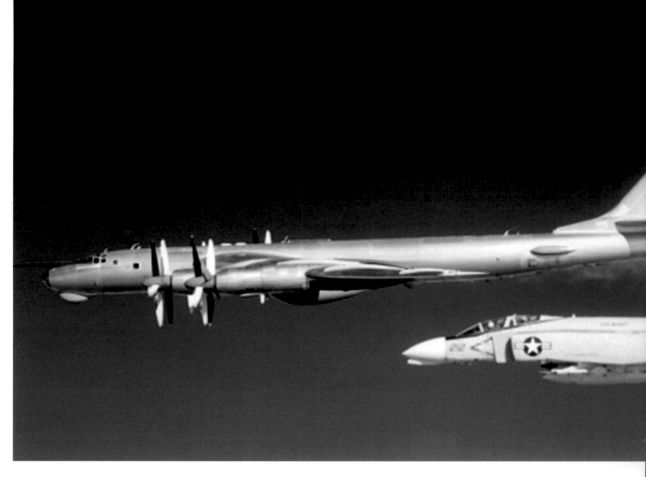

RIGHT: *A US Phantom fighter-bomber shadowing a Soviet Tupelov long-range bomber. These were the two warhorses of the Cold War years. The Tupelov, a double turboprop design known as 'The Bear', was developed in the early 1950s and came into service in 1956. It is still in use and will not be replaced until 2040. The McDonnell Douglas Phantom F4 entered service in 1960. A two-seater supersonic aircraft, capable of carrier launch, it proved enormously versatile as a bomber, a reconnaissance tool and a ground attack weapon in Vietnam. It was phased out by the US Air Force in the mid-1980s, but had already become one of their major arms export earners.*

COLD WAR WEAPONS

By the late 1960s a number of standard weapons were being used by the superpowers, on both a strategic scale and tactically. Most were refinements of enduring designs and imaginative concepts developed in the 1950s.

ABOVE: *The concept of a small, easily launched and target programmable tactical missile, capable of carrying a nuclear warhead – in essence a sophisticated flying bomb – was already developing in the early 1960s. The Cruise missile took many forms, but could travel supersonically at low altitudes, evading radar, and remains in use today.*

LEFT: One of the Soviet Union's most successful exports was the MiG 15 jet fighter, supplied to its allies throughout the Cold War, seeing service over the skies of Korea, Vietnam and the Middle East. It was introduced in 1947, but upgrades of the design, notably the MiG 21 and MiG 29, continue to be produced.

BELOW & BELOW LEFT: It was once said that the most characteristic image of the late 20th century was a peasant carrying a Kalashnikov. Here British Conservative Prime Minister John Major is wielding such a weapon, but the AK-47 assault rifle remains the most widely used small arm in history. The design went into production in 1944, and the AK-47 began to be mass produced in 1947. Since then, over 100 million have been manufactured.

RIGHT &
BELOW
RIGHT: *The
remains of
victims of Pol
Pot's reign of
terror now clutter
memorials in
Cambodia.*

YEAR ZERO IN CAMBODIA

One of the most extraordinary and brutal
episodes of the late Cold War period began in
1975 when, with Chinese backing, a veteran
peasant revolutionary named Pol Pot seized
power in Cambodia. The country had emerged
from the collapse of French Indo-China in
1954 with little political direction, other than
a vaguely Leftist royal family. The Vietcong
used Cambodian territory while pursuing
their campaigns against South Vietnam in the
mid-1960s, and US President Johnson had
authorized illicit bombing raids on Cambodian
territory to ward them off. At the end of the
Vietnam War, with no more American troops
on Cambodia's doorstep, Pol Pot grabbed his
chance for power, determined to create a self-
sufficient communist state.

Linking the historical name for the country
with communist colours, Pot's Khmer Rouge
imposed a devastating regime of radical reform,
in part modelled on China's recent 'Cultural
Revolution'. The remnants of the (often French-
educated) bourgeoisie were immediately
eliminated, and indeed anyone who simply
wore spectacles was soon targeted. Cambodia's
cities were emptied, the urban 'elite' forced to
work the paddy fields in a programme of re-
education. Torture and interrogation centres
were established, and Year Zero declared. In
all, some 2 million Cambodians (about 20 per
cent of the population) were simply wiped out in
what became known as the 'killing fields'.

The Khmer Rouge's outrages eventually
proved too much for their communist
neighbours, and in 1979 Vietnam invaded the
country, forcing Pol Pot and his Khmer Rouge to
flee to the hill country of neighbouring Thailand.
Such was the confusion of the time that British

military consultants became involved in
training Khmer Rouge guerrillas to prepare
for a counter-offensive. The demented Pol Pot

died in a remote jungle camp in 1998 (probably poisoned), following the tentative restoration of the royal Khmer Sihanouk dynasty.

1977-1980

1977	James (Jimmy) Carter (1924-) elected US President (Democrat, to 1981).
1977	Colonel Gaddafi imposes 'Islamic socialism' in Libya.
1977	Civil war in Ethiopia (to 1989).
1978	US-sponsored Camp David Accord: Egypt recognizes Israeli sovereignty, but is consequently expelled from the Arab League.
1978	Communist coup in Afghanistan.
1978	Chinese Cultural Revolution formally ended. Beginnings of economic liberalization in China under Deng Xiaoping.
1978	Vietnamese forces invade Cambodia, ousting Khmer Rouge regime.
1979	China invades North Vietnam.
1979	Islamic Revolution in Iran topples US-backed Shah, who goes into exile; anti-Western theocratic state established under Ayatollah Khomeini.
1979	Soviet forces invade Afghanistan.
1979	Conservative Margaret Thatcher elected as British Prime Minister (to 1990). Conservatives remain in power until 1997.
1979	Beginning of Nicaraguan civil war between the elected Marxist Sandinista government and US-backed Contra forces.
1979	Right-wing military junta gains power in El Salvador during continuing civil war.
1979	SALT II: Strategic Arms Limitation Treaty signed by USA and USSR.
1979	US begins deployment of submarine-launched Trident missile system.
1980	Death of Marshal Tito of Yugoslavia; beginning of disintegration of Yugoslav polity.
1980	Foundation of Solidarity, independent trade union in Poland.
1980	Iran–Iraq war provoked by Western-backed Iraqi Ba'ath government under Saddam Hussein (to 1988).
1980	Black majority rule established in Rhodesia (renamed Zimbabwe).

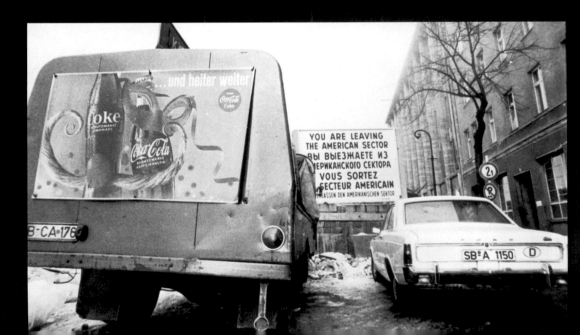

EUROPEAN SECURITY CONFERENCES

After Nixon's opening of channels of communication with the Eastern Bloc, and his fall from grace in the Watergate scandal in 1974, his successor as US President, Gerald Ford, followed up on the possibility of negotiations to reduce nuclear arms. The Strategic Arms Limitation Treaty (SALT) talks had begun in 1972, and interim agreements were made, but the fact was that neither superpower could lose face, and the stockpiles simply grew until 1979 when the treaty was finally signed. Ironically, by then the agreement appeared redundant as right-wing governments in both America and the UK were about to increase the pressure.

THE FOURTH MAN AND THE CAMBRIDGE FIVE

The news that Sir Anthony Blunt, eminent art historian and Surveyor of the Queen's Pictures, was the 'Fourth Man' of the Cambridge 'Magnificent Five' was a shocking revelation to most, except MI5 who had already interviewed him in the early 1960s. They agreed, in return for his cooperation, to keep his culpability anonymous. The publication of *The Climate of Treason* in 1979 unmasked the scholar, and pointed a finger towards the elusive 'Fifth Man', another Cambridge scholar, John Cairncross. Once again, it seemed the British Establishment had closed ranks, as Cairncross had admitted to MI5 in 1951 that he had passed information to the Soviets during his time at the code-breaking centre Bletchley Park in World War II, but nothing had been done about it. His treachery became clear only after the Soviet defector Oleg Gordievsky named and shamed him. Cairncross, like Blunt, was never prosecuted and died in retirement in southern France, aged 85. Blunt was stripped of his knighthood and privileges and died in 1983.

HOT WARS IN AFRICA

Pre-independence campaigns against colonial control, such as that of the Mau-Mau in Kenya, were often vicious, but less so than in many of the post-independence civil wars that broke out in several countries. Many of these concerned control of natural resource assets, but often acquired an ideological dimension. The USSR took advantage of any opportunities to gain a toehold on the African continent, most significantly in backing Egypt in its wars against Israel and funding Colonel Gaddafi's Islamic socialist regime in Libya.

By 1974, Portugal was the only European country to maintain substantial colonial possessions in Africa. A socialist revolution in Portugal in 1974, and the ensuing granting of independence to Angola and Mozambique in 1975, opened the gates to a host of new Cold War areas of activity.

In the 1970s, Soviet airlift and naval capacity allowed it to aid anti-Western movements almost anywhere in the world, but its involvement with Marxist contenders in Ethiopia (1977–89) and in Angola (1975–88) was effected by proxy.

Cuban troops and materiel were deployed in Angola to support the MPLA (Popular Movement for the Liberation of Angola or Party of Labour) in a bitter three-way civil war with FNLA (Democratic Front for the Liberation of Angola) forces in the north and UNITA (National Union for the Total Independence of Angola, the second largest political party in Angola) in the south. Eventually, South African troops were drawn into the conflict, along with Western mercenaries, to support UNITA, and, despite the deployment of 50,000 Cuban

troops, an uneasy truce was achieved in 1988. Like many African conflicts of the era, there was little press coverage.

By the 21st century, a continent as resource-rich as Africa had attracted the Chinese, who began to provide targeted investment, consultancy and technology on an unprecedented scale. The African battleground was being reinvented.

MIDDLE: *By the 1970s the real mainstay of the West's nuclear deterrent lay less in air power than in submarine-launched missiles such as the Polaris.*

RIGHT: *The cost of each Titan missile launch, whether as a security test launch as here, or for peaceful purposes, was in excess of $3 million in the 1970s.*

THE ARMS BALANCE

By the 1980s the USSR had gained the upper hand in the nuclear 'balance of terror', outstripping the USA. To what extent this mattered remains immaterial, since it was yet another demonstration of the redundancy of Cold War strategic logic which would need to be tackled by some very different politicians in the following 10 years.

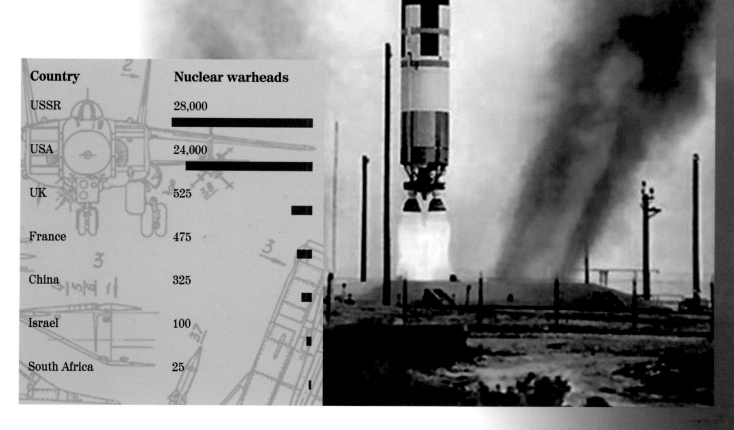

Country	Nuclear warheads
USSR	28,000
USA	24,000
UK	525
France	475
China	325
Israel	100
South Africa	25

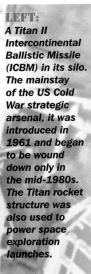

LEFT:
A Titan II Intercontinental Ballistic Missile (ICBM) in its silo. The mainstay of the US Cold War strategic arsenal, it was introduced in 1961 and began to be wound down only in the mid-1980s. The Titan rocket structure was also used to power space exploration launches.

Endgame
1981-1990

Two apparently contradictory factors dominated the last decade of the Cold War. In the West, impatient with the indecision of the 1970s, right-wing administrations emerged who were prepared to call the Soviet bluff. On the other side of the Iron Curtain a new generation of leaders, too, were beginning to realize that the situation could not continue – and why should it? The stand-off was achieving nothing and, with increasingly uncontrollable communications networks, the proletariat masses were beginning to realize that life looked a whole lot better when you looked west.

But at heart it was war-weariness and near bankruptcy that brought the new leaders of both factions to various Scandinavian negotiating tables. If the 1980s appeared to offer even less than the 1970s in Western cultural terms, at least they offered a chance for the East to rediscover a degree of self-determination.

The end, when it came, was quite sudden.

LEFT:
CND marches gathered apace in the 1980s as public frustration at what seemed to be an escalating lack of commitment to a peaceful end to the Cold War became clear.

1981-1985

1981 Former actor and governor of California Ronald Reagan (1911–2004) becomes US President (Republican, to 1989). Immediately adopts aggressive anti-communist foreign policy.

1981 François Mitterand elected first socialist President of France.

1981 Widespread demonstrations against more nuclear missile installations in Europe.

1981 Martial law imposed in Poland due to activities of Solidarity trade union.

1981 First re-usable space shuttle flight (USA).

1982 Falklands War: UK Task Force reconquers islands after Argentinean invasion; covert support from USA; subsequent fall of General Galtieri's military dictatorship (1983) encourages restoration of democracy in Brazil and Uruguay (1985) and Chile (1988).

1982 Death of Soviet leader Leonid Brezhnev; succeeded by KGB boss, Yuri Andropov.

1983 START: Strategic Arms Reduction Treaty talks between USA and USSR begin; not finally signed until 1991.

1983 USA invade Caribbean island nation Grenada after "revolutionary" forces seize government.

1983 Korean Airlines passenger flight 007 shot down by Soviet Union.

1984 Death of Soviet premier Andropov; succeeded briefly by Chernenko (dies 1985). Last of Soviet "old guard".

1985 US air strikes against Libya in retaliation for terrorist bombings.

1985 Mikhail Gorbachev becomes leader of USSR.

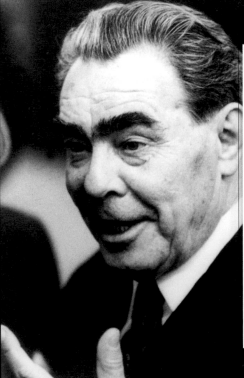

'Isn't it time you went home, Mum?'

AFTER BREZHNEV

The death of Soviet premier Leonid Ilyich Brezhnev (1906–1982), a party hardliner, and a first generation Cold Warrior, inaugurated the beginning of a change in Soviet direction. He was immediately succeeded by Yuri Andropov (1914–1984), former head of the KGB who lasted little more than a year, and then by Konstantin Chernenko (1911–1985), another Soviet Cold War combatant. Aging dyed-in the-wool Soviets were becoming thin on the ground.

The final phase of Politburo control was marked, however, by a cooling of relations with the West. There was increased repression of Soviet dissidents. The Soviet invasion of Afghanistan in 1979 felt like a revival of the Great Game, although in a sense it was a response to the beginning of a new threat to world security that would come to greater prominence after the Cold War – the rise of radical Islam.

After Chernenko's death, the only Soviet leader to have been born after the Bolshevik Revolution, Mikhail Gorbachev (b. 1931) was elected General Secretary of the Politburo. He immediately began to make significant reforms and embarked on a series of diplomatic missions that would lead within five years to the end of the Cold War and ultimately the end of the Soviet Union.

FLIGHT KAL 007

On 1st September 1983, the curiously named Korean Air Lines passenger flight KAL 007 from New York to Seoul via Anchorage, Alaska, accidentally wandered into Soviet airspace. It was shot down by Soviet interceptors, killing all 269 passengers and crew. The Soviets initially denied all knowledge of the incident, then claimed the plane was on a spying flight, a deliberate attempt by America to provoke a war. The incident rapidly turned into one of the most dangerous moments of the Cold War since the Cuban missile crisis two decades beforehand, and was never fully resolved. President Reagan ordered that the military-controlled Global Positioning System (GPS) be made available for civilian use in order to avoid such navigational errors in the future.

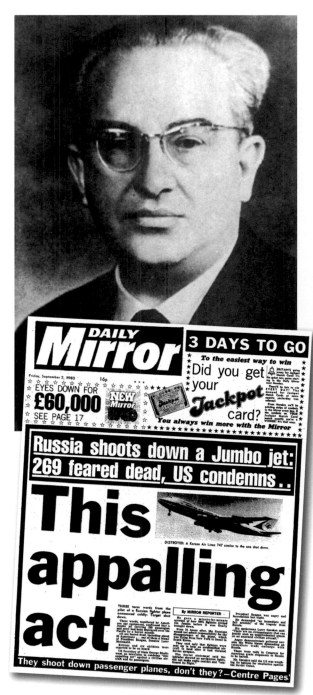

BELOW:
Rough living conditions failed to deter the inhabitants of the camp.

NO MORE WAR

The introduction of a new generation of weapons systems, most notably the Trident submarine missiles and the stationing of Cruise missiles on British soil, reminded many that, in playing host to American weapons and personnel, the nation was becoming a prime target for an intermediate missile strike.

A wave of anti-war protests of a new kind began in 1981 when a Welsh pressure group, "Women for Life on Earth", protested at RAF Greenham Common, Berkshire, against the UK government's decision to allow US Cruise missiles to be stationed there. They set up a permanent "peace camp", the protestors living rough outside the gates. In 1983, the airbase became the focus of another demonstration, when some 70,000 protestors formed a 14-mile human chain linking Greenham Common with Aldermaston and the ordnance factory at Burghfield. Although there were regular attempts to evict the inhabitants of the peace camp, all failed.

The airbase was closed in 1993 following the Intermediate-Range Nuclear Forces (INF),Treaty, but the peace camp lingered on until the next century.

BELOW:
Rough living conditions failed to deter the inhabitants of the camp.

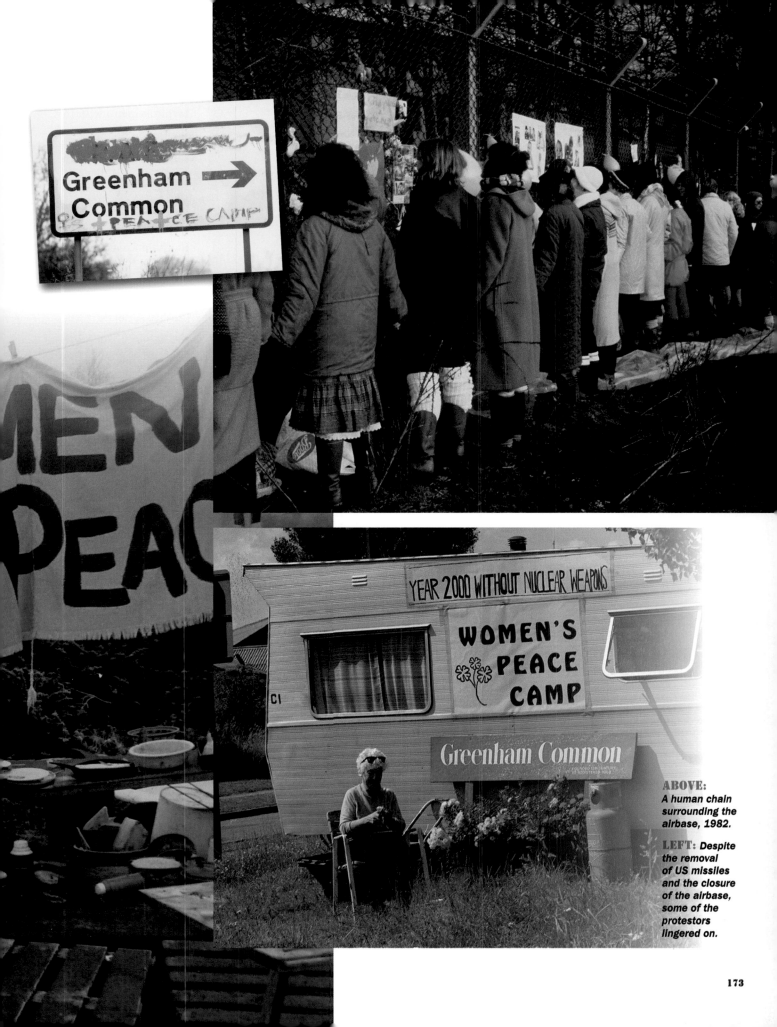

Greenham
Common

WOMEN
PEAC

YEAR 2000 WITHOUT NUCLEAR WEAPONS

WOMEN'S
PEACE
CAMP

Greenham Common

ABOVE:
A human chain surrounding the airbase, 1982.

LEFT: *Despite the removal of US missiles and the closure of the airbase, some of the protestors lingered on.*

RIGHT:
New Cold War hawks Margaret Thatcher and Ronald Reagan paying attention and due respect while the British national anthem was played in June 1980. Reagan was visiting Europe to announce that he would be happy to withdraw US Cruise and Pershing missiles from Europe if the Soviets decommissioned their 370 SS-20 missiles aimed at the continent – an early wild card in what would become a crucial stand-off between West and East.

played a game of brinkmanship with the Soviet Union, designed to bring the Cold War to an end, which it eventually did. Their strategy focused on the twin approaches of a willingness to talk, backed up by unassailable force and the threat of secret new technologies. For the general public this felt like a dangerous policy, one that harked back to the Cold War crises of the early 1960s.

THE TRANSATLANTIC "SPECIAL RELATIONSHIP"

Margaret Thatcher (b. 1925) became leader of the British Conservative Party in 1975, and prime minister in 1979. She authorized a task force to recover the Falkland Islands from an opportunist Argentinean invasion in 1982, which proved her mettle and earned her the sobriquet "The Iron Lady". She did much to rebuild the "special relationship" with the USA that had existed since World War II, finding in the new Republican US President Ronald Reagan an ideological soulmate. Between them the two leaders

RIGHT:
The leader of Britain's Monster Raving Loony Party and political agitator, ex-pop star Screaming Lord Sutch using dog chews in the form of Thatcher and Reagan during an electioneering campaign in 1989. By then Reagan had left office and Thatcher was about to do so.

BELOW:
*President
Reagan
announced
the Strategic
Defense
Initiative
on national
television in
March 1983.*

STAR WARS

One of the most hawkish events of the late Cold War was the Strategic Defense Initiative (SDI). Grandly announced by US President Ronald Reagan in 1983, this was in fact a revival of various ideas that the US military had explored in the 1960s, based on using orbital satellites to intercept and destroy ICBMs. Reagan's presentation was bullish, and appealed to a generation raised on George Lucas's *Star Wars* cycle of films – hence the initiative's sobriquet. The Soviets screamed "foul play" – hardly fair as it was not designed as an offensive move, merely one that might avoid the dilemma of Mutually Assured Destruction. After 10 years of research, costing around $50 billion, the initiative was quietly wound down by President Clinton, although work continues on the concept.

THE COLD WAR: SECTION SEVEN

1986-1990

1986 Collapse of US Southeast Asian puppet buffer state in Philippines under Ferdinand Marcos. Left-wing government elected.

1986 Reagan administration damaged by Iran-Contra arms scandal, revealing depths of US dirty tricks.

1986 USA bombs Libya on suspicion of promoting terrorism.

1986 Launch of first permanently manned space station (USSR).

1986 Chernobyl (Ukraine) nuclear power station melt-down; world's worst nuclear accident.

1987 US stock market crash, causing global economic recession.

1987 Washington Arms Control (INF) Treaty: US and USSR agree to limit intermediate nuclear weapons.

1989 George H. W. Bush (1924–) becomes US President (Republican, to 1993).

1989 Tiananmen Square: pro-democracy student movement violently crushed in Beijing.

1989 Opposition parties legalized in Hungary.

1989 Democratic elections in Poland won by Solidarity.

1989 Democracy restored in Chile after military dictator General Pinochet steps down.

1989 Limited elections in USSR.

1989 Berlin Wall demolished; communist regimes in East Germany, Poland, Czechoslovakia, Hungary, Romania and Bulgaria collapse.

1989 US forces intervene in Panama, arresting President Noriega.

1989 Ceauşescu regime toppled in Romania. Ceauşescu and his wife executed.

1989 Soviet forces withdraw from Afghanistan.

1990 East and West Germany reunited into a single state. Baltic states of Estonia, Latvia and Lithuania declare independence from the Soviet Union.

1990 Democratic election in Nicaragua ends Sandanista rule.

1990 Mikhail Gorbachev (1931-) briefly becomes President of Russian Republic (to 1991).

1990 Boris Yeltsin (1931–2007) elected President of Russian Republic (to 1999). Introduces economic liberalization reforms.

1990 NATO and Warsaw Pact agree terms for limitation of conventional arms in Europe.

1990 African National Congress (ANC) legalized in South Africa.

1990 Soviet Communist party disbanded.

GORBACHEV AND *PERESTROIKA*

By the time of his appointment as Politburo leader in 1985, Mikhail Gorbachev was confronted by a grim reality: the USSR was going bankrupt. It could no longer afford the luxury of a strategic arms arsenal, nor the cost of maintaining its empire in Eurasia and its satellite states in Europe. In order to save the Russian state, he began to introduce liberal reforms such as *perestroika* (economic and governmental restructuring) and *glasnost* (openness – freedom of speech, the press and public debate). He initiated government campaigns against inefficiency and corruption. More dramatically, he introduced the notion of multi-party elections in Russia (although these would not become a reality until 1993), and refused to intervene when the Soviet republics and satellite states began to show signs of breaking away from the Union in the late 1980s. The only exception to this was a heavy-handed intervention when the Baltic States, effectively annexed to the Soviet Union during World War II, demonstrated their desire for independence in 1990.

Gorbachev was the sole candidate in the Communist Party election for the new role of President of the Soviet Union in 1988.

Elsewhere, however, he was not unopposed, Party hardliners plotted against him and his ally, Boris Yeltsin.

Gorbachev was awarded the Nobel Peace Prize in 1990.

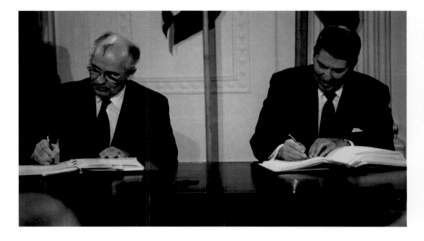

THE INF TREATY

The Intermediate-Range Nuclear Forces (INF) Treaty between the USSR and the USA was signed in Washington in December 1987. It was the product of a series of conferences that had begun in Geneva in 1983 under the title of Strategic Arms Reduction Talks (START). After the tension of the mid-1980s, and the hysteria over the Strategic Defense Initiative, it signalled the beginning of a genuine intention to wind down the arms race. The agreement was intended to eliminate all ground-based nuclear missiles in Europe that were capable of hitting only European targets, including those in European Russia. It also made provision for each country to inspect their adversary's bases. In reality, it only reduced their nuclear arsenals by around 2,000 weapons, some 4 per cent of the total.

In 1991, further reductions were agreed, both superpowers beginning a programme to decommission a further 30 per cent of their nuclear arsenals.

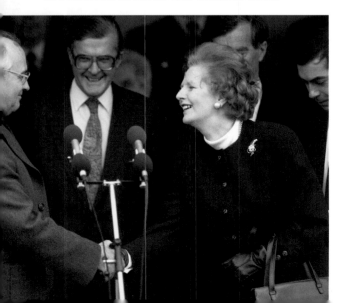

LEFT: *Among Gorbachev's most significant achievements were his foreign policy. He held meetings with Western leaders such as Margaret Thatcher on a regular basis, and gradually moved toward détente.*

POLAND FACES ALL-OUT STRIKE

REBELS IN THE CAMP

As Western Europe moved towards greater economic and political unity within the European Union, the nations of Eastern Europe remained constrained by Soviet communism. In the 1970s the global economic depression saw the Soviet economic model under enormous pressure, food prices soared and many localized riots and protests broke out.

In the early 1980s there were the rumblings of organized dissent, one of the loudest emanating from the Lenin shipyard in Gdansk, Poland, where an illegal trade union movement developed. Led by Lech Walesa, the union, Solidarity, was created in 1980. It extracted from the Polish government under General Jaruzelski the right to form trade

CRISIS - TORN Poland was facing a general strike last night.

The threat came as a fresh wave of stoppages swept across the country.

Workers in five more cities walked out to join the battle for free trade unions.

In an unprecedented move Communist chiefs showed their alarm by asking Cardinal Stefan Wyszynski, the Catholic Primate of Poland, to go on television to appeal for "prudence."

The strikes now affect every corner of the country.

Protests

In central Poland transport workers in Lodz, the second biggest city, walked out.

In the south, in Wroclaw, a city of 600,000 people, a dozen factories were reported to have been made idle.

In the northern port of Szczecin teachers and health workers joined

By DAVID TATTERSALL

the protests. Stoppages were also reported in Rzeszow in the south-east and Olsztyn in the north-east.

At least 250,000 Poles are now staying away from work.

At the strike headquarters in Gdansk workers threatened a "catastrophic" general strike unless more of their demands were met.

Meanwhile authorities were forced to make still more concessions.

Government negotiators at the Lenin shipyards in Gdansk said they accept that workers have the right to strike and will guarantee it by law.

Deputy prime minister
● **Turn to Page Two**

WALESA'S LONE VIGIL

By CHRIS BUCKLAND, Foreign Editor

WITH only hours to go before last Sunday's crackdown by the Polish military government, a man idly plays a piano.

The lonely, thoughtful figure is Solidarity union leader Lech Walesa. He and his colleagues meeting at the Gdansk ship yard had just taken the fateful decision to challenge the government with a general strike this week.

That decision was to lead to martial law and a round-up of the union's leaders.

The whereabouts of Walesa are now unknown. Most reports say he is under house arrest.

An ominous report of the first bloodshed in the country's troubles filtered through yesterday.

French trade union leader Edmond Maire said he had been told by Premier Pierre Mauroy that nine people had been killed and 45,000 rounded up.

A Reuters report from Warsaw said that the back of the protest strikes had been broken. Warsaw was said to be calm once again.

But some sources said the struggle for control was still going on in other areas.

The big test for Poland may come today when Solidarity's big strike is due to take place.

Meanwhile Russia is ever-watchful. Soviet transport planes were landing at Warsaw yesterday—carrying food supplies, according to the Russians.

● **Troops move in—Page Five.**

ence.
kes now affect
ner of the

otests

central Poland
workers in
second biggest
ked out.
south, in Wroc-
ity of 600,000
dozen factor-
ies were reported to have
been made idle.
In the northern port
of Szczecin teachers and
health workers joined

At the strike head-
quarters in Gdansk
workers threatened a
"catastrophic" general
strike unless more of
their demands were met.
Meanwhile authorities
were forced to make still
more concessions.
Government negotia-
tors at the Lenin ship-
yards in Gdansk said
they accept that workers
have the right to strike
and will guarantee it by
law.
Deputy prime minister
● Turn to Page Two

unions and the right to strike. Yet, in a panic, Jaruzelski imposed martial law in 1981 and outlawed Solidarity in 1982. Walesa and other leaders were briefly imprisoned, but when Walesa was awarded the Nobel Peace Prize in 1983 the momentum became unstoppable.

With a Polish pope, John Paul II, being installed in Rome in 1979, pressure was also mounting for reform from outside the country and by 1989 Solidarity was legalized and partially free elections took place. Solidarity won, and the first Polish non-communist post-war government was elected.

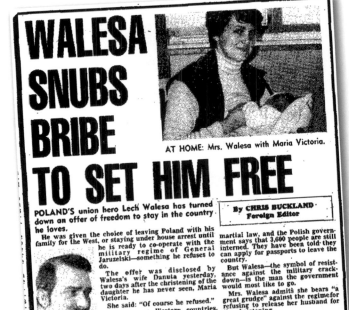

WALESA SNUBS BRIBE TO SET HIM FREE

AT HOME: Mrs. Walesa with Maria Victoria.

By CHRIS BUCKLAND
Foreign Editor

POLAND'S union hero Lech Walesa has turned down an offer of freedom to stay in the country he loves.

He was given the choice of leaving Poland with his family for the West, or staying under house arrest until he is ready to co-operate with the military regime of General Jaruzelski—something he refuses to do.

The offer was disclosed by Walesa's wife Danuta yesterday, two days after the christening of the daughter he has never seen, Maria Victoria.

She said: "Of course he refused."

In any case, Western countries, including Britain, have made it clear that they will not accept Poles forced out of their country in such circumstances.

Yesterday was the 100th day of

WALESA: Won't go.

martial law, and the Polish government says that 3,600 people are still interned. They have been told they can apply for passports to leave the country.

But Walesa—the symbol of resistance against the military crack-down—is the man the government would most like to go.

Mrs. Walesa admits she bears "a great grudge" against the regime for refusing to release her husband for the christening.

She said she intends to visit him later this week at the Warsaw villa where he is a prisoner to show him his seventh child for the first time.

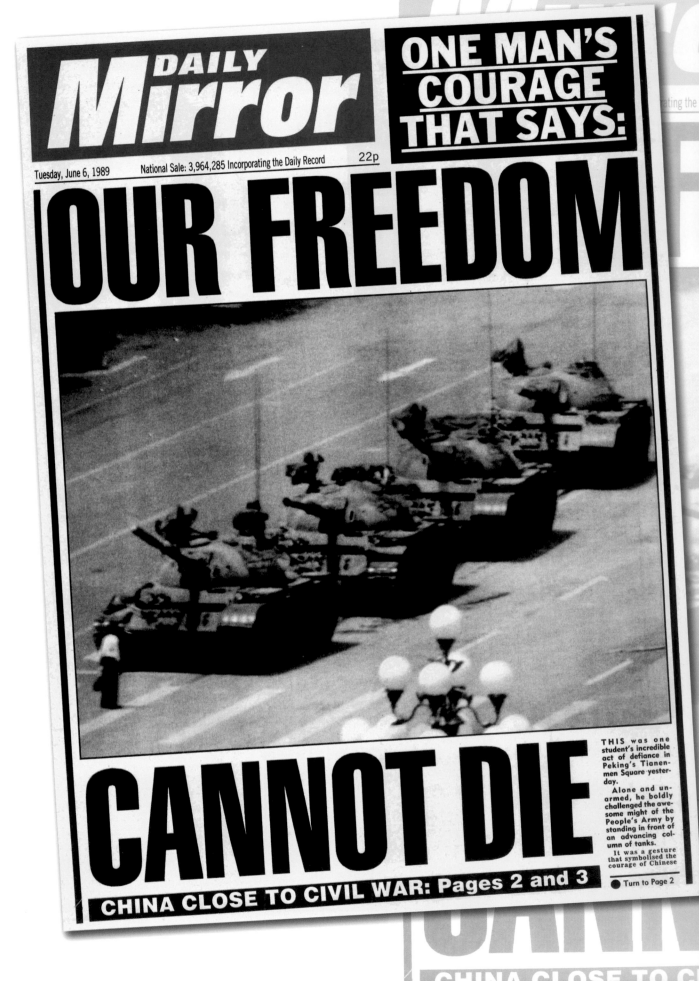

TIANANMEN SQUARE

While the Soviet Union crumbled, on the other side of the communist world a different sort of revolution was taking place in China. Since Mao Zedong's death in 1976, and after a brief interregnum by the "Gang of Four", Mao's former ally Deng Xiaoping became the Chinese leader, beginning a programme of economic liberalization. Then, as now, there was no question the Chinese Communist Party would not retain centralized control, but there was a feeling that change was going to come. Such aspirations were swept away in 1989, when demands by students for a more democratic system were brutally crushed by a massacre of up to 5,000 demonstrators in Beijing's Tiananmen Square. By 1997, Deng was dead, as were most of the generation who had supported Mao through the wars against Japan and the Nationalists. Within two years the country had developed the neutron bomb, normalized trade relations with the outside world, reclaimed the money-spinning colonies of Hong Kong and Macao, and begun a path of at least economic liberalization, which would place it once again near the top of the world's main players.

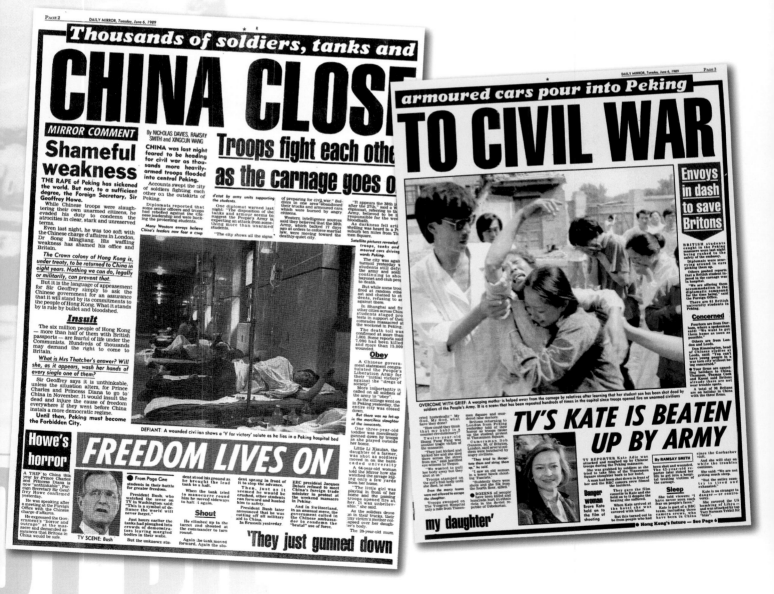

THE COLD WAR: SECTION SEVEN

RIGHT:
A view taken from East Berlin in September 1989 looking across 'No-Man's Land' of 'Death Strip' towards the Brandenburg Gate and the Reichstag. Within days the barrier would become irrelevant.

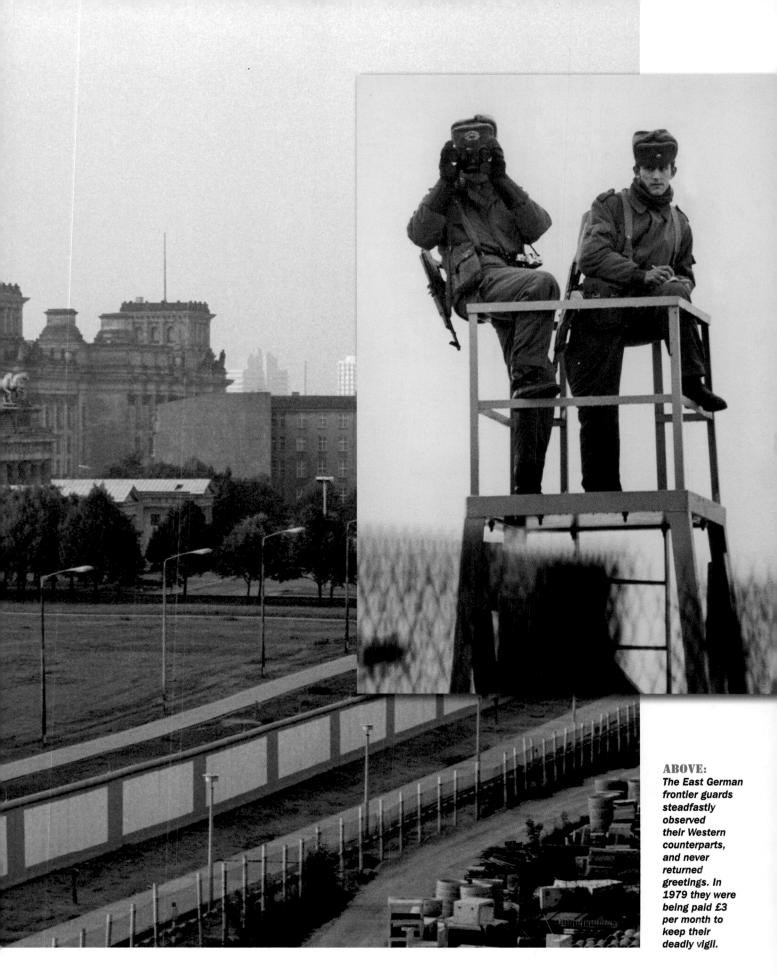

ABOVE:
*The East German
frontier guards
steadfastly
observed
their Western
counterparts,
and never
returned
greetings. In
1979 they were
being paid £3
per month to
keep their
deadly vigil.*

THE WALL COMES DOWN

In spite of momentous events elsewhere in
Eastern Europe, the demolition of the hated
Berlin Wall in November 1989 remains the one
that captured the imagination of the world.

Formal reunification of West and East
Germany did not take place until almost a year
later, in October 1990. The celebrations by then
were somewhat muted, as the sheer economic
burden of accommodating East Germany's
population and economic problems became
increasingly evident.

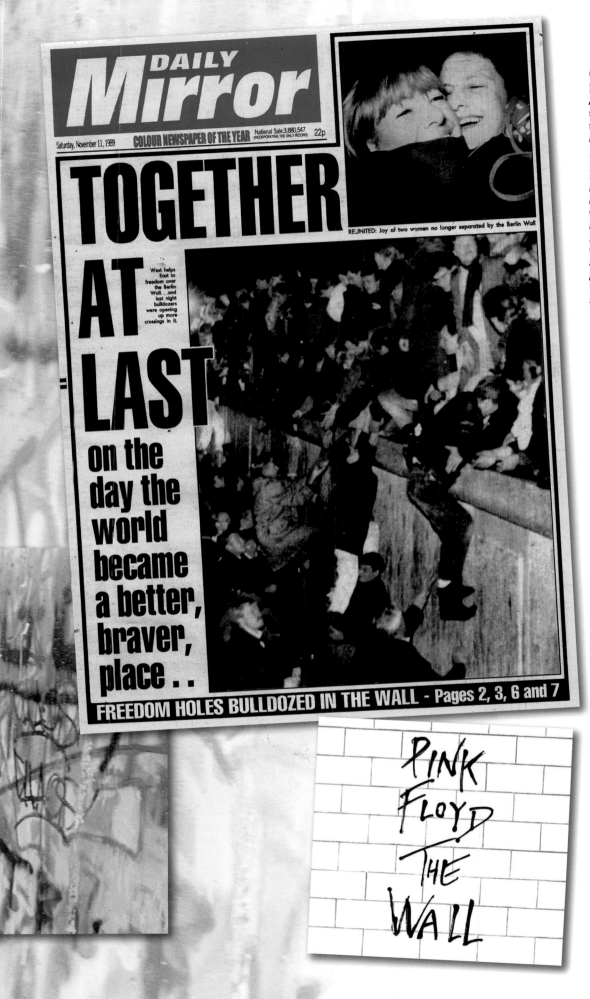

DAILY Mirror

Saturday, November 11, 1989 COLOUR NEWSPAPER OF THE YEAR National Sale:3,880,547 (INCORPORATING THE DAILY RECORD) 22p

REJUNITED: Joy of two women no longer separated by the Berlin Wall

TOGETHER AT LAST

West helps East to freedom over the Berlin Wall. . .and last night bulldozers were opening up more crossings in it.

on the day the world became a better, braver, place . .

FREEDOM HOLES BULLDOZED IN THE WALL - Pages 2, 3, 6 and 7

PINK FLOYD THE WALL

OPPOSITE LEFT: *A glimpse of the exotic East through a fissure in the wall.*

BELOW LEFT INSET: *Days after the border crossing was relaxed in November 1989 Berliners were chopping away at the graffiti-covered Wall, seeking souvenirs.*

LEFT: *One of the seminal records of the later Cold War period was Pink Floyd's* The Wall, *which surveyed societal control from schooldays through to political engagement. The band performed a special concert in Berlin to celebrate the demolition of the Berlin Wall.*

A REVOLUTION OF MANY COLOURS

What had developed in Poland in the confrontation between the communist puppet government and the Solidarity union during the 1980s provided a template that was being emulated elsewhere in Eastern Europe. A

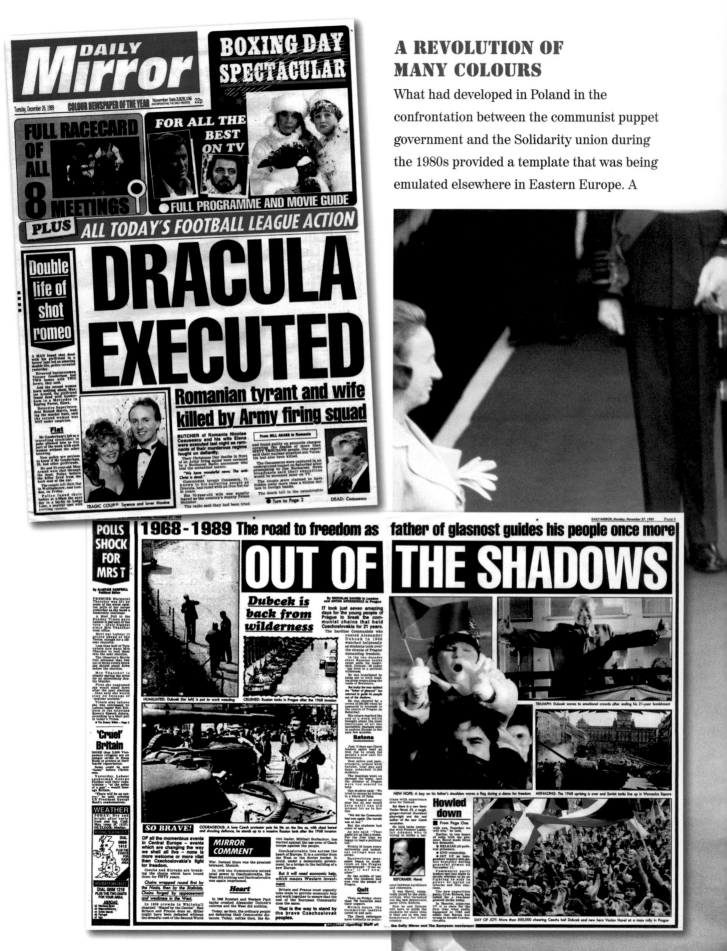

wave of nationalism took hold. Widespread protest in East Germany had brought the communist government down in 1989 and saw the Berlin Wall dismantled. A populist uprising overthrew the communist dictatorship of Ceauşescu in Romania the same year: the ruler and his wife were summarily executed as part of the Christmas celebrations. In a more peaceful manner, economic liberalization and (albeit sometimes limited) free elections were introduced in Hungary, Bulgaria and Czechoslovakia – the so-called "Velvet Revolution" – in 1990.

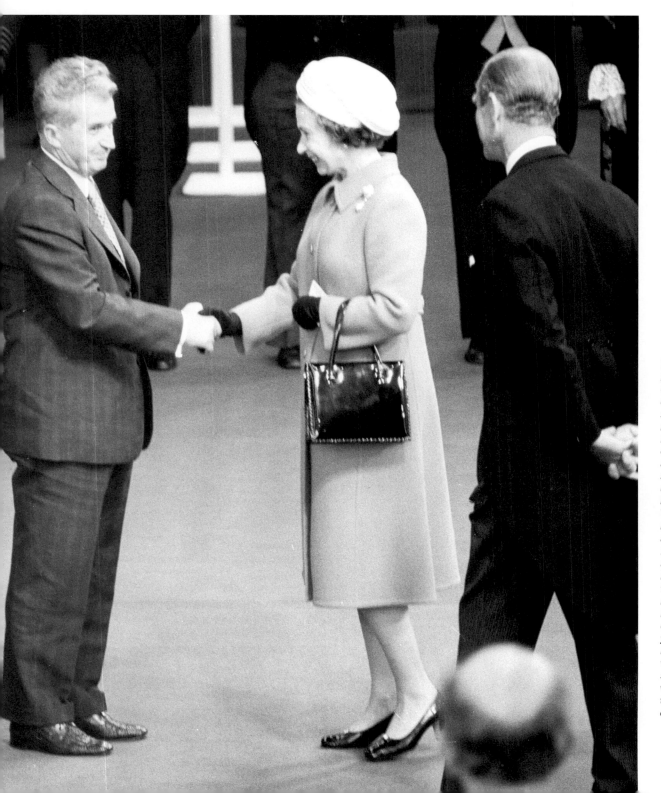

LEFT: *Premier Nicolae Ceaucescu of Romania, sporting a regulation Eastern Bloc crumpled suit and cardboard shoes, backed up by his wife, being greeted at Victoria Station in London on a state visit in 1978. Like many a communist hard-liner, he feathered his nest lavishly at his country's expense. Eleven years later he and his wife would be summarily shot without trial as the Iron Curtain collapsed.*

Freedom from half a century of Soviet economic and political domination was not always an easy path. In Romania the infrastructure was already in ruins. Overcrowded orphan homes briefly caught the attention of the international press. Named the most polluted place on the planet, Romania and its people struggled to survive as the post-independence economy collapsed into freefall.

LEFT: *A couple searching for work in the smog of the railway sidings outside Bucharest.*

BELOW: *The new face of capitalism: burning rubber off old telephone wires to sell the copper would earn these entrepreneurs two euros per kilo.*

Aftermath
FROM 1990

The last decade of the 20th century witnessed the end of monolithic communism in all but a handful of scattered states. The nations of Central and Eastern Europe, hitherto under Soviet domination, had all effectively declared independence by 1991, as had the Soviet Asian republics. At the same time, China opened its doors to world trade and foreign investment, becoming almost at a stroke one of the world's largest and most influential economies, although democracy was held at bay: any dissent or interference was still dealt with summarily.

In the void left by the end of the Cold War, new threats to global stability emerged. Fears voiced by many scientists predicted that human industrial rapacity was causing environmental damage on a massive scale, indeed creating a change in the Earth's climate system that might be irreversible. Scientific advances developed from technologies only half-glimpsed during the Cold War were soon transforming the way in which power politics was conducted.

In the absence of overbearing superpower control, ethnic tensions also escalated, not least in the fracture line between a newly militant Islamic world and the developed world. When al-Qaeda launched its terrorist war on the West with the 9/11 attacks on the American heartland, a new and almost entirely unpredictable adversary had entered the vacuum left by the demise of the Cold War.

It seemed that the human race could not survive without the spectre of apocalypse lurking at its shoulder.

1991-1995

1991	Baltic republics declare independence from the USSR.
1991	Marxist regime in Ethiopia under Megistu toppled by Eritrean and Tigrean separatists.
1991	First Gulf War: US-led coalition war against Iraq following Iraqi invasion of Kuwait.
1991	START: US and Soviet Union sign Strategic Arms Reduction Treaty.
1991	Russia ends preferential trade agreement with Cuba.
1991	North and South Korea sign non-aggression pact.
1991	Boris Yeltsin (1931–2007) becomes president of Russian Republic (to 1999). Introduces economic liberalization reforms.
1991	Attempted coup by Russian communists suppressed. All Soviet republics declare independence.
1991	Union of Soviet Socialist Republics dissolved. A new Russian Federation and Commonwealth of Independent States (CIS) established. Warsaw Pact and COMECON abandoned.
1991	US President George Bush Sr announces the end of the Cold War.
1991	Slovenia and Croatia declare independence from Yugoslavia. Start of ethnic civil war in Yugoslavia.
1991	Last recorded nuclear test by UK (Nov.).
1991	UN brokers peace ending 10-year civil war in El Salvador.
1992	Khmer Rouge, in exile, launch guerrilla campaign against Cambodia.
1992	Civil war in Georgia, Russian intervention in Abkhazia and South Ossetia.
1993	William (Bill) Jefferson Clinton (1946-) becomes US president (Democrat, to 2001).
1993	Oslo Accords, Israel agrees to limited Palestinian autonomy in West Bank and Gaza Strip.
1993	The "Velvet Divorce": following free elections in 1992, Czech Republic and Slovakia divide into independent states.
1993	Second attempted coup by communists in Russia defeated.
1993	Democracy restored in Cambodia.
1993	Last recorded nuclear test by USA (Sept.).
1994	First multi-racial elections in South Africa.
1994	Russian intervention in Chechnya.
1994	Death of communist North Korean leader Kim Il Sung; succeeded by son, Kim Il Sung II.
1994	CIA agent Aldrich Ames arrested for spying for Russians. He reputedly earned $2.7 million.
1995	Communists win election in Russia.
1995	End of war in Bosnia.

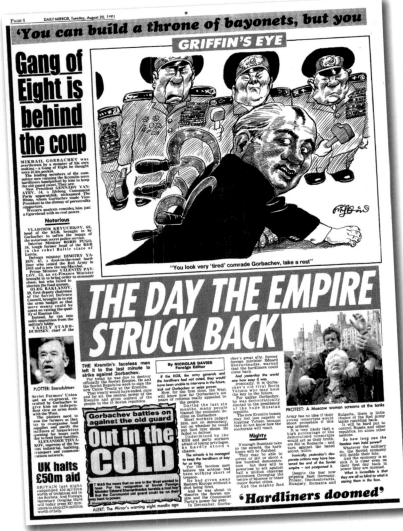

the free elections that saw Boris Yeltsin become president in 1991, succeeding Gorbachev. Unsurprisingly, there was a revolt by the hardline communists, leading to an attempted coup which Yeltsin successfully quashed. The USSR was dissolved by the end of the year, and a new Russian Federation announced. The 14 Soviet republics became independent, although a less formal federation, the Commonwealth of Independent States (CIS), was immediately set up. The Warsaw Pact and COMECON were simply abandoned.

Over the next four years the European nations within the former Eastern bloc

THE END OF THE SOVIET UNION

The implosion of the Soviet Union occurred in stages, the most significant of which were

groped their way towards new, largely Western-oriented, political and economic structures. By 1995, the Baltic states, Poland, the Czech Republic, Slovakia and Hungary had all joined the European Union.

BELOW LEFT:
The president of the new Russian Federation, Boris Yeltsin, holding a press conference standing on a tank after his suppression of a communist coup.

BELOW:
Soviet premier Boris Yeltsin celebrating the end of the Cold War with British Prime Minister John Major. But it was their predecessors who had done the spade-work.

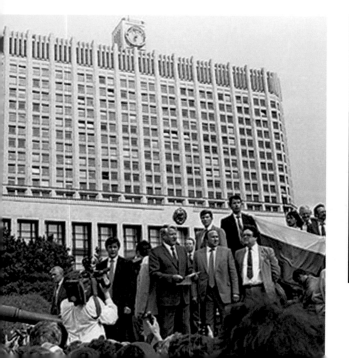

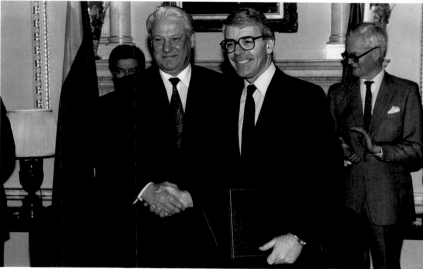

RIGHT:
When NATO deployed forces to quell Serbian aggression in Kosovo, Yeltsin's Russia objected, sparking off what the Daily Mirror warned might be a revival of the Cold War. As it turned out, the Serbs eventually backed down.

BELOW:
There was outrage that a European state, already negotiating to join the European Union, could resort to almost medieval barbarism when dealing with its own people.

ETHNIC CRISES

The removal of centralized, often communist, political control saw a widespread outbreak of ethnic rivalries and demands for self-determination. Within the newly constituted Russian Federation, nationalist movements in predominantly Islamic territories such as Ossetia and Chechnya caused bitter conflict and proved that the new state was still determined to exert control by force within its borders.

In Yugoslavia, the death of the non-aligned but East-orientated Marshal Tito in

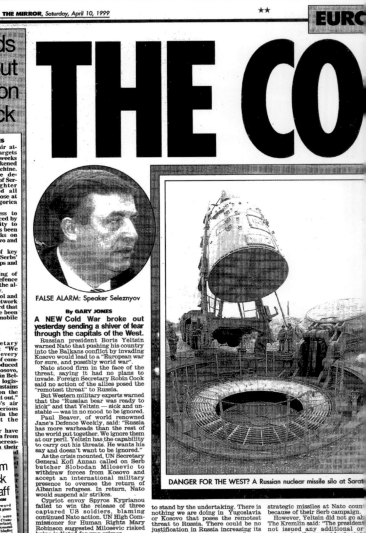

1980 brought a revival of Serb nationalism and began the fragmentation of what had always been something of an artificially constructed state created in the wake of World War I and the Balkan wars that preceded it. Slovenia and Croatia defiantly declared

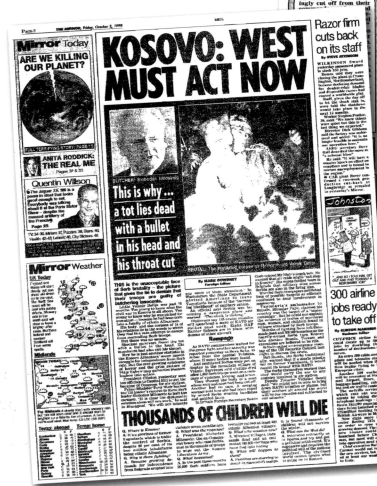

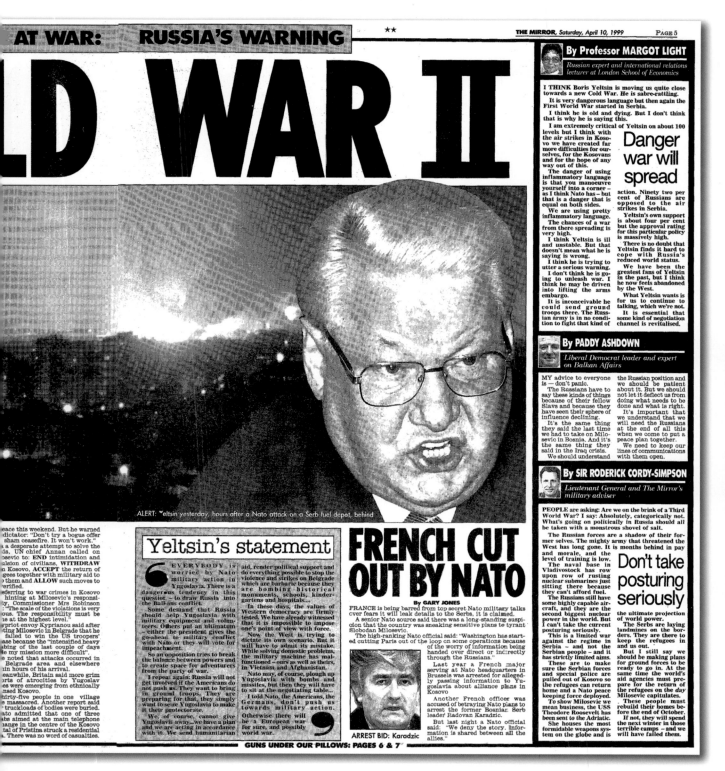

LD WAR II

ALERT: Yeltsin yesterday, hours after a Nato attack on a Serb fuel depot, behind

peace this weekend. But he warned dictator: "Don't try a bogus offer sham ceasefire. It won't work."

s a desperate attempt to solve the is, UN chief Annan called on sevic to END intimidation and ulsion of civilians, WITHDRAW n Kosovo, ACCEPT the return of gees together with military aid to them and ALLOW such moves to erified.

eferring to war crimes in Kosovo hinting at Milosevic's responsi-y, Commissioner Mrs Robinson : "The scale of the violations is very ous. The responsibility must be e at the highest level."

ypriot envoy Kyprianou said after ting Milosevic in Belgrade that he failed to win the US troopers' ase because the "intensified heavy abing of the last couple of days e my mission more difficult".

e noted that attacks occurred in Belgrade area and elsewhere in hours of his arrival.

eanwhile, Britain said more grim rts of atrocities by Yugoslav es were emerging from ethnically ased Kosovo.

hirty-five people in one village e massacred. Another report said truckloads of bodies were buried. ato admitted that one of three hs aimed at the main telephone ange in the centre of the Kosovo tal of Pristina struck a residential . There was no word of casualties.

Yeltsin's statement

❝ EVERYBODY is worried by Nato military action in Yugoslavia. There is a dangerous tendency in this question – to draw Russia into the Balkans conflict.

Some demand that Russia should help Yugoslavia with military equipment and volunteers. Others put an ultimatum – either the president gives the go-ahead to military conflict with Nato or they will vote for impeachment.

So an opposition tries to break the balance between powers and to create space for adventurers from the party of war.

I repeat again Russia will not get involved if the Americans do not push us. They want to bring in ground troops. They are preparing for that, they simply want to seize Yugoslavia to make it their protectorate.

We, of course, cannot give Yugoslavia away...we have a plan and we are acting in accordance with it. We send humanitarian

aid, render political support and do everything possible to stop the violence and strikes on Belgrade which are barbaric because they are bombing historical monuments, schools, kindergartens and hospitals.

In these days, the values of Western democracy are firmly tested. We have already witnessed that it is impossible to impose one's point of view with force.

Now the West is trying to dictate its own scenario. But it will have to admit its mistake. While solving domestic problems, the military machine has malfunctioned – ours as well as theirs, in Vietnam and Afghanistan.

Nato may, of course, plough up Yugoslavia with bombs and missiles, but then they will have to sit at the negotiating table...

I told Nato, the Americans, the Germans, don't push us towards military action.

Otherwise there will be a European war for sure, and possibly world war. ❞

FRENCH CUT OUT BY NATO

By GARY JONES

FRANCE is being barred from top secret Nato military talks over fears it will leak details to the Serbs, it is claimed.

A senior Nato source said there was a long-standing suspicion that the country was sneaking sensitive plans to tyrant Slobodan Milosevic.

The high-ranking Nato official said: "Washington has started cutting Paris out of the loop on some operations because of the worry of information being handed over direct or indirectly through the Russians."

Last year a French major serving at Nato headquarters in Brussels was arrested for allegedly passing information to Yugoslavia about alliance plans in Kosovo.

Another French officer was accused of betraying Nato plans to arrest the former Bosnian Serb leader Radovan Karadzic.

But last night a Nato official said: "We deny the story. Information is shared between all the allies."

ARREST BID: Karadzic

GUNS UNDER OUR PILLOWS: PAGES 6 & 7

By Professor MARGOT LIGHT
Russian expert and international relations lecturer at London School of Economics

I THINK Boris Yeltsin is moving us quite close towards a new Cold War. He is sabre-rattling.

It is very dangerous language but then again the First World War started in Serbia.

I think he is old and dying. But I don't think that is why he is saying this.

I am extremely critical of Yeltsin on about 100 levels but I think with the air strikes in Kosovo we have created far more difficulties for ourselves, for the Kosovans and for the hope of any way out of this.

Danger war will spread

The danger of using inflammatory language is that you manoeuvre yourself into a corner – as I think Nato has – but that is a danger that is equal on both sides.

We are using pretty inflammatory language.

The chances of a war from there spreading is very high.

I think Yeltsin is ill and unstable. But that doesn't mean what he is saying is wrong.

I think he is trying to utter a serious warning.

I don't think he is going to unleash war. I think he may be driven into lifting the arms embargo.

It is inconceivable he could send ground troops there. The Russian army is in no condition to fight that kind of

action. Ninety two per cent of Russians are opposed to the air strikes in Serbia.

Yeltsin's own support is about four per cent but the approval rating for this particular policy is massively high.

There is no doubt that Yeltsin finds it hard to cope with Russia's reduced world status.

We have been the greatest fans of Yeltsin in the past, but I think he now feels abandoned by the West.

What Yeltsin wants is for us to continue to talking, which we're not.

It is essential that some kind of negotiation channel is revitalised.

By PADDY ASHDOWN
Liberal Democrat leader and expert on Balkan Affairs

MY advice to everyone is – don't panic.

The Russians have to say these kinds of things because of their fellow Slavs and because they have seen their sphere of influence declining.

It's the same thing they said the last time we had to take on Milosevic in Bosnia. And it's the same thing they said in the Iraq crisis.

We should understand

the Russian position and we should be patient about it. But we should not let it deflect us from doing what needs to be done and what is right.

It's important that we understand that we will need the Russians at the end of all this when we come to put a peace plan together.

We need to keep our lines of communications with them open.

By SIR RODERICK CORDY-SIMPSON
Lieutenant General and The Mirror's military adviser

PEOPLE are asking: Are we on the brink of a Third World War? I say: Absolutely, categorically not. What's going on politically in Russia should all be taken with a monstrous shovel of salt.

The Russian forces are a shadow of their former selves. The mighty army that threatened the West has long gone. It is months behind in pay and morale, and the level of training is low.

The naval base in Vladivostock has row upon row of rusting nuclear submarines just sitting there because they can't afford fuel.

The Russians still have some highly capable aircraft, and they are the second biggest nuclear power in the world. But I can't take the current posturing seriously.

This is a limited war against the regime in Serbia – and not the Serbian people – and it has strictly limited aims.

These are to make sure the Serbian forces and special police are pulled out of Kosovo so the refugees can return home and a Nato peace keeping force deployed.

To show Milosevic we mean business, the USS Theodore Roosevelt has been sent to the Adriatic.

She houses the most formidable weapons system on the globe and is

Don't take posturing seriously

the ultimate projection of world power.

The Serbs are laying landmines on the borders. They are there to keep the refugees in and us out.

But I still say we should be making plans for ground forces to be ready to go in. At the same time the world's aid agencies must prepare for the return of the refugees on the day Milosevic capitulates.

These people must rebuild their homes before the end of October.

If not, they will spend the next winter in those terrible camps – and we will have failed them.

THE COLD WAR: SECTION EIGHT

their independence in 1991, leaving Bosnia/ Herzegovina and the Muslims of Kosovo to confront Serb aggression and "ethnic cleansing". The conflict in Bosnia eventually ended after foreign intervention in 1995, but new violence broke out when Kosovo attempted to secede and

Serbian President Milošević launched an ethnic cleansing campaign against the predominantly Albanian Muslim population, which was only halted after the deployment of NATO troops and bombers. Milošević stepped down in 2000, and Yugoslavia ceased to exist in 2003.

1996–2000

1996	Taliban gain power in Afghanistan, introducing fundamentalist Islamic regime.
1996	Russian forces retreat from Chechnya.
1996	End of 36-year civil war in Guatemala.
1996	Last French nuclear test in Pacific.
1997	Hong Kong returned to China by Britain.
1998	Both India and Pakistan test nuclear weapons.
1998	Zhu Rongji becomes Chinese leader; commits to further economic liberalization.
1999	Poland, Hungary and Czech Republic join NATO.
1999	Yeltsin resigns.
2000	Global Internet use reaches an estimated 295 million, with almost 100 million Internet host computers.
2000	Border reopened between North and South Korea.
2000	Vladimir Putin (1952-) elected Russian President. Attacks "oligarchs" in an attempt to stabilize the economy.
2000	Serbian premier Milošević ousted.

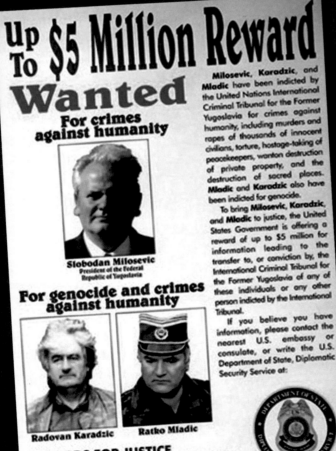

PUTIN'S INHERITANCE

One of the immediate effects of Gorbachev and Yeltsin's economic reforms in Russia was the creation of a number of enormously powerful and wealthy entrepreneurs, many ex-Party men, who took control of the formerly nationalized industries, especially oil and natural gas extraction. They became known as the "oligarchs". The nation was being looted, and there was a concomitant growth in organized crime. Only with the election of a tough ex-KGB man, Vladimir Putin, as president in 2000 did the rapacity begin to be reined in. Putin had been only the latest of several prime ministers under Yeltsin, who resigned in 1999, but he presided over a positive rebuilding of Russia after years of turbulence.

ISLAMIC MILITANCY

With the eradication of the old East–West balance of power, Islamic radicalism suddenly filled the vacuum, regarding both the West and Russia as demons that needed to be destroyed. It was the Soviet Union who first recognized the threat, with their invasion of Afghanistan in 1979. Ten years later, like others before them, they found themselves withdrawing their superior weaponry in the face of a sustained guerrilla war conducted by the *mujahideen*.

For the West, beyond their machinations over sustaining the State of Israel, the conflict started off on the wrong foot when the Western Powers decided that Saddam Hussein's regime in Iraq, which they had supported for years, was getting out of hand. After years of aggression against Iran, and the brutal suppression of ethnic minorities, Iraq's invasion of oil-rich Kuwait in 1990 provoked a slap-down by a US-led alliance in the first Gulf War, or Desert Storm.

In the meantime, the Russian withdrawal from Afghanistan introduced another "rogue" state to the mix, which led another US-led coalition force into an attempt to support an elected government in a seemingly unwinnable war.

An ensuing 12 years of pressure on Iraq led in 2003 to a full invasion, and the eventual defeat of Saddam Hussein. By then Islamic militants, most prominently the non-nationalist group al-Qaeda, had gained the strategic upper hand. They were effectively invisible and untraceable, although US intelligence supported continuing offensives against an invisible enemy in the badlands of Afghanistan and northwest Pakistan.

LEFT:
Though less approachable than Gorbachev, and less fun than the bibulous Yeltsin, Putin understood the importance of at least appearing friendly. His trip to Britain in 2003 was the first state visit to Britain by a Russian leader in over a century.

BELOW LEFT:
After a campaign that had lasted more than twice as long as the Great Patriotic War against Nazi Germany, the Red Army finally withdrew its forces from Afghanistan in 1989. It was hardly an ignominious defeat, as the Western Allies were to discover when they similarly attempted to destroy Islamic fundamentalist groups in the country in a military commitment that began in 2001 and continues today.

OPPOSITE LEFT: *The Serbian Socialist leader Slobodan Milosevic and his henchmen attempted to use repressive techniques such as ethnic cleansing to retain control of the rump state of Yugoslavia. Many of them were brought to trial at The Hague for war crimes.*

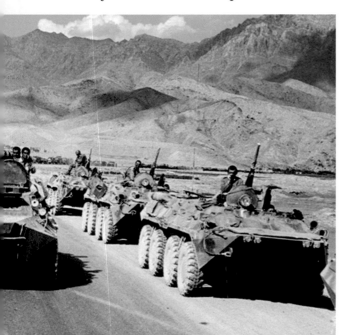

★

OUR LAST CHA

By GORDON BROWN

We must fight this together

PEOPLE ask whether we can solve the challenges of global warming and still have a prosperous economy, that creates jobs and funds our key public services. I say, if we take the right action we can.

Yesterday we set out how.

Individuals, communities, businesses and governments can all play their part.

I am excited by the campaigns already under way, people and charities putting the case for global action.

And just as the Mirror and its readers supported our efforts to end third world debt, now I ask that we campaign together for a greener prosperous world.

But we can go further than campaigning.

We can all reduce the energy we use – buying energy-saving light bulbs, turning down the thermostat a degree, installing insulation or making sure we turn the TV off rather than leaving it on standby.

All of these can help.

Government and businesses need to work together to set a national example – thanks to what we have already done we will cut greenhouse gases by more than 20 per cent by 2010.

But most of all the world needs to act.

THE way forward is global. So yesterday I set out my ideas to bring all nations into a global system of greenhouse gas limits – to ensure that we get every country working together to make the changes necessary.

And I believe that meeting this global challenge offers a real opportunity for British workers and businesses.

Today more than 400,000 jobs in Britain are in the new environmental industries that will be needed. British firms are at the cutting edge of the development of new technologies.

But the potential is even greater. By 2010 the global environmental market could be worth almost $700billion – as big as the successful aerospace or pharmaceuticals industries of today. I believe it is essential that Britain leads in these new industries.

So I am setting up a new commission to ensure we have the skills and ideas we need to do so.

Our ambition will be to create 100,000 more British jobs over the next 10 years.

So just as in recent years Britain has led the world in securing a stable economy with more jobs, I believe Britain can lead the world in creating a stable and sustainable economy founded on low carbon – a Britain that is both pro-growth and pro-green.

By OONAGH BLACKMAN, Political Editor, and MIKE SWAIN, Science Editor

GORDON Brown yesterday vowed that Britain will lead the world in the fight against global warming.

And he indicated that people will not have to pay the earth to save the Earth.

A source close to the Chancellor said: "There is a role for green taxes but no one has any intention of hitting millions of hard-working British families with punishing tax hikes."

Mr Brown writes in today's Mirror: "Government and businesses need to work together to set a national example. But most of all the world needs to act. The way forward is global."

His message comes after an apocalyptic 700-page report yesterday warned of the dangers of climate change.

Hard-headed World Bank chief economist Sir Nicholas Stern said there would be:

● A WORLDWIDE recession worse than that caused by the two world wars.

● MORE than 200 million people at risk of becoming refugees because of drought and flood.

● THE prospect of 40 per cent of the world's animal species being wiped out.

He added: "The task is urgent. Delaying action, even by a decade or two, will take us into dangerous territory. We must not let this window of opportunity close."

Tony Blair said the consequences of inaction were "literally disastrous".

The Prime Minister added: "This disaster is not set to happen in some science fiction future many years ahead, but in our lifetime. Investment now will pay us back many times in the future, not just environmentally but economically as well.

"For every £1 invested now we can save £5 in the future, or possibly more."

The report comes days after it was revealed Environment Secretary David Miliband has called for a menu of green taxes. These include duty on flights, pay-as-you-drive road taxes and higher duty on energy wasting appliances such as washing machines.

But the Chancellor indicated he will not burden lower earning taxpayers in the fight to combat global warming.

Rather than British tax hikes Mr Brown wants a worldwide carbon market – extending the European Emissions Trading Scheme to countries such as the United States, India and China – to create a "low carbon global economy".

These major polluters need to be brought on board for any initiative to work.

Mr Brown's plans also include a Europe-wide emissions reduction target of 30 per cent by 2020 and at least 60 per cent by 2050.

● Report calls for action on global warming apocalypse

● Chancellor draws up for world to tackle emis

And to have five per cent of all UK vehicles running on bio-fuels by 2010.

In his report, Sir Nicholas said the result of doing nothing would be catastrophic.

He added: "If no action is taken to reduce emissions, concentration of greenhouse gases in the atmosphere could reach double its pre-industrial levels by 2035 virtually committing us to a global average temperature rise of more than 2C.

In the longer term there would be a 50 per cent chance that the temperature rise would exceed 5C.

"This would be very dangerous indeed," Sir Nicholas said. "Such changes would transform the physical geography of our planet as well as the human geography – how and where we live our lives." Sir Nicholas added the price will be the equ five per cent of global product a year and possi cent.

"It would cost an estima person on the planet –

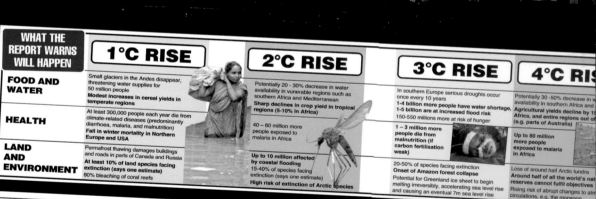

WHAT THE REPORT WARNS WILL HAPPEN	1°C RISE	2°C RISE	3°C RISE	4°C RIS
FOOD AND WATER	Small glaciers in the Andes disappear, threatening water supplies for 50 million people **Modest increases in cereal yields in temperate regions**	Potentially 20 - 30% decrease in water availability in vunerable regions such as southern Africa and Mediterranean **Sharp declines in crop yield in tropical regions (5-10% in Africa)**	In southern Europe serious droughts occur once every 10 years 1-4 billion more people have water shortage, 1-5 billion are at increased flood risk 150-550 millions more at risk of hunger	Potentially 30 -50% decrease in availability in southern Africa and **Agricultural yields decline by 15 Africa, and entire regions out of (e.g. parts of Australia)**
HEALTH	At least 300,000 people each year die from climate-related diseases (predominantly diarrhoea, malaria, and malnutrition) **Fall in winter mortality in Northern Europe and USA**	40 – 60 million more people exposed to malaria in Africa	1 – 3 million more people die from malnutrition (if carbon fertilisation weak)	Up to 80 million more people exposed to malaria in Africa
LAND AND ENVIRONMENT	Permafrost thawing damages buildings and roads in parts of Canada and Russia **At least 10% of land species facing extinction (says one estimate)** 80% bleaching of coral reefs	Up to 10 million affected by coastal flooding 15-40% of species facing extinction (says one estimate) **High risk of extinction of Arctic species**	20-50% of species facing extinction **Onset of Amazon forest collapse** Potential for Greenland ice sheet to begin melting irreversibly, accelerating sea level rise and causing an eventual 7m sea level rise	Loss of around half Arctic tundra Around half of all the world's nat reserves cannot fulfil objectives Rising risk of abrupt changes to atm circulations, e.g. the monsoon

VOICE OF THE MIRROR: PAGE 6 ● **HELP S**

200

GLOBAL WARMING: THE NEW HOT WAR.

After decades of living under the daily threat of nuclear annihilation, the world invented a new apocalyptic doomsday machine: "global warming". Once again this was the product of human technology, but one that crept up and took everyone by surprise. There was little political edge to the issue. Although some blame could be attributed to ageing industrial systems in both the Eastern bloc and America, the burning of fossil fuels – which was identified as the main reason for the problem – continued unabated. America appeared to isolate itself from the debate until the 21st century, demanding scientific evidence for its culpability in a planet-threatening situation.

OPPOSITE LEFT: *The full panoply of Cold War rhetoric was directed to the threat of climate change, with the fully informed British Prime Minister throwing his considerable weight into the debate.*

LEFT: *The ownership, extraction and consumption of fossil fuels, plus the attendant pollution hazards when things go wrong, remains one of the key issues in the post-Cold War world.*

201

2001-2010

2001 George W. Bush (1946-) becomes US President (Republican, to 2009).

2001 Islamic extremists use hijacked passenger planes to destroy the World Trade Center in New York and attack the Pentagon in Washington DC. US President George W. Bush declares "War on Terror".

2001 US-led coalition forces begin offensives against Taliban strongholds in Afghanistan.

2001 FBI agent Robert Hanssen arrested for spying for Moscow. In a 22-year career he had passed over 6000 documents to the Russians.

2002 Further agreement between USA and Russia on reduction of strategic nuclear weapons.

2002 NATO and Russia form council to collaborate in countering terrorism.

2003 Second Gulf War: US-led coalition invades and occupies Iraq.

2006 Suspected nuclear test explosion by North Korea.

2007 Defection to USA of Ali Reza Asghari, former Iranian Deputy Defence minister and head of Iran's nuclear programme.

2009 Barack Hussein Obama (1961-) becomes first black US President (Democrat).

2009 Iran denies any attempt to create nuclear weapons.

2010 North Korea torpedoes South Korean military vessel.

2010 CIA announce defection of Iranian nuclear scientist Shahram Amiri whilst on Hajj pilgrimage to Mecca.

2010 US President Barack Obama announces agreement with Russian Federation for new reductions in nuclear arsenals.

2010 FBI arrest eleven Russian spies in various cells based on the US East Coast.

THE WAR ON TERROR: THE "AXIS OF EVIL"

It was given to US President George W. Bush (Jr), the son of the US President who had announced the "end of the Cold War", to declare that a "War on Terror" had now begun after the 9/11 attacks: he identified Iran, Iraq and North Korea as his principal targets. As it turned out, for the first decade of the 21st century, it would be Iraq and Afghanistan – subsequently identified as the heartland of Islamic terrorism – that would absorb most of the West's military endeavours.

NEW TECHNIQUES OF CONTROL

By the end of the 20th century, several technologies that were unimaginably more powerful than anything developed at the height of the Cold War had emerged: global satellite television broadcasting; mobile (cellphone) telecommunications; and the World Wide Web, or Internet. No longer were physical barriers capable of ring-fencing information, limiting what was fed by governments to their subjects. One of the key aspects of the Cold War, social control, had been swept away.

Satellite television was the first medium to break down the barriers, with news-streaming channels such as CNN providing information round the clock. Broadcast stations such as al-Jazeera also provided a platform for Osama bin Laden to deliver video messages directly into the homes of his enemies.

The mobile phone became not just the communication device of choice in both the developed and developing worlds (where landline infrastructures were limited) but also became the logistical weapon of choice among terrorists, allowing them to operate networks seamlessly in "enemy" territory – and to detonate bombs.

The Internet was originally created at minimal cost and as a means of linking scientific centres around the world, but it soon became available to anyone with access to the right computers and communication links. It became clear that it could also be used for subversion – both Russia and China have managed to cause Internet meltdowns against countries and organizations who displeased them – while the ability it provided to hack into digital security systems has largely replaced the need for human spies.

OPPOSITE LEFT: *The Muslim fundamentalist Osama bin Laden represented the new face of terror for the 21st century. He and his organisation, al-Qaeda, used many of the technologies of the West (jet airliners, mobile phones, the Internet, video and TV broadcast) to wage a new 'hot' Cold War.*

LEFT: *New Cold War techniques such as Internet assault, either to hack into security systems or to jam national/ governmental sites, and cutting off supplies of oil, electricity, gas or water are increasingly used as methods of applying political pressure which echo those of the Cold War.*

DAMAGE UNLIMITED

Despite the Cold War being officially over for two decades, there still exists an alarming stockpile of nuclear weaponry – over 11,500 warheads remain on standby, shared among nine nations. There have been 2,055 nuclear tests since the Trinity test on 16th July 1945.

THE NUCLEAR ARMS BALANCE 2009

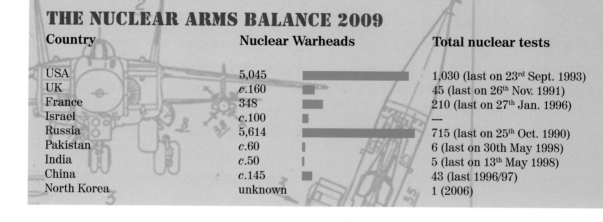

Country	Nuclear Warheads		Total nuclear tests
USA	5,045		1,030 (last on 23rd Sept. 1993)
UK	c.160		45 (last on 26th Nov. 1991)
France	348		210 (last on 27th Jan. 1996)
Israel	c.100		---
Russia	5,614		715 (last on 25th Oct. 1990)
Pakistan	c.60		6 (last on 30th May 1998)
India	c.50		5 (last on 13th May 1998)
China	c.145		43 (last 1996/97)
North Korea	unknown		1 (2006)

Expenditure on arms still remains enormous, with a total world spend of $1,160 billion. The USA devotes over $500 billion per annum from its budget – nine times more than any other country – but then it derives $1 trillion from its arms trade. The other big spenders (and earners) are Britain ($60 billion), France ($53 billion) and China ($50 billion). Russia limps in at seventh place after Japan and Germany, spending only $35 billion.

The size of standing armies remains almost equally impressive.

Country	Military personnel
China	3.75 million
India	3.05 million
USA	1.54 million
Russia	1.45 million
North Korea	1.3 million
Pakistan	920,000
Egypt	800,000
South Korea	693,000
Brazil	673,000
Turkey	617,000

As the first decade of the 21st century closes, the shadow of nuclear war persists, not so much in the hands of the long-standing "nuclear club", but in the acquisition of nuclear weapons by less accountable states such as Iran and North Korea. While the West's certainty that Saddam Hussein's Iraq possessed "weapons of mass destruction" proved to be largely baseless, the possibility of terrorists assembling smaller nuclear "dirty bombs" remains a very real threat.

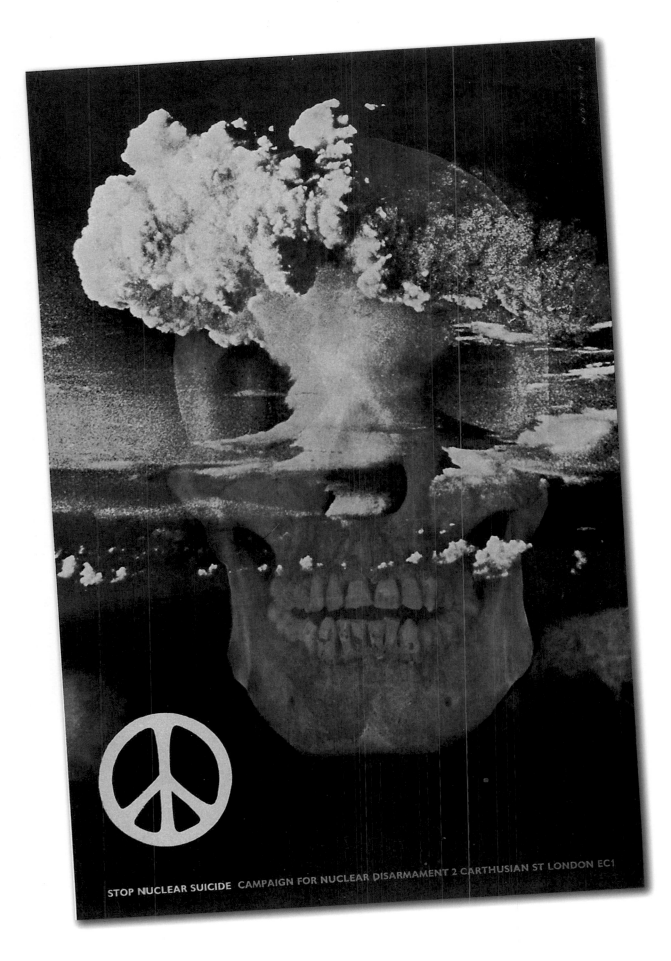

STOP NUCLEAR SUICIDE CAMPAIGN FOR NUCLEAR DISARMAMENT 2 CARTHUSIAN ST LONDON EC1

INDEX

Picture acknowledgements
All pictures © Mirrorpix, with the following exceptions:
[c= centre; l= left; r= right; tl= top left; tr= top right; bl=bottom left; br=bottom right]

Wikimedia Commons: 13, 16-17 tl/br, 20-21, 27c, 38, 45br, 47br, 48, 49c, 56tl, 59, 61bl, 62, 71tl, 72br, 76c, 96bl, 103tl, 104-105tc, 126c, 127tl, 138c, 157tr/br, 159br, 160-161t, 195bl, 199bl

US Government/public domain:31tr, 40-41, 47tr, 51, 52-53, 58, 66-67, 70-71, 74-75, 104c, 152tl, 153t, 156, 158t/b, 166, 167r, 176-177, 198, 202

Private collections: 26bl/tr, 32, 34, 39, 63, 64-65, 72tl, 78tc, 80, 82, 122, 128-129, 133, 140, 142bl/tc, 150, 175, 187br, 204

Commissioned photography: Amelia Heritage: 26, 74br, 81bl, 137c, 163bl

Bibliography and recommended further reading

America, Russia and The Cold War, Walter Lefeber, 2002
Defence of the Realm, Christopher Andrew, London 2002
The Climate of Treason, Andrew Boyle, London, 1979
The Cold War, A New History, John Lewis Gaddis, 2006
The Cold War, Mike Sewell, 2001
The Traitors, Alan Moorehead, London 1952 (revised 1963)
Where We Are Now/Snapshots, CIRCA, London/New York, 2008/2009

Author's acknowledgements
This proved to be an enormously more ambitious, broad-ranging and, in the end, compressed project than
I imagined when I signed up to it in the summer of 2008.
I would like to thank my family for their support whilst completing the manic final stages of this project, not least
my wife and business partner Ailsa, who dug me out of a hole once again by being both forceful and understanding.
Thanks too should go to Philippa Baile, who helped out on picture research, in addition to the team at Mirrorpix who
were heroic, and Elizabeth Stone the project editor, who took a very rough and ready manuscript and came back to
me with only a sprinkling of 'Author's Questions', for which I remain very grateful. Kevin Gardner has done a great
job of clearly bringing to life what was often, in my head, a rather rambling vision of 20th century history.
The ideas and opinions (which I have tried to avoid) expressed in this book are mine, and mine alone. As are any
omissions, of which I am aware there are many.